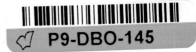
William Henry Jackson

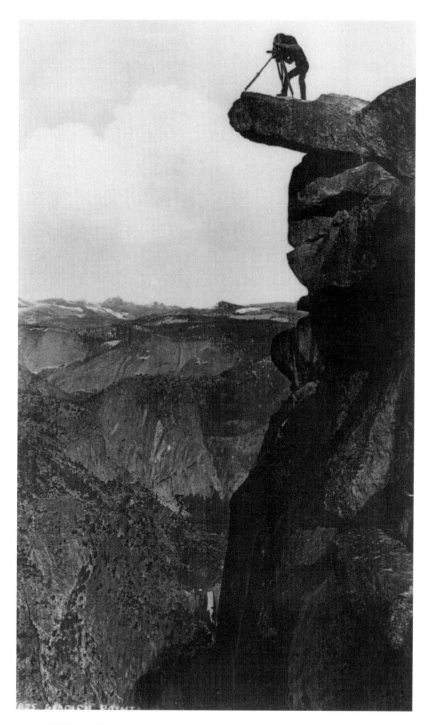

William Henry Jackson atop Glacier Point in Yosemite, California.
— Courtesy Colorado Historical Society

William Henry Jackson

FRAMING THE FRONTIER

Douglas Waitley

Mountain Press Publishing Company
Missoula, Montana
1999

Cover painting by William Henry Jackson,
courtesy Scotts Bluff National Monument

Maps by William L. Nelson

The publisher would like to thank the following sources for providing photographs,
information, and assistance:

Amon Carter Museum of Western Art
Brigham Young University
Chicago Historical Society
Colorado Historical Society
Denver Public Library
Douglas County (Nebraska) Historical Society
Library of Congress
Scotts Bluff National Monument
U.S. Geological Survey

All diary quotes are reprinted by permission of the Colorado Historical Society, Denver.

Library of Congress Cataloging-in-Publication Data

Waitley, Douglas.
 William Henry Jackson : framing the frontier / Douglas Waitley.
 p. cm.
 Includes bibliographical references and index.
 ISBN 0-87842-381-8 (alk. paper)
 1. Jackson, William Henry, 1843-1942. 2. Photographers — United States —
Biography. 3. Photography — United States — History — 19th century. 4. West
(U.S.) — Pictorial works. I. Title.
TR140.J27W35 1998
770'.92 — dc21 98-43915
[B] CIP

PRINTED IN THE UNITED STATES OF AMERICA

Mountain Press Publishing Company
P.O. Box 2399 • Missoula, MT 59806
406-728-1900 • 1-800-234-5308

Contents

Introduction

William Henry Jackson saw himself as "one of the fortunate." He was born in 1843 during a unique era in American history, when the United States was about to break from its eastern orientation and become a continental nation. Its victory over Mexico[1] (when Jackson was five) would add the huge Southwest and California to its domain, and at the same time Great Britain would relinquish its claim on Oregon.[2]

Jackson would have been the first to acknowledge that he had an utterly insatiable wanderlust. At twenty-three years old, Jackson fled from a disastrous love affair and bummed his way with two chums across New York State, through Detroit (where they slept in the city jail when they ran out of funds) and Chicago (where Jackson earned a few dollars giving art lessons), to St. Joseph on the Missouri River. There the trio got jobs as bullwhackers with a wagon supply train heading to western mining camps via the Oregon Trail. At one point Jackson found himself alone in California working as a flunky at a stagecoach station.

Eventually Jackson made his way to Omaha where, with the financial help of his parents back east, he bought a photographic shop. The next year he married, apparently believing he was ready to settle down. Had he done what was expected, the nation would have been deprived of his vibrant photographic record of the frontier.[3] But there was no danger of that, for Jackson had sand in his shoes that neither a wife, nor children, nor even lack of funds could remove.

In 1869 Jackson secured a low-paying commission from the Union Pacific—which had just completed the nation's first transcontinental railroad—to take promotional photographs along its line. So he and an assistant spent the summer out on the rails. It was anything but a lark, however. Jackson's primitive cameras did not operate with dry film (which had not yet been perfected) but required large glass plates that he had to coat specially with light-sensitive chemicals for each picture. The cameras, chemicals, plates, developing tent, and other paraphernalia weighed almost three hundred pounds, and to expose and develop a negative on one of the glass plates consumed nearly an hour.

Despite the drawbacks, Jackson was enthralled by both vagabonding across the countryside and recording what he saw in visual images. He had a feeling for history in transition. He was seeing the railroad replace the Oregon Trail. He was seeing the huge buffalo herds thin, then virtually vanish. He was seeing powerful tribes—like the Sioux who had been a threat when he bullwhacked through their territory—become harassed nomads, then humbled reservation Indians. And he felt he must be there to record those precious moments with his camera, cumbersome as it was, before they vanished.

In 1870 Jackson received an invitation from the distinguished scientist Ferdinand Hayden to join the U.S. Geological Survey expedition that was going to map and

evaluate the vast, largely uncharted western lands. For the next eight years he spent nearly every summer with the survey, carting his photographic equipment to bleak mountaintops and across churning rivers, through hostile Indian camps and wild mining towns, across rain-soaked wetlands and parched southwestern deserts. His persistence was nearly as notable as the quality of his pictures. Jackson's photos received considerable public attention during his time. Some were even distributed to Congress as part of the successful campaign for the creation of Yellowstone National Park—which, as the nation's first, became a precedent for the national parks that followed.

So what kind of man was Will Jackson? Physically he was unimposing. Even with his long, narrow head and deep-set eyes, many women found him handsome. He was quiet, sensitive, and learned, yet he could be friendly and gregarious, and enjoy bending an elbow with his buddies when the occasion was right. Rather than a ribald sense of humor, he had a subtle wit that comes through unexpectedly in his writings. Although he became something of a celebrity, he tended to downplay his accomplishments. This modesty won him many lasting friends.

Yet Jackson had his faults. His work always came first. Thus while his first wife, Mollie, lay dying during childbirth, Jackson was lobbying in Washington D.C. for the creation of Yellowstone National Park. Jackson also spent long periods away from his second wife, Emilie, and his three growing children as he tramped the byways of the West and went on an epic seventeen-month tour through Europe and Asia.

Jackson's importance to students of the American frontier lies primarily in the photos he took during his years with the U.S. Geological Survey, when the West was just opening up to American settlement after the Civil War. These remarkable photos, obtained with primitive equipment and often under difficult and dangerous circumstances, showed the West as it really was, not the idealized image that such talented artist-explorers as George Catlin,[4] Karl Bodmer,[5] Albert Bierstadt, and others had earlier presented.

Jackson's photos highlight a staggering assortment of Indians, mountain men, explorers, miners, and railroad workers—not in romantic poses, but often exhausted, grubby, and out of sorts, exactly as they were during this tumultuous era. He also recorded inspiring vistas of forested mountains, shimmering valleys, and boulder-strewn river canyons as they appeared before humans left their scars on them. Such photography had never been done before, at least not in the wild regions of the Rocky Mountains where Jackson tramped with his balky mules and bulky photographic equipment.

To understand Jackson, however, we must understand what he was not. He did not invent anything new in photography, nor did he ever claim to have done so. The invention of the photographic process had been made public by Frenchman Louis Daguerre in 1839, four years before Jackson was born.[6] The daguerreotype picture, formed on a silver-coated copper plate, proved so popular that by the late 1840s nearly

every city in the United States had its resident photographer, and small towns and villages were served by traveling picture takers with wagons fitted as studios and darkrooms. In 1858, at the young age of fifteen, Jackson began work as a retoucher, i.e., a colorist, for a photographer in Troy, New York.

Public interest in photography grew rapidly throughout the 1860s. During the Civil War, Mathew Brady and his team of photographers took their cameras right onto the battlefields to get pictures that revealed the glories and horrors of the conflict.[7] Portrait photographers, such as Julia Cameron in England, were also gaining popularity. Jackson was just beginning his photography career during this period, and by the decade's end was taking shots along the newly built Union Pacific lines.

Although it was Jackson's photos that brought him fame, he also kept a meticulous diary in which he fleshed out his experiences during those exciting times. The diary records not only his experiences with the survey but also his preceding adventures along the Oregon Trail. These writings provide devotees of the West with vivid accounts of what it was like when wagon trains were fortunate to grind out twenty miles a day and when Indians were still powerful enough to protect their territories.

Despite his unique experiences and photographic successes, Jackson was a very modest man, and his writings disclaim any elevation to greatness. His photos were meant to be pictorial records, not works of art—although some of his shots would fit into the latter category. Not until the early part of the twentieth century did photographers like Alfred Stieglitz begin turning pictures into explorations of a subject's soul. However, while Stieglitz and his school, aided by new, refined equipment, could take pictures that were technically superior to Jackson's, they didn't capture history. Jackson and his camera were there at the very dawn of a new era in the West. His photos are a vital resource for any historian who wishes to understand that era. Jackson had his moment and he utilized it to the fullest. His photographic account of the Old West will forever guarantee him an important place in the history of the American frontier.

PART I
Early Life in the East

Born to Roam

Growing Up in New York State, Vermont, and Elsewhere (1843–1862)

The lean, sunburned soldier put young Will on his knee. The year was 1848, and Uncle Edward had just returned from far-off Mexico where, he told the boy, he had fought a man named Santa Anna. The boy could only gape openmouthed as Uncle Edward related his adventures in the war. Edward recalled marching along the Santa Fe Trail, where buffalo herds swept across the horizon in numbers so immense that they looked more like ocean waves than thundering animals. And there were feathered Comanche warriors scowling at the intruders as they crossed their hunting grounds.

Although in his autobiography, *Time Exposure*, Jackson admitted he could remember only the telling and not the contents, his Uncle Edward's stories helped spark his love of the West, a feeling that was to play such an important part in his future.

It was not just Jackson's uncle who excited the boy's imagination. His own father, George, had an almost uncontrollable wanderlust. Before George was twenty, he had roamed as far as the Mississippi River, which in the 1830s was the edge of the frontier. George had his own brushes with danger, but he returned to his home in Keeseville, New York, with enough cash to open a blacksmith and carriage-building shop. Thereupon he asked Miss Harriet Allen to marry him. This she did and a year later, on April 4, 1843, she gave birth to William Henry Jackson, probably named for president William Henry Harrison, who had died in office two years earlier.

Having a wife and child did not relieve George's itch to be on the move. So in 1844 the young family pulled up stakes and made the difficult journey to Columbus, Georgia, where an opportunity to make carriages awaited George. It was here that little Will met Uncle Edward, hero (at least to him) of the Mexican War. George endured a sedentary life for only three years before he herded his family back to New York. They lived in Plattsburg for a while, then George bought a two-hundred-acre farm in Peru Township near Keeseville, where the Jacksons lived until Will was eight. It was upon this home that Jackson's childhood memories centered. As he recalled in his autobiography:

> My sharpest picture is of the kitchen, with my mother and the hired girl always stirring about with the cooking and baking, or putting up jelly, or filling a tub with hot water to do the washing. . . . It was the center of life, that kitchen, a room of ample size. Extending nearly the full width of the building, it must have been close to forty feet long. *(TE, 8–9)*[1]

Dried apples and shucked corn hung so low from the kitchen ceiling that a tall person had to stoop to avoid them. At one end of the kitchen was the stove on which

his mother seemed always to be brewing some delicious concoction. At the other end were a horsehair sofa, four rocking chairs, and a plank table where they ate and socialized after the farm chores were done. In the evening Harriet Jackson would read to Will and his brothers and sister by the light of a turpentine lamp.

The giant fireplace in the center of the kitchen was built of rough rocks brought in from the fields. During the long Adirondack winters, logs always crackled there. Harriet used an oven compartment at the base of the fireplace to bake bread and cookies. "No bread ever quite equaled the big round loaves that came straight from the hot brick floor to the table," Jackson recollected. "No day passed that failed to yield a pastry of some sort. When bread was not being baked there might be molasses cookies in the oven, or gingerbread, or, at the very least, a thick apple pie."

The farm was its own grocery store. Cows provided the Jacksons with milk and butter. Chickens gave them all the eggs they could use—as well as some of the best fryers in upper New York State. Sometimes George went hunting and returned with rabbits for stew or venison for steaks. In the summer the garden furnished vegetables in abundance, although during the winter the Jackson family consumed mostly potatoes, turnips, and the greens they had dried earlier. They picked fruits from trees that grew in the meadows and on the hillsides. But exotic foods like oranges were so rare that they were placed as special prizes at the bottom of Christmas stockings. For the

Jackson sketched this picture of his boyhood farm. —Courtesy Scotts Bluff National Monument

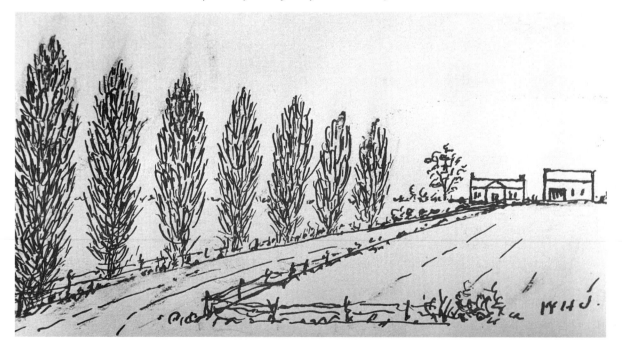

few things that the farm did not produce, the Jacksons used the general store down the road. Here a grumpy gentleman sold them such necessities as horse liniment, tenpenny nails, brown sugar, black thread, and coffee.

The family was a unit in which everyone had chores. Will, as the oldest of the five children, had to gather eggs from the barn, bring in the cows at milking time, and carry water out to the haying hands. The entire farm community was closely knit. When a family needed help, everyone around responded. Jackson recalled one barn raising get-together at a nearby farm. Men from all over the township helped with the construction, while the women tended to the refreshments. The children were left to themselves. This was a mistake.

Jackson and a half dozen other boys played a game of follow-the-leader. When one was passed a container of hard cider, he drank a cupful, and so on down the line. Eventually the game was forgotten and the boys concentrated on the cider. Soon they all became roaring drunk and had to be carried to the wagons. Jackson did not remember anything more of that particular barn raising.

Sometimes relatives came calling, and that was a special event. One such relative was Uncle Sam Wilson, the family celebrity. During the War of 1812 Sam had a meatpacking house near Albany where a large contingent of American troops was camped. He shipped them pork and beef in barrels upon which was marked "US," which meant they were for the U.S. troops. But somehow word began to circulate that the initials stood for Uncle Sam, the packer. The name stuck and within a decade he had become a symbol of the staunch, rural patriot, the backbone of America.[2]

When Jackson was eight, his father received a commission to set up a factory in Petersburg, Virginia. So they were off again. In Virginia Jackson had his first real contact with slavery. Having been only four when his family moved from Georgia, he couldn't remember ever seeing such large groups of black people. Although he was unable to grasp the concept of slavery — one person actually being owned by another — the disquieting vision stayed with him as he grew older.

Still on the move, the family soon migrated to Philadelphia. The wages there were low, however, so George and Harriet turned the front room of their home into a tobacco and candy shop. Jackson was attracted to the candy but also to the tobacco. One day he snitched what he called "a ferocious black stogie." But when he lit it, he found it did not taste like the licorice it resembled but had an evil flavor that made him cough and feel sick. "That first cigar convinced me that I had no taste for tobacco," he later confessed.

Philadelphia did not suit George Jackson, so he prepared to move the family back to New York State — this time to Troy, Harriet's hometown. It was decided that Will, now ten years old, would leave before the rest of the family and stay temporarily with his uncle and aunt in order to resume school at the start of the term. His parents deemed him old enough to make the trip alone. "No adventure of mine has ever provided excitement to equal that of my trip from Philadelphia to Troy in 1853," Jackson wrote many years later.

Jackson's send-off was such a special occasion that his father bought him a brand-new suit, complete with a rakish traveling cap, at the extravagant cost of eight dollars. On the morning of his departure, the entire family, including Jackson's four younger siblings, took a hired carriage to the train depot. His mother handed him a brown paper bag with sandwiches. Then, amid tears and farewells, he was off.

The train was a thrill to ride, with the mighty engine belching smoke and steam and the whistle shrilling so loudly that the windows rattled. Soon the train was speeding through villages where houses shot by so quickly that they seemed not to exist at all. Sometimes it drove through woods and other times clattered over bridges. Eventually it settled down to the long chug through New Jersey farmlands. It groaned to a stop at the broad Hudson River opposite New York City. Jackson took a ferry across the river, then spent a brief time marveling at the steeple of the Trinity Church. He thought surely no building could ever be made taller. Then he walked to the wharves where, as planned, he boarded the steamboat headed for Albany.

It was late afternoon as Jackson stood by the rail watching the side-wheels churn the water. The steam boilers drove the machinery with a force that shook the deck. From a pair of tall stacks overhead, smoke rose in a dense, acrid cloud that drifted off behind the boat, leaving a sky trail for nearly a mile. After dark, young Jackson went to his tiny stateroom, curled up on his bunk, and slept until morning.

When the boat docked at Albany, Jackson found the wharf jammed with people — pushy debarking passengers, rough teamsters in large wagons filled with farm produce for the downstate market, sweating stevedores and longshoremen who shouted and shoved as they carried goods to and from the steamboats. The bedlam frightened the boy, who now realized what it meant to be all alone. Fortunately, a kindly fellow passenger noticed that no one was meeting the lad, so he directed him to the stagecoach bound for Troy, six miles north. By noon Jackson was at his uncle and aunt's home, where he would stay until his family arrived. He had made good time, for the entire 275-mile journey had taken only thirty hours.

Jackson began school immediately. About his studies he would later recall very little, except that mathematics was important because money conversion was tricky, what with the American currency consisting of U.S. silver, French francs, English shillings, and various Spanish coins. He did remember the teacher, a mean, lanky man with jet-black hair that flowed down to his collar. He reminded Jackson of a cat in the way he prowled about the classroom as if he were searching for prey. When he found a boy chewing spruce gum, he would grab him with a headlock and jam his finger down the lad's throat to pry out the offending substance. The boys found this most frustrating—it took half a day of vigorous chewing to turn spruce sap into a good wad.

School was something to be endured, but drawing—that was a real pleasure! Jackson's mother had a talent for watercolors and one day, after the family arrived in Troy, she gave him a copy of J. G. Chapman's *American Drawing Book*. "No single thing in my life, before or since that day," Jackson admitted, "has ever been so important to

William Henry Jackson's parents, George and Harriet Allen Jackson, later in life. —Courtesy Library of Congress

me. . . . From Chapman I learned the mysteries of perspective [and] the rules of composition and design." They would serve him well, not only in his artwork but later in his photography.

Soon the ten-year-old was spending so much time drawing that his parents allowed the second floor of their backyard toolshed to become his studio. It was small and cramped with his easel and supplies, but he loved it. "I drew or painted every day," he recalled. "For a while I did nothing but landscapes. . . . A year or so later I began to copy old portraits. I completed a family gallery, including a likeness of Samuel Wilson." Jackson's mother's supportive criticism was a great help. He wished she could give him more time, but her days were full with the care of a husband and four younger children.

Since the family was just scraping by, no money was available for art supplies. So by the time Jackson was twelve he began searching for a job. That summer a Troy law firm hired him as an office boy. There he was kept busy carrying mail, filing reports, and copying outgoing correspondence. For a nine-hour day he received fifty cents. It was a low wage, but after some time he could purchase paints and brushes.

A year or so later Jackson made what he called "the most important discovery of my life"—that he could actually make money from his artistic talent. A druggist named Johnson wanted some display cards for his windows. Since young Jackson was not only cheap but reasonably skillful, Johnson hired him to do the blue, red, and gold lettering, complete with curlicue flourishes in the latest fashion. That job did not take long, so Jackson began looking for additional customers. Soon he was drawing placards for other merchants as well as for churches and political groups.

Then he found a new field, involving the black screening that was placed on doors and windows to protect against bugs. When the people of Troy began enlivening their dull screens with colored paint, Jackson saw a perfect opportunity: Why not paint scenery on the screens? Jackson charged fifteen cents to convert a screen into a work of art—or at least near-art. He was proud of his work, and it was fun to walk down the street and see what he had done. "Here were Mr. Jones' parlor windows parading the virtues of home life among the Romans," he wrote. "There were Mrs. Smith's testifying to her travels through the Black Forest and an idyllic honeymoon on Lake Lucerne; just beyond, Dr. Robinson's eloquently bespoke of his love of grazing cows, old mills, and waterfalls."

At the age of thirteen, Jackson became interested in politics. Although the Whigs (the party of Henry Clay and William Henry Harrison) had disintegrated, the Republican Party had taken its place and was putting up its first presidential candidate, John C. Frémont.[3] Frémont, one of the more flamboyant men of the era, had helped blaze the way to California and later boldly proclaimed its independence from Mexico—a premature gesture that helped cause the Mexican War.

The victory over Mexico had serious and unforeseen consequences when it brought huge territories into the American fold. These included California and Texas, as well

as the even larger expanse between them that would eventually become Nevada, Arizona, and New Mexico in the south, and Utah and much of Colorado to the north. These new territories intensified the antagonism between the southern slave-holding states and the northern free states. The South demanded that the line of the Missouri Compromise, dating back a generation, be extended to the Pacific, which would cause most of the new territory to be opened to slavery. Confronted with the challenge of slavery's expansion, the abolitionist Republican Party grew rapidly in the North.

Young Jackson became caught up in the antislavery fervor. He marched in several Republican processions down Main Street in Troy and even attended a mass meeting where orators roared out against Southern arrogance. Some of the placards carried in these events had been made by Jackson himself.

Although Frémont was defeated in 1856 by Democrat James Buchanan, the Republican surge continued. Contributing to the party's emotional appeal was a play entitled *Uncle Tom's Cabin*. Written by Harriet Beecher Stowe, it vividly portrayed life on a southern plantation where the harsh overseer, Simon Legree, treated the slaves with a brutality that shocked most Northerners. When *Uncle Tom's Cabin* came to Troy's local theater, Jackson watched the play breathlessly, as did the entire audience. Even years later he remembered it as "a real thriller."

At age fifteen Jackson took a job at a local photographer's studio, where he learned to hand tint photographs. By this time the controversy over slavery had reached a fever pitch. Out on the prairies of Illinois, two men vying for a Senate seat began arguing the issue in a series of debates that was featured in newspapers all over the nation. One of these men was Stephen A. Douglas, leader of the Democratic Party and possibly the best-recognized figure in America.[4] The other was a little-known politician by the name of Abraham Lincoln.

The Lincoln-Douglas debates fascinated the citizens of Troy. People discussed them on street corners, in barbershops, and at church gatherings. Douglas, a short, dynamic man nicknamed the Little Giant, said there was no need for a conflict in the territories since the western lands were not suitable for intensive cotton cultivation, the mainstay of the plantation system. Thus free men would be in the majority there and so would always control the legislatures, whereby they could pass local laws that would restrict or even eliminate slavery. This doctrine Douglas called "popular sovereignty."

But to Abraham Lincoln and the Republicans the very idea of making it legal for slavery to spread into the West was unacceptable. Lincoln ably challenged Douglas's thesis that local lawmakers could deal with a national problem. So the argument raged in Illinois and across America. "I followed [the debates] closely," Jackson recalled, "and it was a real personal blow when, some months later, the Illinois legislature re-elected the Little Giant to the United States Senate. . . . Lincoln was already something of a hero to me."

Although Douglas was back in the Senate, his claim of being a national leader had been demolished. Southerners were horrified that the head of the party they

regarded as their protector from Republican extremists should propose a doctrine encouraging legal restrictions on slavery. As the split between the two Democratic factions deepened, the presidential election of 1860 took on an unparalleled importance. The Democrats held a tumultuous convention in Charleston, where Stephen Douglas won the presidential nomination. Outraged Southerners stomped out of the convention and reconvened in Baltimore. Here they chose their own presidential candidate, John C. Breckinridge of Kentucky.

The Republicans met in Chicago. With the opposition split, optimism ran high. Lincoln had his special cheering section, which due to their volume many called the "leather lungs." As the wooden walls of the hall resounded with their battle cry, "Lincoln! Lincoln! Lincoln!" the delegates were finally compelled to nominate Lincoln as the Republican candidate.

The Southerners now declared that the Republicans were the party of the blacks and called them Black Republicans. Thereupon many Republicans took up the name proudly. Jackson had attended a preelection parade and remembered these Black Republican white men well. Behind a brass band playing martial music the men marched, row upon row, their faces shrouded by ink-black caps and their bodies draped in capes as black as the darkness that was gathering over the nation. On and on they came, their boots striking the pavement with the thud of raw power and righteousness. Onlookers, including Jackson, realized there was no mistaking the meaning: should the South rebel, men such as these would crush it.

Troy was a Republican hotbed, and on the night before the election there was another parade. Again the rousing drums and bugles played, and file upon file of Black Republicans, more than four thousand of them, marched through the town. But now the effect was even more impressive because they carried torches, which flickered over their ebony capes and turned Troy's main street into a vision of Judgment Day. With flags waving, they marched down aisles of cheering onlookers and up to University Hill, where they set off Roman candles that lit the town below "in a blaze of glory that I have never seen equaled," Jackson recalled.

On Election Day tension shrouded Troy, and indeed, the entire nation. Although Jackson was only seventeen and unable to vote, he walked to the telegraph office where a crowd had gathered to hear the returns come in. A clerk was posting the results state by state. It was a great show. "With each announcement of votes for Lincoln the crowd yelled and stamped in wild approval," Jackson remembered. Slowly the Lincoln totals grew. New York was going for Lincoln. And Pennsylvania. Then Ohio was in the Lincoln camp. More cheering. Men thumped each other on the back. Farmers danced jigs. Soon it became clear that the entire North was going for Lincoln. Who cared if the slave states were just as solidly opposed to him? The North had more electoral votes. Honest Abe would be the next president! At two o'clock in the morning Jackson walked home, weary but joyful.

The North was deliriously happy. Although the South had threatened to secede if Lincoln were elected, the threat was not taken seriously. The South was weak, with almost no industry and no army. If it came to hostilities, "a couple of weeks and a brigade or two would fix them"—so Jackson, and most of the North, reasoned.

Of course, they were wrong.

Yankee with a Sketchbook

Army Service During the Civil War (1862–1863)

President Buchanan, still in office, could only warn the Southern firebrands that they had no right to secede, but he did not possess the power to prevent such an act. The first to make good on the South's threat was South Carolina, which withdrew from the Union in late December 1860. Within a matter of weeks six other states had joined South Carolina, and in February 1861 delegates meeting in Montgomery, Alabama, proposed the creation of a new country called the Confederate States of America, with Mississippian Jefferson Davis as its president.

Jackson, along with most Northerners, was not overly concerned. "This crisis," Jackson recalled, "hardly attracted my attention. Something much more important was happening to me." A photographer from Rutland, Vermont, about ninety miles northeast of Troy, needed a retoucher to color photos, and Jackson's current employer had recommended him. So he was off to Rutland for a salary of six dollars a week.

Hostilities between the North and South began in April 1861 when South Carolinian cannons forced the surrender of Fort Sumter, which had plugged Charleston's harbor. Up in Rutland, where eighteen-year-old Jackson was now working, the Fort Sumter episode roused more indignation than apprehension. There were noisy clamorings that President Lincoln should simply send the army to Charleston and end the matter quickly.

The people of isolated Rutland were not the only ones who failed to comprehend the monumental conflict that the action at Fort Sumter had precipitated. President Lincoln, apparently convinced that a few weeks and a small army would be sufficient to pound some sense into the Southerners, issued a call for seventy-five thousand volunteers for three months.

But it took more than two months just to assemble the would-be Union soldiers around Washington. By that time they had only a few weeks left to serve. No matter, one victory was all that was needed. Thus in mid-July 1861, the half-trained force was sent down the road to Richmond, the Confederate capital, one hundred miles south. Accompanying them were several congressmen and assorted "bon vivants" wanting to see the fun while it lasted. Though almost as disorganized, Confederate soldiers battered the Union force at a creek called Bull Run, and soon the federal troops and stunned spectators were making a frantic, undignified retreat.

News of Bull Run shocked the North. "The impact was tremendous," Jackson recalled. Only then did Northerners comprehend that this was to be a full-fledged war. Lincoln determined that the next time he sent a force into Virginia it would be

well trained. Thus the Army of the Potomac was formed, with military perfectionist George McClellan at its helm. By April 1862 General McClellan was ready to move. He confidently transported his men to the long peninsula between the James and York Rivers, surrounding the Confederates, and advanced on Richmond. With a quick march he could have taken the city. But he dallied so long making sure his army was in parade condition that Robert E. Lee, the tactical genius leading the Southern troops, outmaneuvered him and forced another disgraceful Union retreat.

With the war going so badly, on July 1, 1862, Lincoln called for three hundred thousand more volunteer troops, this time for three-year enlistments. The North was already weary of the war, and the response was disappointing. So in August the president issued another call, this time for just nine-month enlistments, but with the warning that if the states did not meet their quotas, the deficit would be made up by a draft. Jackson disdained the indignity of being drafted, so he joined the Rutland Light Guard. In late September he arrived at the training camp in Brattleboro, Vermont, where he was issued a woolen blanket and a rubber mat and assigned a sleeping area on some straw.

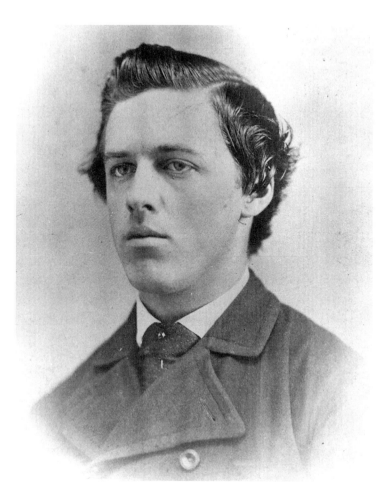

Jackson was nineteen years old when this photo was taken and was about to volunteer for the Union army.
—Courtesy Colorado Historical Society

15

The next day the Guard, soon to become Company K of the thousand-man Twelfth Vermont Regiment, which Jackson's brother Ed also joined, were set to work putting up the walls and roof of their barracks. Later each man was issued a backpack in which he was expected to transport everything from his overcoat, blankets, poncho, and extra boots to his frying pan and coffeepot—in total more than one hundred pounds. Finally, each was given a musket, complete with bayonet. Then it was drill, drill, drill. For six weeks the recruits were trained to become army men. Jackson grew tough and muscular.

Meanwhile on the battlefront General Lee and his brilliant subordinate, General Thomas Jackson, whom both friend and foe called "Stonewall," had struck the Union front line once more along Bull Run. This second Battle of Bull Run, bigger and bloodier than the first, had the same outcome. Again the defeated Union troops streamed back to the fortifications around Washington.

Lee now moved north, confident that if he could show his power beyond the Potomac River, strong antiwar sentiments would force Lincoln to end hostilities. McClellan met Lee at a creek called Antietam, just twenty-five miles from the Pennsylvania line. Here, on September 17, 1862, one of the bloodiest battles of the entire war was fought. Despite the gory struggle, McClellan could not defeat Lee. Though Lee turned back to Virginia, the Confederates claimed victory.

The Union casualties at Antietam were horrendous: twelve thousand men dead or seriously wounded. News of the bloodbath shocked the North, for nobody had anticipated such a cost in human lives.

Now more Union army units were ordered to the front. Among them was Will Jackson's Twelfth Vermont, which moved out of camp in early October 1862. The soldiers marched past cheering crowds and buildings draped with colorful bunting to the Brattleboro railroad station. They waited six hours for the train, then were jammed into boxcars and rattled off toward Washington. It was slow going, since the train was often delayed to allow the passage of commissary freights. To Jackson it seemed as if "enough milk, hogs, flour, and coal passed us that night to supply all the armies of the Republic for twenty years." But there were more than a hundred thousand fighters in blue to be fed, clothed, and supplied with guns and ammunition.

The going was tense through Baltimore, where pro–South sympathies ran so high that the first group of federal troops to reach the city had to fight its way through with bullets and bayonets—leaving one hundred dead. But by this time Baltimore's rebel element realized it was useless to obstruct the passage of Union soldiers, and the boys from Vermont passed through the city without incident.

When Will Jackson and his regiment reached Washington, they pitched their tents about a mile east of the Capitol. "I took every opportunity to visit the Halls of Congress," Jackson wrote. He also stood respectfully before the White House, unaware that within its walls Abraham Lincoln was going through some of his darkest days as Union losses grew. The nation found his leadership disappointing, and in the

November elections the peace-oriented Democrats won seven states and came within a rebel's yell of ousting the Republicans from control of Congress.

After not quite three weeks in Washington, Jackson's regiment, along with three others forming the Second Vermont Brigade, was given marching orders. They tramped down Pennsylvania Avenue in full battle gear and over the Long Bridge across the Potomac into Virginia, pitching their tents eight miles south of the river. Although it was quiet, they knew they were now on enemy soil. The brigade was part of the large picket force guarding the nation's capital.

In December the main body of the Army of the Potomac, now under the command of the pompous Ambrose Burnside after McClellan's failures, hurried down the northern side of the Rappahannock River, hoping to outflank Lee by a quick crossing at Fredericksburg. The crossing was not quick enough, however, and Lee was waiting with most of his army hidden. The result was more carnage and another serious Union defeat.

Fortunately for Will Jackson, his brigade was not part of the Fredericksburg slaughter. His unit had been ordered to move about twenty miles west to the Fairfax Courthouse in order to block possible advances against Washington. The part of Virginia he now traversed was a desolate, war-seared region where the flow of hostilities had left most of the houses charred hulks. Buildings that still had roofs were serving as hospitals. "Seven soldiers in the convalescent camp died this night" was a typical entry in Jackson's notebook. Also of concern were the rotting bodies of soldiers killed in earlier fighting. "Some fifty of the boys were ordered to near-by Chantilly Battlefield," Jackson wrote, "to help rebury the hurriedly interred soldiers who had fallen there nearly three months earlier."

Just before Christmas the weather became so frigid that standing water turned into ice nearly two inches thick. Although the main armies were in winter quarters, raiding parties were active. On December 28, scouts brought reports of the Confederate cavalry heading toward the Vermonters. Companies B and G rushed forward to act as skirmishers while the rest of the regiment prepared to defend itself. Jackson could hear firing and see the flash of guns in the night as he lay beside the earthen breastwork. To Jackson's relief, the rebel horsemen turned back and nothing more came of the incident.

The early months of 1863 were quiet except for a night in March when a Confederate raider, John Mosby, with a dozen handpicked men eased through the Union lines, entered the quarters of the Second Vermont Brigade's commander, General Edwin H. Stoughton, and brazenly kidnapped him. It was an act of unbelievable bravado that showed the vulnerability of the Union's frontline positions.

In spite of the war's uncertainty, Jackson found army life to his liking. Aside from drilling and the excitement of an occasional raid, there was actually very little to do, and Jackson amused himself by sketching. The men in camp were eager to have their portraits done, so Jackson became popular and soon came to the attention of a Colonel

Blunt, who ordered him to make a visual record of camp life. The colonel was so pleased with Jackson's sketches that he had him draw dioramas of the surrounding countryside, which the army engineers used to help design the system of breastworks and trenches protecting the nation's capital.

Jackson made many small sketches on three-by-five-inch cards. On the reverse of these he often wrote notes to his family and friends, then sent them off as postcards. His sketches were used similarly by others in his regiment, and in later years the story circulated that he was the originator of the picture postcard—a claim he modestly denied.

Although sketching was fun, Jackson was a restless young man who craved adventure. Thus, early in April 1863 he embarked on an astonishing enterprise, which he regarded as a lark at the time. Having mapped most of the land around Fairfax, he tramped south to Bull Run. Discounting the fact that Confederates often patrolled

While serving with the Union army, Jackson became popular among the soldiers and officers for his sketches of camp life. He often drew them on cards, which the men mailed to loved ones at home. —Courtesy Scotts Bluff National Monument

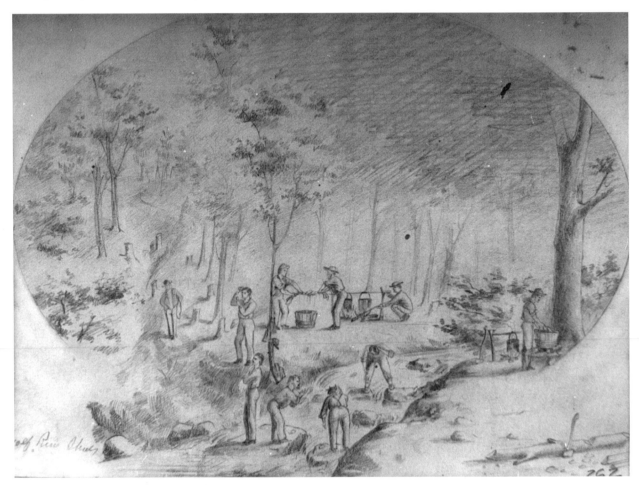

the southern shore, he found a raft and began floating down the sluggish stream, making notes as to its course for a future map.

The setting was beautiful with clumps of willows and oaks tinted with spring growth. He was completely absorbed in his notebook, oblivious that he was an easy target in his bright blue uniform. Suddenly he heard the sharp click of muskets being cocked. Only then did he realize his danger. Pickets on the shore yelled, "Who goes there?" with their guns leveled. Very fortunately for Jackson, they were Northerners. He stammered, "Friend," and poled his clumsy craft to the shore, where the pickets escorted him to their squad sergeant. After scrutinizing his papers, the sergeant berated him for such a foolhardy escapade, then released him.

In May military action began again. The Army of the Potomac was now under the command of coarse, liquor-loving Joe Hooker. Despite his many flaws, General Hooker was a capable strategist and conceived a scheme that could well have defeated General Lee. His plan was to station a large, aggressive force across the Rappahannock River from Lee at Fredericksburg. Then, screening the movements of his main army, Hooker would march twenty miles upriver to Chancellorsville, where he would cross undetected to the Confederate side. Lee, caught in a vise between federal troops at Chancellorsville and at Fredericksburg, would face a crushing defeat.

The plan seemed to be working to perfection. By May 1, Hooker's corps was safely in Chancellorsville and Lee was in his pincers. Hooker confidently told his subordinates that they would tend to Lee's destruction the very next day. But confusion took over when the Federals discovered that the area around Chancellorsville was a tangle of trees and underbrush, making it difficult to determine the enemy's exact location.

To support Hooker, Jackson's brigade had been moved to Catlett's Station, the vital railhead supplying Hooker's troops, twenty-eight miles north of Chancellorsville. Here the Vermont brigade's pickets were ambushed by the ever-cunning Mosby's Raiders. Jackson was close enough to hear the yelling and firing, although other Vermont units drove the raiders off. But the questions remained: From where had they come and to where did they vanish? Were there more Confederate forces, perhaps much larger, in the vicinity?

Meanwhile in Chancellorsville, Hooker, unsure where Lee was, dared not attack. Little did he know that Lee had dispatched Stonewall Jackson on a flanking movement of his own. Just before sundown General Jackson struck a blow so fierce and unexpected that a portion of the federal army had caved in by the time darkness forced a halt to the fighting. With that setback Hooker lost his nerve. Although most of his soldiers had not even seen action and he outnumbered Lee almost two to one, Hooker ordered a retreat. Thus one more humiliating Union defeat was chalked up on President Lincoln's report card.

After the Chancellorsville fiasco, William Jackson's brigade was pulled back to Union Mills, in northern Virginia, to reinforce the guard of Washington. There the

Vermonters were under constant harassment by small Confederate forces. One group of rebels attacked a supply train near camp, sending the twenty-two guards scurrying into the woods for safety.

From the Union Mills camp the Vermonters sent out foraging parties, some of which Jackson apparently joined. Sweeping over the local Virginia countryside, they forced farmers to "donate" pigs and calves to the regiment's larder. However, by early June the Northern occupation troops had become better supplied, and soon Jackson and others were enjoying the charms of local belles, whom Jackson remembered as "vivacious."

But in mid-June the reprieve ended. Lee, now on the offensive, had begun advancing northward. His purpose was to invade Pennsylvania and thereby discourage the North from continuing the war, which had grown so unpopular that mass demonstrations and draft riots had erupted in some communities. Many Northerners, appalled by the casualties, hated Lincoln more than Confederate leader Jefferson Davis! Lee believed that one good Confederate victory could topple the president.

Lee glided quietly around the Union army and was halfway to Pennsylvania before Hooker caught on. Frantically, Hooker ordered his commanders to hurry nearly all units, including Jackson's, northward to intercept the Confederates. Jackson wrote in his notebook:

> Monday 15th: Early in the morning the 11 corps came in [a corps was around twenty thousand men] and pitched tents. . . . We came across detachments of the 2nd, 6th and 12th corps. . . . The whole army seems to be in motion.

As the troops moved out the next day, the supply wagons moved in — an almost endless train of them. All the food and accoutrements of war had to be carried to the site of the upcoming battle and the oxen and draft horses groaned under their loads. Each group of wagons had its own specialty. Some had stacks of muskets, some barrels of gunpowder, some heavy cartons of cannonballs. Others carried bags of salted beef or coffee, or boxes of the dehydrated vegetables that the soldiers called swine slop. And of course there was the ominous line of hospital wagons transporting the doctors, nurses, and medical supplies.

Jackson's Second Vermont Brigade, ordered to guard a portion of the supply train, broke camp and joined the northward movement. No one knew where they were going or what the purpose of this movement was, but Jackson realized that "something tremendous was stirring." By June 30 Jackson and his comrades had passed into Pennsylvania, marching through a drenching rain that left water ankle deep in many places. That night they camped three miles east of a little town called Gettysburg.

General Lee and the Confederate army had arrived just west of town the same night. Lee had not intended to fight here. The locale was only a handy place to gather in his troops, which had become strung out over sixty miles during their hurried tramp up from Virginia.

It happened that an advance federal guard had already reached Gettysburg by the time the first Confederate scouts entered the town the next morning, and what

started as a skirmish soon turned into a major confrontation. General George Gordon Meade, with whom a frustrated Lincoln had replaced Hooker, hurriedly erected earthworks along Gettysburg's Cemetery Ridge. Jackson's brigade was assigned to guard the supply wagons in the rear. Heavy fighting continued and by evening the Union had suffered ten thousand casualties. Jackson found dazed and wounded men wandering around his camp trying to find their regiments. Their search was often hopeless, though. It was difficult to locate a particular unit since the soldiers had been rushed haphazardly into positions as soon as they arrived.

The next morning, July 2, fighting resumed even more fiercely than before, both sides realizing that if Lee was going to continue his northward advance, he must defeat the Army of the Potomac here. To do this he must rout them from their entrenched positions. Lee hurled his men at different places along the ridge that day. Many times the Confederates almost gained their objectives, but at the last moment Union heroics repelled them. Everyone knew the third day would be decisive, for both armies were nearing exhaustion. The Vermonters expected to be sent to the front if the Confederates broke the Union lines.

It was not until early in the afternoon of the third day that Lee had his troops in position. Then his batteries opened the fiercest bombardment of the war. When the guns had chewed up the Union lines, the Confederates charged. On and on they came, fifteen thousand of the South's finest, led by the handsome, young George Pickett. The Federals raked them with a murderous fire, but they kept advancing.

Jackson and his companions guarding the baggage train grew nervous as the tempo of the battle rose. The sound of firing was all around—even behind them, where Confederate cavalry had only to pierce the protective cover of Union horsemen to descend on them. But Union general George Armstrong Custer, brash and bold, rallied the Michigan cavalry and the rebels were repulsed.

Meanwhile Pickett had gained the crest of Cemetery Ridge, and the outcome of the battle hung in the balance. In the end the Confederate forces, decimated by Union guns during their exposed charge, could not hold the ridge. Pickett was forced to retreat with terrible losses.

The next day, July 4, Lee pulled out and headed back south. Although the war would last another two years, the South no longer had the strength to seriously threaten the North. The fate of the Confederacy had been decided.

The fighting at Gettysburg had left wounded and dying soldiers everywhere. The screams of men being operated on were horrible to hear. Eventually the hospital wagons were loaded with bandaged and bloodied casualties from both armies and began lumbering off to towns where the men could receive better care. Those Confederates who could walk were marched to Union prison camps. Jackson's brigade was assigned the job of guarding twenty-three hundred of these dispirited men during their trudge to the confines of Fort McHenry in Baltimore.

By the time the brigade reached Baltimore, the soldiers' enlistment period was almost over. So Jackson and the others went to the railroad station and boarded boxcars for their trip back to Vermont, where they would be discharged. During much of the trip the tracks were lined with crowds waving flags and cheering as the Gettysburg victors rode past. The men accepted the adulation, although Jackson found it ironic that he had spent the better part of a year at the front without once firing at the enemy.

Toward a New Life
Vagabonding from Vermont to Nebraska City (1863–1866)

When Will and Ed Jackson returned to Rutland after their war service in late summer 1863, Will was something of a celebrity, as it seemed nearly everyone knew about his drawings of camp life. He went back to work for his former employer, but he was now paid by the number of photos he colored rather than receiving a fixed salary. Because he was in great demand, his salary jumped to twelve dollars a week.

Soon Jackson augmented his income by offering art lessons to young ladies of leisure. His association with them led to invitations to picnics and church suppers where he mingled with Rutland's more affluent families. Before long he was enjoying carriage jaunts with his new friends. He became known for his dash and daring, and whenever another buggy driver sidled up to him, Jackson would call out a racing challenge, then crack his whip and send his horse dashing down the lane.

A group of young hotbloods asked Jackson to join their exclusive clique. They dined and drank together, and occasionally their rowdy antics would cause a minor stir in the staid town. The group even had a secret name, abbreviated the S.S.C.— which only the initiated knew stood for the Social Sardine Club.

By the following spring Jackson had a sweetheart, Caroline Eastman, whom friends called Caddie. Caddie, the belle of the town, was beguiled by the handsome war veteran. Caddie's stepfather, a substantial citizen, also liked Jackson and probably had made ambitious plans for him after he and Caddie announced their June 1866 wedding date.

Meanwhile Jackson had accepted a job with a well-known photographer named Styles in Burlington, Vermont, seventy miles north of Rutland. His pay jumped to twenty-five dollars a week. "I could hardly believe it," Jackson recalled. "Anyone whose salary was a thousand a year was a man to be looked up to as a potential capitalist; and here I was, at twenty-one, actually being offered $300 in excess of that magic sum." But how would he see Caddie? Fortunately a train made the run between Burlington and Rutland in a couple of hours. Jackson worked on Saturdays, but he could take the train early Sunday morning and be with Caddie until evening, then return to Burlington in time for his job on Monday.

Though it meant separation from Caddie, the association with Styles was a good career move. The larger and more prosperous town of Burlington offered far more opportunities than did Rutland. In addition, the state university was there, and its students and their parents were eager for portraits.

A good photographer in those days was an important personage, since picture taking was an enterprise far beyond the talents or finances of the average person.

Cameras were expensive and cumbersome contraptions that required certain lighting and were complicated to operate. In addition, there was no such thing as film. Instead photographers used large glass plates onto which they applied a colloidal mixture of chemicals. Immediately upon being coated, the plates had to be inserted into the camera, then, after exposure, developed promptly in a nearby darkroom.

"It is hard for many people to comprehend the universal importance of the professional [photographer] during the decades preceding the 1890s," Jackson noted, for the handheld camera had not yet been invented. "If you wanted a picture, you sat in a chair, put your head in a vise, watched the birdie, and laid your cash on the barrelhead. There wasn't any other way."

A visit to Styles's Gallery of Art was a tense occasion. The patrons, arriving in their Sunday best, were solemnly ushered into a spacious reception room complete with plush chairs, an ornate chandelier, and even a piano for those who were not too nervous to manage the keys. At the rear of the reception room, through a Moorish arch, was a smaller area lined with mirrors. In this "primping room," fidgeting patrons tended to last-minute adjustments of their hair and clothes, hoping to present the most favorable aspect of themselves.

In 1866 Jackson worked as an assistant in this early photographic studio. Notice the head clamps that patrons had to wear to be certain they did not move during the long exposure time. —Courtesy Scotts Bluff National Monument

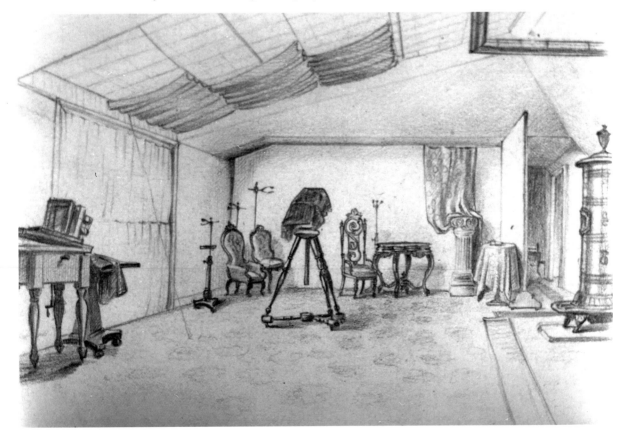

Beyond the reception room, carpeted stairs led to the studio itself. Its gas lamps and large skylight created an almost unearthly glow. About the room were backdrop screens, some plain, some with scenery. There the camera stood, staring at newcomers with a menacing, cyclopean eye that would highlight every blemish or clothing rumple. Permeating everything was the incense of photographic chemicals.

Once the patron was seated in the stiff-backed chair, Styles would wheel the camera forward until he got the best balance of light and shadows. Then he would carefully adjust the focus. When this was done, he would fasten the subject's head with a clamp so he or she would not move during the fifteen- to thirty-second exposure. Styles would caution his subject that just deep breathing could disturb the delicate photographic process. When at last everything was ready, Styles would remove the lens cover, count the seconds, then replace the cover and remove the exposed glass plate. This done, he would hurry to his darkroom to develop the picture on paper made shiny by the addition of egg whites.

After the picture emerged, the patron usually chose to have Jackson color it. This required artistic perfection, as the wrong shading could seriously mar the photo's appeal. But Jackson was the best colorist in that part of Vermont, and when he completed a photo it became a cherished possession to be displayed proudly in the owner's home.

Jackson's life was good in Burlington. He moved to larger quarters and took up playing the flute. He acquired a yen for bodybuilding and bought weights and dumbbells. He also joined a literary society where young men and women discussed such authors as William Shakespeare, Charles Dickens, and Henry Thoreau. And there were dances at which the orchestra sometimes played such naughty steps as the waltz.

The girls in Burlington were pretty, but Caddie was still everything to Jackson. He could hardly wait for Sundays and the train to Rutland. Caddie was always at the station when the locomotive came to a grinding halt, her dark hair blowing beneath her fashionable bonnet. Then, for ten whole hours they were together—laughing and talking about the events of the week. Of course, they were never without a chaperone nearby, but they could hold hands and snuggle close when no one was looking. Each Sunday they discussed their June wedding and dreamed of the blissful eternity ahead when they became husband and wife.

Then one Sunday in April everything changed. "We had a difference, a difference so slight that I haven't the remotest idea now of its origin," Jackson recalled. "She had spirit, I was bullheaded, and the quarrel grew." The air between them was cold when they went to the depot that evening. "Good night, Mr. Jackson," Caddie said icily. He bowed formally and replied with equal hauteur, "Good night, Miss Eastman." He boarded the train and did not even look at her as it pulled out of the station.

But he was miserable the entire week that followed. His dreams, his goals, his entire future had been formed around Caddie. He could not imagine the coming years without her. What a fool he had been to antagonize her over a trivial matter. By Friday he

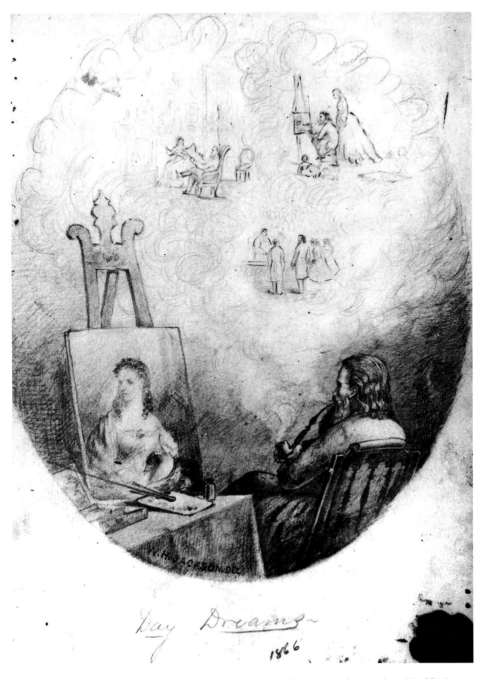

Day Dreams

1866

This was no doubt sketched while Jackson was still going with Caroline "Caddie" Eastman. Entitled "Day Dreams," it apparently pictures their wedding and their future home life, with Caddie and baby watching him paint. —Courtesy Colorado Historical Society

was so upset that he could not work. That evening he took the train to Rutland, hoping to patch things up over the two-day weekend. But for some reason his pride got in the way. "If I had possessed the wit of a squirrel," Jackson wrote in later years, "I would have acknowledged my fault—whatever it was—and been forgiven. But at twenty-three I knew hardly more about the feminine mind than I do today, and I failed miserably." Jackson blamed himself for the breakup, although arguments are seldom one-sided.

Caddie told him she did not wish to see him again. This was a terrible blow not only to his emotions but to his pride as well, for this rejection would affect his standing among his friends. "I found it impossible in my shame to face the world," Jackson admitted. He came to a quick decision. If she could reject him, then he could reject her! He would leave Vermont and go where one's status was not decided by whether a coquette twirled her parasol his way. He'd make a fortune, then she'd see what she had missed!

The very next morning he packed up the letters Caddie had sent him along with their once-sacred memorabilia and mailed them to her with a bombastic note declaring the end of their life together. Then he bundled up a few clothes, gathered his meager funds—evidently Jackson spent nearly all he earned in those days—and boarded a train to New York City.

Arriving in New York with barely thirty dollars in his possession, Jackson spent the night in a modest hotel and the next morning walked down to the Battery while he mulled over his plans for the future. He did not know where he was going, only that he must seek a new life away from Caddie. By chance he encountered a former army buddy named Ruel Rounds, whom everyone called Rock from his work as a stonecutter. Jackson learned that Rounds had just lost his job and was as much at loose ends as Jackson himself was. Rounds suggested they get a job with one of the mining companies in the Montana Territory, where there were great opportunities in silver. All they had to do was get there.

The jumping-off point for Montana was St. Joseph, Missouri, where the railroads ended. Here many wagon trains assembled to cart supplies to western towns, and the wagon companies were all looking for strong young drivers. But St. Joe itself was half a continent away, and Rounds was flat broke. Jackson was not much better off, for one of New York's many skillful pickpockets had just relieved him of most of his money.

Jackson managed to convert his prize watch and chain into sixty-six dollars cash, which he was glad to get even though the watch had cost him more than double that amount only a year before. But that had been during another life. Getting rid of the watch relieved him of some painful memories.

At this time they were joined by a third young man, Billy Crowl, a friend of Rounds. Although Crowl had a job, the lure of the West was so strong that he was glad to chuck his employment and join them just for the fun of it. With the money Crowl added to Jackson's they would have enough to get to Detroit, where Crowl had a married sister who he was convinced would donate the $150 that would get them to

St. Joe. They left for Detroit just one week after, as Jackson said, "Caddie Eastman had blighted my life." But her memory still haunted him, and he could not bring himself to discard the small picture of her he kept wrapped in a handkerchief in his breast pocket.

The three spent the night at Niagara Falls, where they viewed the spectacular cascade from the Cave of the Winds and received a considerable soaking in the process. The next morning they boarded the train again. To conserve funds they had bought second-class tickets, which put them in a car jammed with poor European immigrants. The seats were hard wooden benches. But far worse was the stench of garlic, bad whiskey, and bodies not recently bathed. "The only boon," Jackson recalled, "was the odor of tobacco, and although I still didn't like to smoke myself, I was grateful for Rock and Billy's cigars." But, even with the tobacco smoke, the smells were so offensive that the three slipped into the first-class car. With their gentlemen's clothing and trimmed hair, they tried to fit in with the other passengers. The conductor scrutinized them, but he was apparently an understanding fellow and left them alone.

Detroit in 1866 had barely passed the frontier stage. It was both a trading post for the surrounding region and, because it was on the far end of the Lake Erie steamship lines, the point of departure for Chicago. While Rounds and Jackson explored the

Although Jackson never saw Caddie again after their breakup, he kept this picture of her for the rest of his long life. —Courtesy Brigham Young University

streets, most of which were yet unpaved, Crowl went to his sister's home to pick up the money for their trip. But soon he was back, reporting that his sister had other uses for $150, and the best she would do was offer to go with him to Cleveland and see what their father might come up with.

The round-trip to Cleveland took three days by steamship. When Crowl returned, he told Rounds and Jackson happily that his father had agreed to furnish the necessary funds by way of Mr. Knight, his sister's husband, with whom he was in business. But Crowl had a weakness for overstatement—Knight gave him just twenty dollars, and that was out of his own funds. This was a shock to Rounds and Jackson, whose hotel bill alone came to more than half that!

In order to obtain enough cash for the passage to Chicago, the boys headed off toward the country, where they intended to get jobs as farmhands. Before they had gone very far, however, they realized that their chances of being hired were as remote as Crowl's $150—after all, they looked like dandies with their fashionable stovepipe hats and well-tailored coats. Besides, their hands were so soft from city living that it was obvious they wouldn't last longer than a mule's grunt with heavy farm equipment.

The only thing to do was to hock some of their expensive clothing. Reluctantly Jackson traded the fine coat, for which he had paid forty dollars in his better days, for five dollars and a faded yellow jacket so small he could hardly inhale after he buttoned it. The trio took a room in what Jackson called a "shabby dive" and began living on brown bread and milk, which cost eighteen cents. Whenever they needed additional money they sold more of their clothing. Finally they were down to so little that one cold night they could not bear to stay in their unheated room and begged law officers to let them sleep in the city jail. In the morning the friendly policemen took up a little collection, resulting in seventy-five cents. The next day their pitiful story made the *Detroit Daily Tribune*, which called them strapped young gentlemen from New York.

At last the three of them decided that, since Jackson had the best chance of landing a decent job, they would pool their funds and buy him a railroad ticket to Chicago. Once Jackson had earned enough, he would send them their fares. They ignored, for the moment, the problem of how they would get the rest of the way to Montana.

Jackson reached Chicago with just three dollars in his pocket. Fortunately he remembered an amiable man from that city named Rawson who had visited the photo studio in Rutland, and quickly looked him up. Rawson offered Jackson a room in his apartment, which Jackson was glad to accept.

Chicago at this time was one of the most dynamic cities in the Western Hemisphere. Its role as the nation's transportation center had begun a decade and a half earlier when railroads reached the then-little town. Soon timber from Wisconsin was flowing into the city, where sawmills transformed it into the lumber that would build homes and commercial structures all over the nation. In addition, the trains gave farmers from newly established Midwestern agricultural areas access to processing

facilities for their cattle and hogs, as well as a way to ship the meat to eastern markets. The extensive Chicago Stockyards had been incorporated just a few months before Jackson's arrival.

Jackson found a job as a sign painter, and after a week he collected eighteen dollars. Now Rounds and Crowl could join him. They in turn obtained work with a stone-cutting company. With the Three Musketeers—as they called themselves—all earning income, they would soon have enough money to get to St. Joseph.

About this time Jackson met a young man named St. Clair, who engaged him as a painting instructor at twenty dollars a week. Jackson and St. Clair hit it off. They began to frequent the theater, seeing such provocative plays as *Wild Oats* and *Richelieu at Sixteen*. As Jackson felt himself more flush, he purchased an expensive box of watercolor paints, then, on a whim, a small flute.

St. Clair's purpose in taking art lessons was to open a studio. Chicago did not suit him, he said, and he persuaded Jackson to accompany him to La Salle, a rapidly growing town in the burgeoning Illinois farm country. But when they arrived, they found La Salle to be a dirty place with no feeling for the arts. Accordingly they left for Davenport, Iowa, on the far bank of the Mississippi River. A bridge spanned the wide river, and as the train cautiously proceeded over the trestle, which was then undergoing repairs, Jackson experienced a thrill of anticipation because, as he later wrote, "the great prairies of the West lay just beyond."

Jackson and St. Clair spent three weeks in Davenport, during which time their relationship grew increasingly strained. Jackson became homesick and despondent. Particularly difficult was June 6, the day he was to have married Caddie. Now all he had was her tiny photograph, which he still carried next to his heart. He gazed at it incessantly and even began work on a color portrait of her based on the photo. He wrote letters to his friends in Vermont, anxious to learn what was going on with Caddie and the world he had forsaken.

In mid-June the two men's relationship reached the breaking point. St. Clair brusquely paid Jackson off, confiscated all his paintings, and ended their association. Jackson was left with $22.75, which dwindled instantly to $4.50 after he purchased his fare to St. Joseph. He tried to delay his departure until he heard from Rounds and Crowl, who were still in Chicago, but by the time his cash had shrunk to $1.75 he had no choice but to take the steamboat to Quincy, Illinois, where he would board the train to St. Joe.

The trip down the Mississippi was discouraging. The river was so low that the boat seemed to be running on mud. At one point the entire cargo had to be taken off so the steamer could plow through the shallows. At twilight the next day the boat chugged into Quincy. To Jackson's amazement, there on the levee were Rounds and Crowl. They had arrived the day before and believing that Jackson would eventually reach Quincy, had been watching every boat that came in.

After totaling their assets, the trio found that together they had only $3.50. They slept in the depot and the next morning had a breakfast of stale crackers and "rat

cheese." Then they boarded the St. Joseph train and spent the next night at Macon, Missouri, where, after foolishly squandering some of their meager funds at a circus, they slept on the hard seats of a railroad car on a siding. They arrived in St. Joseph the following day.

St. Joe was known as the gateway to the West. However, as a gateway the town was not much—mostly flimsy wooden buildings and streets composed of mud and garbage. But it was here at the railhead on the Missouri River that men were hired for the wagon trains going west. St. Joe was also famous as the home of the famed Pony Express, which had had its brief existence just a few years before Jackson arrived.[1]

Almost immediately the Musketeers scanned the local newspaper's help-wanted ads and found the notice, "100 Teamsters Wanted." Although they had a decided lack of teamster experience, they applied for the job at the employment agency. Here they were informed that one wagon train's destination was Montana—the very place they wanted to reach—and that in three days a boat would leave from St. Joe for Nebraska City, from where that wagon train would depart. The agent reluctantly said he would take them on as drivers, since labor was short, but each of them must pay the agency's fee of $1.50 before the deal could be finalized.

A dollar fifty each—when they had barely a dollar among them! What to do? Rounds could not get a job as stonecutter in this wooden burg. Crowl had no special trade. And all Jackson had was his skill at photo retouching and a box of watercolor paints. Jackson made the rounds of St. Joe's few photographic studios the next day, but no one was hiring. Then, with their money almost gone and no work in sight, a most amazing event occurred.

Rounds and Crowl had spent the morning gabbing with a group of men loitering around the wharves. After the pair told of their desperate plight, one of the men, a quiet person named Smith, motioned them aside and gave them a five-dollar bill. "It was an act of spontaneous generosity that has been equaled only once in my experience," Jackson recalled. "[That was] an hour later, when . . . this same Smith, without the slightest solicitation, gave us another five dollars to buy provisions with!"

The next day they boarded the paddle wheel steamboat *Denver* and headed up the Missouri River for Nebraska City, which they reached three and a half days later. There they were met by an agent who led them to the company store, where each received a pair of blankets, a rubber raincoat, a Colt .44 revolver, and other gear needed for the forthcoming trek across the plains and mountains. But they were quickly informed that these were not gifts: the sum of forty dollars would be deducted from their wages, which were only twenty dollars a month. Jackson had been making four times that coloring photos in Vermont, but what did it matter? He was on his way to Midas's wealth in Montana.

Next they met Ed Owens, the wagon master. From him they learned the particulars of the operation. There would be twenty-five wagons in their caravan. Each wagon would be crammed with eight thousand pounds of goods. Drawing this staggering load required the strength of twelve massive oxen. A single teamster would be in

charge of each wagon, which meant he had to tend to the oxen, both day and night, as well as guide the unsteady vehicle through dangerous sand, across treacherous rivers, and eventually, over rocky, snow-slick mountain passes. There would be torrid heat on the plains, as well as tormenting flies and mosquitoes, and when they reached the mountains, brain-addling cold. Through it all the wagons must keep going.

Ed Owens scrutinized the recruits, too many of whom, like Jackson, Rounds, and Crowl, were green city boys. Could they take it? He would see.

PART II

On the Trail

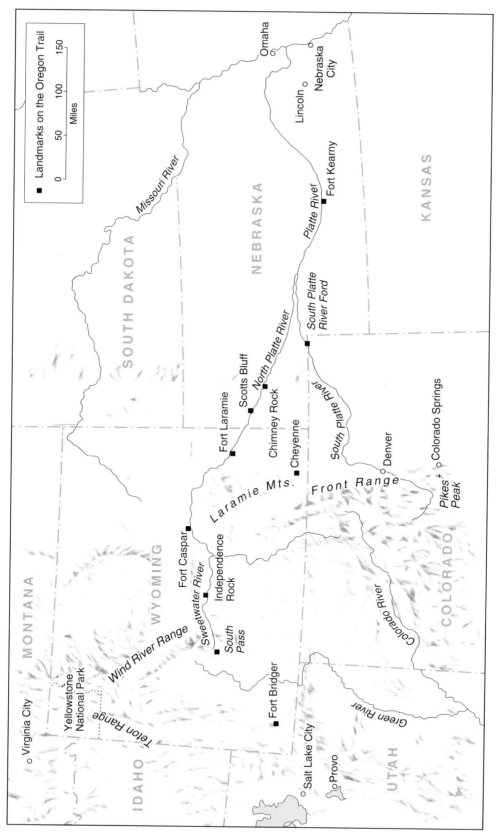

Landmarks along the Oregon Trail helped travelers like young teamster Will Jackson mark their progress.

Learning the Ropes

Bullwhacking from Nebraska City to Fort Laramie on the Oregon Trail (1866)

Jackson's introduction to bull driving was unnerving. The sky was barely red when he was roused by the cry, "Roll out! Roll out! The bulls are coming!" Suddenly into the circle of wagons the animals stormed — snorting with ill temper, waving their horns viciously. They were half-wild Texas longhorns, accustomed to roaming the plains in freedom, unwilling to submit to the yokes with which Jackson and his fellow bullwhackers were about to encumber them.

There were three hundred of the rambunctious beasts. On eastern farms, like the one Jackson grew up on, the oxen had all been tamed. But tame ones were rare out here, only a few old broken standbys, not enough to make manageable teams.

Even an experienced bullwhacker had quite a job in culling his own bulls from the jostling herd, then yoking them and hitching them to the wagon. For the best men among them it was a two-hour ordeal. But for Jackson, who had never done it before, it was a hellish experience that lasted until nearly noon. By that time he was begrimed with sweat, dirt, and globs of cattle dung.

No one was allowed breakfast until he was through with the bulls. And what was the repast for which he had worked so hard and waited so long? Why, the same as he had had for dinner the night before, the same as he would have for nearly every meal from then on: bread the texture of sandstone, fried bacon that was mostly gristle, and coffee boiled to the consistency of mud. The only way to make the coffee halfway palatable was to add a tubful of sugar, but the sugar would run out before long.

At last the teams were ready. Wagon master Ed Owens rode to the head of the line and they moved out. Before them was the famed Oregon Trail. The trail had been active for about twenty-five years now and in most places was well marked by ruts, discarded equipment, and the graves of those who had died from the dreaded cholera picked up at polluted water holes.

The two-mule prairie schooners used by the pioneers were like toys compared to the massive wagons in Jackson's train. Although each bull pulling a wagon was several times stronger than a mule, it took a dozen of them to get the heavily loaded vehicle over level ground. When the train encountered a steep hill or riverbank, double teams of twenty-four oxen had to be yoked up — and still the animals strained to their utmost, often to their deaths, to move the wagons.

Jackson would never forget the difficulties he went through each morning as he yoked reluctant oxen during his stint as a young bullwhacker. —Courtesy Scotts Bluff National Monument

An overloaded wagon, unruly bulls, and an inexperienced bullwhacker made for a volatile mixture. Jackson later recorded his problems:

> Now that we were all hitched up it was with some trepidation that I faced the responsibility of managing this big team of uncertain cattle on the road, but I went at it with the same determination with which I went into the corral earlier in the morning. . . .
>
> Everything went well until I came to a rather steep hill where the proper thing to do was to halt the team and put a chain lock on the hind wheels before making the descent. At the brow of the hill I "whoad" . . . but the leaders [bulls], with the rest of the team, tugged all the harder; I kept up my whoaing while they kept on going, and once on the descent they went like runaway horses. I ran after them yelling with all my might, expecting every moment to see the wagons go tumbling over in a heap; but it was our good fortune to reach the foot of the hill in safety. (*D*, 39)

They made only ten miles that first day. Fortunately for Jackson, Owens was a very patient wagon master. More than that, he was a true gentleman—a rarity on the frontier. Indeed, not only did he seldom raise his voice, but he almost never used profanity. Nevertheless Owens was a savvy frontiersman who exercised firm control over the thirty misfits who made up his bullwhacker corps.

Far more important than the men (at least in the eyes of the supply company) was the cargo that was being hauled at such expense across more than a thousand miles of perilous wilderness to the Montana mining camps. Although Jackson mentions only the "important" items, such as sugar and whiskey, a supply train such as his probably would be loaded with a vast assortment of goods—everything from blankets, knives, and rifles, to salt, flour, and perhaps the luxury of dried fruits.

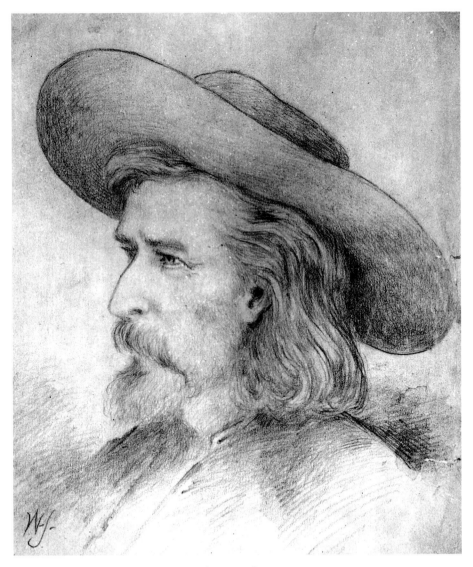

Jackson's drawing of Ed Owens, the wagon boss. —Courtesy Colorado Historical Society

After a week or so, Jackson began to get the hang of managing the bulls. The key was his bullwhacker's whip. It was a formidable weapon, the only thing the bulls respected. Called a blacksnake, each whip was about eighteen feet long with a two-foot handle. At the other end was a strip of tough buckskin that cracked like a pistol. When snapped against a bull's flank, it could cut to the quick. Usually a well-directed snap close to a bull's ear was enough to cause him to reconsider any misbehavior.

Each day the teamsters drove from dawn until noon. Then they stopped for their midday meal, dividing into messes of five or six men each. One of the mess members was designated as cook, whether or not he knew a bean from a bullet. The other members' duties were agreed upon among themselves. Some gathered firewood if there were cottonwood trees nearby. If not, they could always collect buffalo chips, dung dried in the sun. Someone else got water and made coffee. Another kneaded dough and baked bread over a fire in a Dutch oven. When lunch was ready, the men would find a shady place beside a wagon and eat sitting on the grass. After resting themselves and their animals they drove another five or six hours until sunset.

When the men halted for the evening, their work was not yet done. They drew up the wagons in a circle, then unyoked the oxen and turned them out to graze. Two men served as herders to prevent the animals from straying. Each man had to take a shift. Thus it was not unusual for a bullwhacker to work for sixteen hours during the day, then spend several more hours guarding cattle at night.

Slumber was a mixed blessing, as Jackson recalled in the diary he kept:

> I very frequently have queer dreams. With one single exception my dreams every single night have been about my "Bulls." I very often imagine them up to some impropriety and go tearing out of the wagon. Billy [Crowl] usually wakes up [and] brings me back.
>
> One dream was rather comical. I got up and commenced pulling at the rope under Billy's head in a most energetic manner. He, of course, demanded my reason. . . . I replied, still asleep, "I can't get my dam'd leaders' heads around." I was dreaming of the contrary old brutes. (*D,* 49)

Although most of the area that Jackson's train was passing through was still partially wild, the frontier was moving west steadily. Each year, almost each day, sections of the old frontier melted away as American plows turned up the prairie. It had been only about a dozen years before that the Pawnee and Omaha tribes had ceded their vast claims along the Platte. Almost instantly Congress formed the territory of Nebraska.

By this time, land-hungry pioneer farmers had pushed the frontier fifty miles outward from the Missouri River and the territory's population had reached over one hundred thousand. The tiny town of Lincoln had been formed, and the following year, when Nebraska became a state, Lincoln would replace Omaha as the capital. But the situation on the frontier was still fluid, and Indian hostility was a great concern. An estimated forty thousand Indians lived in Nebraska, and it was common talk that they had had enough of American encroachment. Word was that the mighty Sioux intended to drive all whites out of the Platte Valley, the route of the Oregon

Trail. The Indians had even been so bold as to burn the town of Julesburg, on the South Platte, just the year before. Jackson wrote, "Almost every day brought reports of fresh killings and scalpings west of [Fort] Kearny."

Jackson's wagon train encountered its first Indians, who were Otoes, upon reaching the Platte River. The Otoes, together with their blood brothers the Iowa and the Missouri, had been pushed around the plains by stronger tribes. Now they were few in number and bitter toward everyone.[1]

When Jackson's train halted for the noonday meal that day, half a dozen Otoes galloped up and gestured that they wanted chewing tobacco. Billy Crowl offered one brave a chaw, but the Indian grabbed the entire plug and wheeled his horse to leave. Thereupon Crowl drew his Colt pistol and grabbed the horse's bridle. Everyone tensed until the brave reluctantly hurled the tobacco at Crowl and rode off. After the Indians were gone, Owens called the men together. He had noticed another Otoe circling the camp and he was concerned. "Indians don't drop by in this country for a cup of tea, gentlemen," he drawled, as Jackson recounted. "Nor just for tobacco, Mister Crowl. But they sometimes do count up the men in a wagon train. That's one reason why you carry Colts. That's one reason why we've got a stand of carbines with us. Never forget it, *never forget it!*"

"[Owens] never had to remind us again that warlike Indians were not necessarily confined to newspaper columns," Jackson noted. But it was not Indians who caused Jackson and his comrades the greatest discomfort on the trip—it was the climate. The incessant sunlight searing down from an almost cloudless sky combined with the ceaselessly blowing wind proved devastating to the skin. Seasoned bullwhackers were hardened to the weather, but tender easterners like Crowl, Rounds, and Jackson suffered greatly. "By the end of the second day every new man had a cracked and bleeding mouth," Jackson wrote in his diary. He could hardly swallow. Just talking brought pain.

The discomfort did not stop there. His feet became so swollen that each step was an effort. Yet on and on the wagon train plodded: ten miles, fifteen miles, sometimes up to twenty miles a day. His clothes were constantly drenched in sweat. Nor did the torture end at night. When Jackson tried to sleep his body ached with the exertion of the day. He wondered what he was doing out on the plains. "I cursed the folly that had prompted me to throw up my well-shaped career in Vermont," he admitted to himself.

In the daytime his thoughts often turned to Caddie. He remembered her smile and the sound of her laughter. He recalled the buggy rides they had taken through the green Vermont farmlands. Prancing horses. Picnics by cool streams. Happy parties with their society friends. Ah, the life he had led! Could it be that just two and a half months ago he had been making more than one hundred dollars a month doing work that he enjoyed? Now he was getting barely twenty dollars a month for whacking bulls while he ate dust, swatted flies, and tramped in manure. "I have made a fool of myself by not going back . . ." he admitted in his diary on July 2.

That very day, when a post rider appeared Jackson scratched a note to Caddie and gave it to him. He prayed she would send him a letter by way of Fort Laramie. If only she did, he would gladly desert this miserable enterprise and hurry back to her arms! But Laramie was still many hundreds of miles ahead. So he kept trudging on.

Gradually things got better. Little by little the wind tamed and Jackson's skin tanned. Surprisingly, he began to find that tramping across the prairie was an exhilarating experience. "It was good just to be alive in that glorious atmosphere," he wrote. Wildflowers grew in profusion. Elk were appearing, and in the distance antelope streaked along the crest of infinity. Ducks rested placidly in many of the streams, where large fish cruised sleekly through the weeds. Sometimes a wolf or two dogged the train just beyond rifle shot, and in the evenings their plaintive howls lulled the men to sleep.

And the grass—that was the most impressive. It rode the crest of every hill and carpeted every valley. When the wind was gentle, the grass hissed; in rough winds it tossed its mane like an angry lion. Green, green, green—it colored the landscape from horizon to endless horizon. At night it turned silver in the moonlight, and at dawn, wet with dew, it sparkled prismatically in the sun's first rays. Grass was the lifeblood of the wagon trains. Horses, mules, and cattle all required it to live. No train could move across the prairies until the grass had matured in the late spring. Wagons that disregarded the natural cycle of the grasslands by setting out in April often had to turn back.

Progress through eastern Nebraska was difficult, with its fast-moving streams and steep hillsides. The bulls became unruly so often that Jackson wore out a whip within the first week. Constant shouting made him and many of the others so hoarse that they could hardly speak by evening. Thus it was with great joy that they came to the level valley of the Platte River, where the portion of the Oregon Trail they were on merged with the routes from Independence and St. Joseph. The next leg would be almost a pleasure going up the friendly, if faceless, valley.

On the evening of July 11 the party reached Fort Kearny. They'd spent two weeks on the road, averaging fourteen miles a day. The fort, built in 1848, was the first military station on the Oregon Trail. It was named for General Stephen Kearny, hero of the Mexican War.[2] For almost twenty years the venerable place had served as the principal resupply and repair point in the Platte country. By now it had grown into an impressive collection of buildings and earthworks. In the spring it was always active—one year more than thirty thousand emigrants and gold rush prospectors stopped there. Fort Kearny was also an important stop for the Overland stages that thundered along the trail. The Pony Express once had a station at Fort Kearny, but ever since the telegraph displaced it, telegraph stations had occupied the route.

Jackson's wagon train had to camp three miles from the fort because government regulations forbade camping closer, hoping to preserve the grass for government ponies and to keep the post's water supply clean. Cholera, usually contracted from contaminated water, was the most feared disease on the trail. The next morning, while

Owens made arrangements to continue west, Jackson went to the fort, where he posted a note to a friend back east begging him to remind Caddie to send him a letter at Fort Laramie, the next major point on the trail.

Soon the wagon train was off into hostile Sioux country.

The Sioux were relatively recent denizens of the Great Plains. When the early French explorers encountered them, the tribe had been living in Minnesota and were already known for their warlike character. Other tribes, when using sign language, would denote the Sioux by running their fingers across their throats, a reference to the Sioux's gruesome custom of cutting off enemies' heads.

The Sioux, who were often described by travelers as exceptionally tall and handsome, were horsemen without peer. Their warriors could let loose a flurry of arrows while at a gallop, enabling them to chase down buffalo with ease. With ample resources Sioux numbers grew, and by the time Jackson passed through they numbered more than twenty thousand, making them the most populous tribe on the plains. They had grown accustomed to lording over their neighbors. Otoes and Omahas cowered before them, and even the Pawnee, who had once reigned supreme on the plains, feared and hated the Sioux, calling them "snakes" or "enemy."

Therefore it was not surprising that the Sioux were highly displeased when white men began pushing through their territory. Just two years before Jackson traveled the route, the Sioux had overrun this portion of the Oregon Trail, burning stagecoach stations, cutting telegraph wires, and causing general panic. Things had quieted since then, but tension was building.

By 1866 no train of fewer than thirty wagons was allowed west of Fort Kearny. So Owens linked his train up with ten wagons belonging to the Doolittle brothers. Everyone in the group carried a Colt revolver, and the wagons were loaded with carbines and muskets for quick use. With nearly fifty armed men Owens did not fear a general Sioux attack, but concern about ambushes and sorties caused Owens and the Doolittles to proceed westward with great caution.

Despite the potential danger, Jackson found the next two weeks a joy. The Platte ran almost due west, and the road was so smooth that sometimes Jackson could ride on the wagon tongue instead of treading beside the oxen. The river's rich waters provided a haven for a multitude of waterfowl and refreshment for the buffalo. Indeed, the bounty of the Platte was attracting settlers in droves, and an ever-growing number of ranch houses was beginning to dot the landscape. Since there was no good timber within hundreds of miles, the pioneers had to construct their homes of sod cut into bricks. Dank, dark, and dirty, the settlers' cabins were crude and far less comfortable than the Sioux's airy tepees.[3] Jackson passed many homesteads that had fallen prey to the Indians, the desolate shells of sod testifying to many broken dreams.

The primary inconvenience along the Platte was the lack of firewood for boiling coffee, baking bread, and most of all, frying bacon, which by this time was so teeming

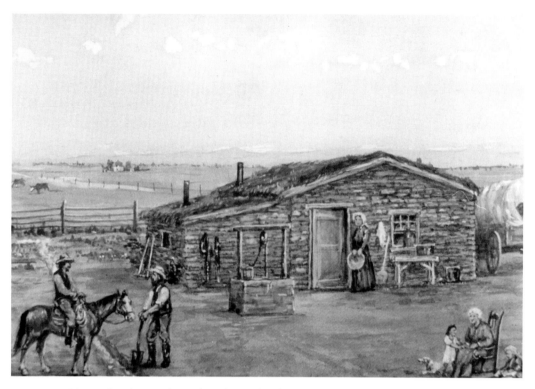

Pioneer families on the treeless plains of Nebraska had to build their homes of sod.
—Courtesy Scotts Bluff National Monument

with insect larva that it almost crawled. Yet in its strange way the prairie provided fuel with the ubiquitous dried buffalo dung, and the men made do.

Aside from the food, the bullwhackers' main complaint was low wages. They were getting barely sixty-seven cents a day for work that was some of the most difficult and unpleasant on the continent. To add to that effrontery, they'd receive no earnings until they paid back the forty dollars for their equipment. So they were, in effect, working the first two months for nothing. Therefore when they neared the village of Cottonwood and the bullwhackers saw signs advertising for Union Pacific work crews, many were interested—although Jackson, with his dreams of gold in Montana, was not.

The Union Pacific was the talk of the trail. The railroad had started building from Omaha the previous year and was now halfway to Fort Kearny. The railroad paid such attractive wages that not even Ed Owens's silver tongue and the promise of raising the men's pay to forty dollars a month could prevent five whackers from cutting out. Jackson expected a long layover in Cottonwood while Owens hunted for replacements, but the wagon boss quickly talked half a dozen discontented locals into joining up, and within a few hours the wagon train moved on.

A half day beyond Cottonwood, the Platte forked and the trail continued along the south branch. On July 25 the train passed through a group of ten or so houses and saloons called Julesburg. Burned by the Sioux the year before, the town was now being reconstructed. Three or four miles beyond Julesburg, the wagon train came to the great fording place of the South Platte River. Buffalo traces, Indian hunting routes, and the Oregon Trail all used the same location. It was a magnificent scene and Jackson recorded it in his diary:

> The river was filled from bank to bank with wagon trains passing over and oxen recrossing for another wagon. The drivers as a general thing were minus pants and attired in the light and airy costume of shirt and hat only.
>
> The bulls when they first enter the stream are timid and it is extremely hard work to get them started, and the yelling, the hooting, the hurrahing and the cracking of whips of the drivers make [for] pandemonium. The cattle plunged and tugged and geed and hawed & after a deal of trouble pulled out of the plunge from the bank of the stream. Clear across the river it was the same yelling at the oxen — "yaw-ho, whoa haw," all the time laying on your very best and might with cudgel or whip. (D, 52–53)

Jackson found the crossing difficult. The river bottom was so treacherous with quicksand that his wagon had to be double-teamed to get across. Yet even with twenty-four bulls and the assistance of several whackers, Jackson got stuck in the river bottom several times.

By sunset all the wagons were across except a few—one being the wagon where Jackson had left his only pair of pants as well as his revolver and boots. Just as Jackson and some fellows were about to recross the river a violent thunderstorm hit. Although the bullwhackers took refuge in their heavy supply wagons, the furious wind nearly capsized the vehicles. Lightning flashed and thunder rolled, then came hail: great icy balls that snapped like bullets against the thick canvas wagon tops. The heavy rain that followed went through the canvas as if it were a sieve. Jackson, still pantless, threw a buffalo robe over himself for protection from the rain. But the night was so warm and the robe so thick that he was soon drenched more from sweat than he would have been from rain.

The next morning was clear, so Jackson and some other men crossed back through the river. To Jackson's immense relief, he found that his pistol, boots, and those irreplaceable pants were safe.

The South Platte ford had been so tough on man and beast that Owens let the men remain in camp the rest of the day. They could not relax, however—the boss had them grease the axles, repair some wagon tongues, and dry out the blankets and other goods. Nonetheless, Jackson had a few free moments to make a sketch of the ford. Years later he turned the sketch into what became one of his most famous watercolors.

While the wagon train was corralled the following evening, a group of Sioux entered the camp. One of the bullwhackers, named Frenchy, had been quite boastful about his lovemaking with Indian women. There were some winsome young women

with the Sioux group, so Jackson and the others taunted Frenchy to demonstrate his prowess. Frenchy, under the eyes of his comrades, went to one Sioux lady and signaled his intent. The woman quickly sized him up as a braggart. She smiled and suddenly grabbed Frenchy's arm and yanked him to her. A frightened Frenchy stammered and tried to pull away, raising a tremendous shout of laughter from the camp.

The following day the teamsters headed up to the North Platte River, then turned westward again. They were in drier country now, where the lush, tall grass that had nourished their cattle and horses was replaced by tough, short grass barely digestible to the animals. Day by day the landscape became more arid until even the short grass was sparse. Now the plains started breaking up into ridges surrounded by stark buttes. Although the fine river road gave way to more difficult terrain, Jackson rejoiced in the change, for the Great Plains had been monotonous. At last he had variety. And what colors! The dull "yellows were turning into reds and saffrons, while the blues were becoming deep purples."

Jackson found beauty even in the western storms:

> Before we had finished getting supper a tremendous thunder shower came up. . . . It was shortly after sunset & the heavy, massive thunder clouds were lit up with a dull lurid light reminding one of the infernal regions. . . . Two or three of us hovered constantly over [our campfire] to screen it as much as possible from the rain. To make it burn the faster, we would throw in the grease as it [dripped from the bacon]. It would flash brightly, lighting up our white rubber raincoats into a brilliant contrast against the dark, stormy ground. (D, 57)

Camping at Court House Rock, he found the whole scene "worthy [of] the pencil of Rembrandt." He was a happy man and in the evening played his flute. As the music lilted through the twilight, his thoughts turned to Caddie and the letter he was certain would be waiting for him at Fort Laramie.

The next day, when Chimney Rock came into view, Jackson made several sketches and years later a watercolor painting of the famous Oregon Trail landmark.[4] Now they were in a world of sculptured buttes, which Jackson visualized as "castles, palaces, and almost every style of building one can imagine." Then came the massive bulwark called Scotts Bluff, named in remembrance of an early fur trader abandoned by his comrades here to die.[5] The trail squeezed through Mitchell Pass, recently named for General Robert Mitchell, commander of this region during the Civil War. It was Mitchell who had cut the path to make the way more passable for wagons. If he had known his name would be on that miserable road for eternity, perhaps he would have done a better job. The passage was still perilous, as Jackson discovered:

> Water had worn down the steep and crooked roadway through the soft marly rocks into a deep channel but little wider than the wagons. As we approached this ravine it was after sunset and almost dark, and at the same time the trampling and sliding oxen raised such a dust cloud that it was almost impossible to see anything.

> All I could do when I came to this place was to lock the wheels, start the team, and let them slide down the incline as best they could. . . . At this point the wagon bosses and assistants were lined up [on] each side and with "blacksnakes" and much noise helped me up the opposite incline. . . . Had the wagons gone over, I would have been taken with them, for I was between the team and the ravine. (*D*, 61)

The danger did not diminish Jackson's fascination with the bluffs, however, and after the train got through and the men made camp Owens let him go back to sketch the pass. Decades later he turned this sketch into a watercolor, memorable with its bleak, gray landscape, its weary line of ox wagons, and its skeletal telegraph line. The telegraph was another irritant to the Sioux and their Cheyenne allies. It had been bad enough when the Americans sent Pony Express riders loping along the Platte. The telegraph was even worse, with its tall posts like lances stuck in the sod, proclaiming that this land no longer belonged to the Indians.

The wagoners continued westward along the North Platte River. After several days they saw the humped outline of Laramie Peak in the blue distance—the mountains at last!

The trail, which had become sandy and difficult to travel, was cluttered with countless items abandoned by migrating families. There were farm implements, once-precious oak furniture, harnesses, saddles, and clothing. The travelers would dump almost anything to lighten their wagons. The saying was that the trail didn't have to be marked—all you had to do was follow the line of junk.

Not all the emigrants continued to Oregon. Some had laid out their homes in this wild land. One of these was a man who married a Sioux woman and founded a ranch on Horseshoe Creek, where the wagon train stopped for the night. Jackson found that the area around the ranch was covered with tepees of visiting Sioux. The Indians mingled freely with the wagoners and everyone was friendly. It showed how things could be when the two races met in a noncombative atmosphere. However, Jackson encountered the dark side of the frontier soon thereafter when the wagon train passed the vicinity of the Grattan massacre. Here, in 1854, Sioux warriors killed thirty soldiers led by Lieutenant John Grattan. The fight had been instigated by the theft of a cow.

On August 7 the teamsters reached Fort Laramie, one of the key military and resupply outposts in the West.[6] Its barracks, officers' quarters, commissary, administration building, and other structures were built in a hollow square. The fort needed no walls because the strength of the garrison alone was enough to deter Indian attacks.

Thousands of men were heading to Montana at that time, each sure he would strike it rich. Indeed, Jackson was headed there himself. There was gold there for certain—miners had recently taken sixteen million dollars' worth of nuggets from goldfields near Helena. News of the strikes had caused the area's already unruly population to explode. At this time, Montana had just been admitted as a U.S. territory. One of the West's most lawless towns, Virginia City, was its capital.

Jackson took this photo of Fort Laramie in 1870. A few of the original buildings still stand.
—Courtesy U.S. Geological Survey

Getting supplies to Montana had become a serious problem. Wagon trains like Jackson's had to follow the Oregon Trail all the way to Fort Hall, Idaho, before turning north to Montana. That distance could be shortened considerably if wagons took the Bozeman Trail, which unfortunately plowed directly through some of the Sioux and Cheyenne's finest hunting grounds.[7] Officials at Laramie tried to get the Sioux to agree to the government's plan to fortify the trail, but the tribe resented the Americans' pressure. In defiance the Indians, under the dynamic Sioux chief Red Cloud, created much turmoil and bloodshed along the Bozeman Trail. Finally, in the summer of 1866, the government sent out a treaty commission to meet with Red Cloud and the other chiefs at Fort Laramie.

Red Cloud was a firebrand who had fought against American expansion for most of his forty-four years. At Fort Laramie, he remained fiercely opposed to the Americans' plans to build three forts along the Bozeman Trail. It was sheer coincidence that in the midst of the council General Henry Carrington rode up leading the very troops designated to construct the forts. Red Cloud recognized him and jumped onto a platform shouting that this was the white man's way: to discuss a matter after it had already been decided. Angrily Red Cloud called on the Sioux to break camp. There could be no relenting now. It would be war!

Jackson and his wagon train entered Fort Laramie shortly after this disastrous council. Although he was interested in the stories of Red Cloud, Jackson's main concern was letters from home. There were seven. Nervously he flipped through them. Some from his parents and some from friends—but none from Caddie! Would there never be a letter from her? Was she gone forever?

A Change of Plan

Bullwhacking from Fort Laramie to Salt Lake City on the Mormon Trail (1866)

Jackson felt dejected as the supply train moved out of Fort Laramie on August 7, 1866. Caddie . . . he had lost her. His western venture had been a miserable failure so far. "[I] am beginning to ache to go back," he wrote in his diary. "Everyone tells me I was a fool for leaving." But he could not return, as he had no money. He must continue until he reached the Montana goldfields and made his fortune.

The road became very rough. "There are some awful pitches and it is a wonder we don't all smash up," he recalled. Toward afternoon they came to a two-mile segment so steep that the wagons had to be double-teamed. When the long ridge was surmounted, the men had to retrace their steps with the teams, rehitch the bulls to another wagon, and traverse the entire distance once more. It was three o'clock in the morning when they completed the operation and the exhausted men and animals bedded down for what remained of the night. Double- and even triple-teaming was to be a regular occurrence now that they were in the foothills.

On August 10 they came to the Bozeman Trail. The shortcut north to Montana would save the wagon train nearly four hundred miles. The army was in the process of establishing Fort Reno and two other forts to protect the route. But word was that Indian hostility was so great that the trip would be perilous for all except trains of more than three hundred wagons.

Ed Owens held up while he pondered his options. Jackson hoped he would take the shortcut. In his blue mood he would have welcomed the danger. But Owens, always a prudent man, flagged his train on down the Oregon Trail. Several days later, when the word circulated that the Sioux had attacked Fort Reno, Jackson was glad for Owens's caution. What Jackson did not know was that the attack on Fort Reno was far more than the usual Indian skirmish. Red Cloud, true to his threat, had marshaled an estimated four thousand fighting men—not only Sioux, but also Cheyenne and Arapaho. It was one of the largest groups of Indian warriors ever assembled.

Throughout the latter half of 1866 the Indians would raid the trail so fiercely that it became known as the Bloody Bozeman. The climax would come at Fort Phil Kearny (not to be confused with the fort named after Stephen Kearny in Nebraska). Here Red Cloud ambushed and killed Captain William Fetterman and eighty-one troopers. The army regarded the Fetterman affair as a major defeat. Shortly afterward the three forts were abandoned and the Bozeman Trail was closed.

As Jackson traveled westward on the Oregon Trail, the grueling days were made only slightly more enjoyable by eating the wild cherries that grew along the North

Platte River. There were currants, too, but they were so tart that the men joked that the pucker lasted for two days. One time Jackson put some currants into dough to make berry shortcakes for his messmates. He added a liberal amount of sugar, which Rounds filched from bags earmarked for Montana. Unfortunately, he so overcooked the cakes that they tested the strength of his companions' jaws.

The next morning a "church train" of about three hundred Mormons emigrating to Salt Lake caught up with the bull drivers.[1] A Mormon advance guard of young men on foot carried shotguns—which were intended as much to shoot sage hens for dinner as to ward off Indians. Behind them came the wagons, with most of the adults trudging silently beside them. Some of the older travelers clung to the wagon sides for support. On the fringes of the group, little girls darted about gathering flowers and colored pebbles.

That night the Mormons camped near Jackson's group. Fifty sagebrush fires encircled their corral of wagons, and soon the fragrance of baking bread and bacon sweetened the mountain air. Someone played a fiddle. Others began to sing. And everywhere girls and boys danced merrily. The pleasurable scene nonetheless filled Jackson with melancholy, reminding him of how much he missed his own family. Perhaps he should go to Salt Lake City instead of Montana, he thought.

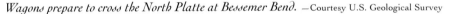

Wagons prepare to cross the North Platte at Bessemer Bend. —Courtesy U.S. Geological Survey

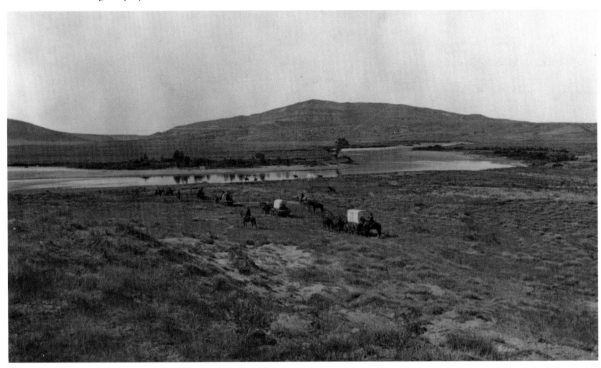

The next day the teamsters rounded Laramie Peak. Jackson had seen it darken the horizon for nearly two weeks, which was more than ample time for him to sketch it. By now there was nothing left of the broad valley, and the trail often led away from the Platte River to avoid its narrow, boulder-strewn canyon. The land all around was rusty red and dry as buffalo bones. There was almost no vegetation, and the jagged rocks cut up the men's footwear. Their precious oxen were dying from the heat, from lack of water, and from sheer exhaustion.

And still there was the constant fear of Indian attacks. On the morning of August 18, "flames suddenly shot up behind us," Jackson wrote. "A few minutes later . . . a mail rider galloped by, shouting 'Indians!'—a band of braves had swooped down on the [telegraph] station at daybreak and set the place on fire." At least three men had been scalped. Soon soldiers from nearby Fort Caspar thundered past.

That same evening they came to Fort Caspar and the famous Platte River Bridge, one thousand feet long and the only one over the river. Fort Caspar, named in honor of Lieutenant Caspar Collins, was a vital supply point on the Oregon Trail. Twelve months earlier Lieutenant Collins and a small detachment had been ambushed and killed by Cheyennes almost within sight of the fort. A year after Jackson passed through, the outpost, under severe Indian pressure, would be abandoned.

Owens hardly paused at Fort Caspar. By the next day the train was moving through the scenic Red Butte country over land so dry that thick clouds of choking dust actually obscured Jackson's lead ox team. Still, Jackson was fascinated by the area and sketched it several times. It was here that Rock Rounds, Jackson's best friend, had a run-in with Owens. The conflict started because the whackers had depleted their allotment of highly prized sugar. So Rounds, who was driving the sugar wagon, had been helping himself to the cargo. When Owens found out, he thundered that the shortage would be deducted from Rounds's wages. Rounds, with a pistol strapped to each leg, shouted that Owens could be damned. With that, Rounds and Gray, another whacker, stomped out of camp.

By the time Owens's group reached the Sweetwater station, Rounds had already found a job cutting hay for the telegraphers' horses. "So departed the first of the Three Musketeers," Jackson glumly recorded in his diary. When he said good-bye to Rounds, he believed they would meet again. But they never did, nor did Jackson ever hear from him. Many years later he learned that Rounds had died in Boise, Idaho, while only in his forties.

The wagon train was now following the narrow Sweetwater River, a branch of the North Platte. On August 23 the men edged past Independence Rock, a monolith shaped like a buffalo's hump, upon which so many emigrants had carved their names that it had become known as the Register of the Desert.[2] The group camped a few miles past Independence Rock, and Jackson sketched it. In the evening they experienced a ferocious thunderstorm and learned in the morning that lightning had killed one of the men on Doolittle's wagon train, which had been traveling several miles

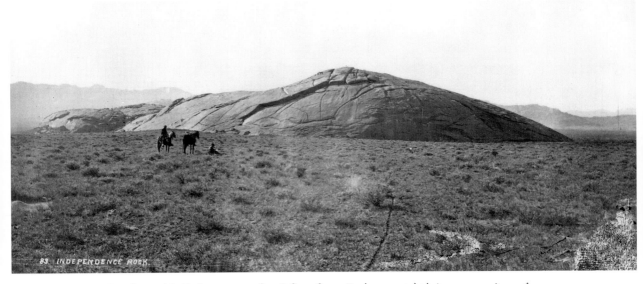

Most Oregon Trail pioneers paused at Independence Rock to scratch their names on its surface. Many of these markings are still visible. —Courtesy U.S. Geological Survey

ahead of them. Jackson's group passed the Doolittle party as they were burying the man. His grave was marked by a piece of spare wood from one of the wagons. It would soon rot and blow away. Jackson had seen many such graves along the Oregon Trail.

The next day, the train skirted the spectacular cleft in the rocks known as Devil's Gate.[3] Later the teamsters paused at a ranch, where Jackson came across some old Salt Lake City newspapers. Yellowed as they were, he gobbled down every word. The papers reminded him of home and caused him to wonder again if he should go to Salt Lake rather than the lawless Montana gold country.

The wagon train moved steadily uphill, heading toward the fabled South Pass and the Continental Divide. By August 29 the whackers spotted the Wind River Mountains, shimmering with snow. The weather turned colder and on the night of August 30 there was sleet. Fortunately the men had gathered pine logs at a telegraph station, and the wood provided a roaring fire, superior to the smoldering buffalo chips they were used to. But the cold pursued them as they plodded toward South Pass. Jackson was pitifully underdressed with nothing but a pair of thin pants, shoes without socks, a summer shirt, and a frayed coat. Even worse than the weather was his mad desire for sweets. He finally cut into a hundred-pound sugar sack and took what he needed—Owens could go to hell!

Owens stopped at a telegraph station near the summit of South Pass and spent most of a day fashioning ox yokes out of some telegraph poles he'd purchased. Camped

at the station was a group of around one hundred soldiers on their way east. A lively trade went on for coats, boots, pistols, and whiskey. The last was duly passed around for a merry night. The next day the bull drivers ascended the pass over such a broad, gentle slope that they barely realized they were crossing the Great Divide and entering the Pacific watershed.[4] But the wispy air and the lofty peaks to the north let them know they were on the rafters of the continent. "The air at eight thousand feet was exhilarating," Jackson wrote. "The Wind River Mountains, blue-purple and topped with snow, were a splendid sight."

The church train had caught up with them again, but now the Mormons were suffering. So many oxen had died that there were hardly enough to pull the wagons, even after they had jettisoned nearly every heavy item and beloved keepsake not absolutely essential. For the women, with their bulky dresses and dainty shoes, the going was particularly difficult. So when Owens offered the ladies the luxury of riding on the tongues of his wagons, they gratefully accepted. "Possibly the presence of fair passengers . . . slowed the progress of the train somewhat," Jackson wrote. "If so, the quickening of pulses made up for it." The Mormon train accompanied the Owens

Jackson's drawing shows pioneers skirting Devil's Gate as they tread slowly up the Sweetwater Valley.
—Courtesy Colorado Historical Society

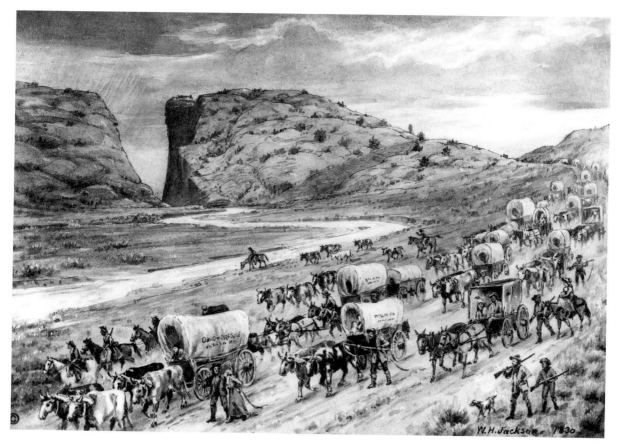

group for the next few days as they made for Fort Bridger, where the Oregon Trail would head northwest toward the Snake River and the Mormon Trail southwest to Salt Lake City.

A few days later Owens's train came to the Green River crossing, with the Mormons a short distance behind. As was customary, before entering the water the whackers removed their pants to keep them dry. But the crossing took longer than expected. Some of the men were still pantless in the river and many more were pantless on the opposite shore when the Mormon train came upon the scene. Since the teamsters had no way of immediately retrieving their pants, there was much laughter and embarrassment. That night Jackson simply wrote in his diary: "Naked legs & Mormon women." He knew he would remember what it meant.

By that time Jackson had made up his mind to go to Salt Lake City. The next morning, after Owens had already yoked up, Jackson and seven others informed him that they were leaving. Owens lost his usual composure. To have eight men out of twenty-five walk off would jeopardize the entire supply train. He exploded in such a thunderstorm of rage that the men cowered before him. He cussed and threatened that he would have them all arrested if they deserted, then that anyone who left would not reach Salt Lake City alive!

After that barrage six of the men backed down, including Jackson's close friend Billy Crowl. Only Jackson and another young whacker named Bill Maddern kept to their decision. Owens calmed. He could get by with the loss of just two. But he angrily took back all of the equipment the company had sold them, since the outfitting had been contingent upon them completing the assignment. Then he ordered the train to move out, leaving the pair standing alone in the middle of the trail. Jackson never saw Billy Crowl, the second Musketeer, again.

Jackson and Maddern walked to a nearby stagecoach station, where they quickly found work harvesting hay for a local farmer. They worked on the farm for three weeks, then signed on with a train of fourteen wagons headed for Salt Lake.

It took twenty-two days to reach Salt Lake. The first part of the journey was a pleasure. The food improved considerably as they closed in on civilization. Now they could get fruit and vegetables and even fresh milk! But autumn was upon them, and soon the weather began deteriorating. Day after day cold rain pelted them. When they reached Fort Bridger on October 1, Jackson immediately checked for letters from home—perhaps even one from Caddie. But there was nothing.

Jackson found the fort fascinating. It had been opened as a trading post in 1843 by Jim Bridger, renowned for his exploits as a fur trapper and mountain man, and for his knowledge of the Rockies and its people.[5] When Brigham Young and the first Mormons came through Fort Bridger in 1847 Bridger scoffed at Young and warned him that he would never be able to coax any crops out of the impossible desert around the Great Salt Lake. Bridger ought to know about the Salt Lake country—he had discovered it. To Bridger's astonishment the Mormons, who brought mountain water

to the dusty desert by an ingenious system of irrigation ditches, did not fail but actually prospered to the extent that they bought out Bridger himself in 1855.

The trails split at Fort Bridger. The road to Oregon went northwest through what would one day be called Idaho. The road to Salt Lake City headed southwest into the Bear River Range. The weather had improved by the time Jackson's party started out for Salt Lake. A few days later the wagon train entered Echo Canyon. Jackson had looked forward to seeing the breastworks erected there by Brigham Young's militia in 1857 during the Mormon War.

Government conflict with the Mormons had begun nine years earlier, when the Mormon territory became part of the United States. In 1850 Congress established the territory of Utah, and Brigham Young became its governor. But most Americans felt a great deal of ill will against the Mormons for their practice of polygamy, and in 1857 the newly inaugurated President James Buchanan deposed Young and named Alfred Cumming, a non-Mormon from Georgia, as the new governor.

Realizing there would be opposition from the Mormons, the federal government dispatched fifteen hundred federal troops to escort the new governor to Salt Lake City. As predicted, the Mormons resisted. Brigham Young called out the Mormon militia and began constructing barricades across Echo Canyon, the main route to Salt Lake City. The soldiers waited at Fort Bridger while a government mediator hurried to Salt Lake hoping to convince Young that the Mormon religion and Mormon ways would be respected. Thereupon Young agreed to the installation of the new governor. The armed conflict did not occur and Utah fell under federal authority. Nonetheless, the real ruler of Utah continued to be Brigham Young.

Jackson's train spent the better part of three days in Echo Canyon, giving him the opportunity to sketch its rugged boulders and towering walls. He even made the difficult ascent of Hanging Rocks, which he found "wild and picturesque." But he was nevertheless disappointed in the canyon. He had expected to see rugged Mormon battlements but found none.

On October 12 the wagoners started through Silver Creek Canyon. The next several days were among the most torturous in Jackson's life.

> Sun 14th. Air cold and raw . . . The roads are very muddy & slippery . . . While Sam & I were preparing supper it commenced to snow & continued during the whole evening. . . .
>
> Mon 15th. Day opened cold, raw & stormy with a couple inches of snow on the ground. . . . Had nothing but moccasins to wear and the snow got through, making my feet very cold. . . . Mud most awfully deep and we had a terrible time in getting up [a hill]. . . . Tore the soles off my moccasins and the soles of my bare feet were exposed to the snow and frozen ground. Suffered very much from the cold from insufficient clothing. . . . My feet got so benumbed & senseless that I felt but little pain in them although running over brushwood, snow, stones & such.
>
> Tues. 16th. Very cold blustery & snowing. Feet felt very sore and I couldn't get up. . . .

> Wed 17th. Feet so sore that I could not possibly walk & laid in the wagon all day.
> Awful rough riding in the wagon, just shook all to pieces. (*D*, 78–79)

There is no doubt that Jackson's feet were partially frozen and that he came very close to losing them. Yet the wagon boss had the audacity to dock Jackson's wages for the two days he spent recovering in the wagon. "In my whole life," Jackson wrote as an old man, "I can recall no single mean act quite the equal of that one."

Early on October 18 they hauled out of the hellish canyon and emerged on the wide Salt Lake plain. It was a sight to behold. "The morning's sunlight disclosed a scene of rare beauty—the City of the Saints, the goal of a long summer's journey, lay spread out before us in all its charm of glistening white houses and emerald green foliage." The Mormons, by sheer hard work and as they believed, divine guidance, had turned a bleak, sterile wilderness into a fertile paradise. The homes and streets were bordered with a profusion of bright flowers. Trees were heavy with fruit. Children came running to the wagons, their hats and aprons filled with gifts of juicy peaches, apples, and pears.

The homes here were mostly of whitewashed adobe and though small, were as clean as a peach leaf. Behind Main Street was a large group of church buildings, some of which seemed palatial to Jackson. He took it all in as the wagons made their way through the city's wide avenues to the Main Street warehouse, where the men unloaded the cargo they'd brought to the city with such toil and hardship.

So, at the age of twenty-three, Jackson found himself virtually alone in a strange city several thousand miles from home with only a few dollars in his pocket. His feet were raw and aching. He went to the post office, but there were no letters. With no place to stay that night, he slept outdoors in a frigid wagon.

"Went to bed disconsolate" was his final diary entry for that day.

Ticket to Paradise

With a Wagon Train from Salt Lake City to California (1866–1867)

Jackson sat inside his drafty wagon, hunched and miserable, as a cold, late October wind snarled about him. He knew he was on a downslide.

> Let me take a look at myself and see what I am like [he wrote in his diary]. Six months roughing it on the plains has darkened me down considerably. My face looks rough from the hair that has taken it to itself. . . . My hands are black & it sometimes seems as if I never should get them presentable again.
>
> My apparel however caps the climax. My clothes in the first place are surprisingly dirty and very very ragged. My pants [are] all but a continuous series of rents. I pull on another pair, very ragged also, but in different places, so between the two I manage to hide my nakedness. [My] coat has faded very much & holds itself together most perseveringly. . . . My hat beats all . . . the most vivid imagination would fail to assign it any shape and it is about as easy to keep on my head on a windy day as a newspaper.
>
> Taken as a whole, you have a very seedy individual. What makes me feel blue, now, is that this dilapidated exterior will prevent my obtaining the work I wish to get. (*D, 82*)

As if to verify this analysis, he was refused a job at the local photographic shop. Adding to his misery, his cash ran out. In desperation he wrote his parents asking for one hundred dollars, admitting to his diary that such a letter "is humiliating in the extreme."

Billy Maddern found them a cheap apartment. There was no bed, so they slept on the floor. Another young bullwhacker named Wilson agreed to share the room, and he brought with him a little cash which they all shared. On Sunday Maddern and Wilson went to the Mormon Tabernacle. Jackson, feeling miserable and having no suitable clothing besides, stayed in the drab room. Billy did not get back until eleven o'clock that night, having joined a group of locals for singing and dancing. He had also managed to pound out the dents in his cornet and enlivened the party with something resembling music. Jackson, left out of the fun, continued to mope.

Soon Jackson had become almost a prisoner in the apartment. He did the housekeeping and cooked the meals. He also wrote letters and sketched. But he rarely ventured out. Within a week all the other whackers of his group had found work. Wilson said he could get Jackson a job bullwhacking, but, apparently hoping for something more attractive, Jackson refused.

Meanwhile Maddern found labor with a farmer named Birch, whose spread was four miles south of town. Birch was a kindly middle-aged Englishman, as industrious as he was illiterate. He was in the process of putting up a barn, and when Maddern

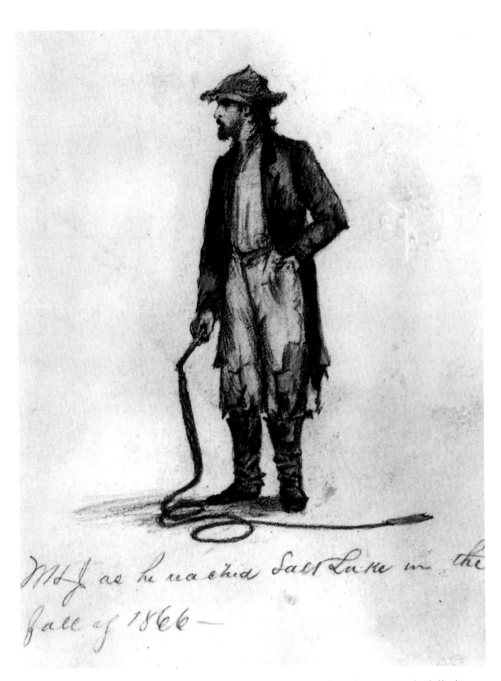

M&J as he reached Salt Lake in the fall of 1866 —

Jackson depicts himself as he looked when he reached Salt Lake City in the fall of 1866. —Courtesy Denver Public Library, Western History Collection

told him about Jackson's unemployment, Birch agreed to hire him. Jackson's work involved tearing down an old adobe building, loading the bricks onto a cart, and wheeling them to the barn site. The adobe clay was very heavy, rendering his fingers lame. Sometimes it snowed, making everything worse. But he kept working.

He lived for mail from home. One day a letter from a friend arrived with the startling news that Caddie had actually written to him. He was overcome with elation. The friend said Caddie had sent the letter to Virginia City, Montana, where Jackson had planned to go. Of course! He should have realized she would send it there.

And so his mood soared. After savoring the joy for several days, he carefully composed a letter to her.

> [I] took great pains to write her a neat well looking letter as I used to in other times. It seemed really like olden times writing to her and I could hardly make myself believe that our relations were so changed. The name on the neat white envelope looked so natural & just exactly as the semi-weekly ones were wont to look. I wrote as simple [and] familiar a letter as possible, taking it for granted that she was willing to renew former ties. From what I have heard through Jim and others I do not think I've made any mistake. (*D*, 88)

At work, Jackson and Maddern ate their meals at Birch's table with his three wives and their children. Jackson was impressed with the family's devotion and the fact that they said grace before every meal. Birch, for his part, was fascinated with Jackson and Maddern, mainly because they could read and write. The two young men generally remained at the Birches' home into the evening, when they would read old issues of the *New York Ledger* aloud to the family. The paper afforded the Birches about the only knowledge they had of the world outside the Great Salt Lake. The family listened intently to such news as President Andrew Johnson's difficulties with Congress or the Fourteenth (Civil Rights) Amendment to the Constitution. Perhaps most astonishing of all was the story of the telegraph cable that would go clear across the Atlantic to Great Britain.

Birch and his family developed a tender feeling for the young men. One day Birch said to them, "There's one thing I wish you'd leave me when you go, and that's your knowledge." The pair enjoyed the Birches, too. Sometimes Jackson would get out his flute and serenade the family. Maddern often joined in on his cornet. Some evenings they all played poker and other card games. A visit from neighbors usually inspired spirited singing. It became such a pleasant relationship that after the barn was up and there was no more work for them, Birch offered Jackson a room in which to paint and sketch. Here Jackson worked on pictures of the Platte crossing, Chimney Rock, Echo Canyon, and many other places. One day Jackson did a portrait of the Birch family and gave it to them.

Meanwhile Jackson was developing an attachment to the Salt Lake area. The valley was beautiful. He was enchanted by the interplay of light on the eastern mountains: "Could gaze on them for hours without tiring." Once, just for the pure pleasure

The notation in the upper left corner says, "Where some of the other boys lived." The date, 1866, indicates that this was likely sketched in Salt Lake City. —Courtesy Colorado Historical Society

of it, he climbed one of the lower peaks. He also explored the city itself. He was impressed by its wide streets, laid out so a team of oxen could turn around without backing up.

He visited Temple Square in the center of town. It covered a full city block, with a fifteen-foot-high wall of adobe and sandstone around it. Inside, work was being done on both the temple and the tabernacle. Construction had started on the tabernacle three years before and would be completed in ten more months. The builders hauled logs three hundred miles across the semidesert from forests in southern Utah. When finished, the building would house one of the finest organs in the world.

The temple, too, was yet to be completed. Work on it was going far slower, since it was being constructed of granite from a quarry twenty miles away. Eventually the tallest of the spires would soar twenty-one stories above the salt flats. Atop that spire would perch a twelve-and-a-half-foot statue of the angel Moroni, overlaid with gold leaf. The temple was Brigham Young's special project—he had seen it in a vision

when he picked out its site in 1847. But he would not live to glory in its full splendor. It was not completed until 1892—fifteen years after Young's death. When Jackson viewed the temple, its walls were only a few feet high. Mormon services were held in an open-air enclosure called the Bowery. Jackson sometimes attended.

One evening Jackson and some of the other whackers went to the theater. Although he could afford only balcony seats, he enjoyed the play. In the audience Jackson first saw Brigham Young, with his bushy beard and solid build, accompanied by just three of his twenty-plus wives.

During their idle time Jackson and Maddern had been reading Mormon literature. Believing them ripe for conversion, a Mormon called Brother Scott came over to the Birches' one evening. Seated in the kitchen, he gave the two a quick course in Mormon history. Brother Scott described how the angel Moroni visited Joseph Smith, giving him the sacred Book of Mormon. He told of the persecution of Smith and his followers in Nauvoo, Illinois, and of Smith's murder. After that, as Brother Scott explained, Brigham Young led the Mormons out of Nauvoo over hundreds of miles to the Great Salt Lake and there built their Zion.

Jackson made this drawing of the Salt Lake Valley at age twenty-three. The note at the bottom states that it was sketched from the Birch farmhouse. —Courtesy Scotts Bluff National Monument

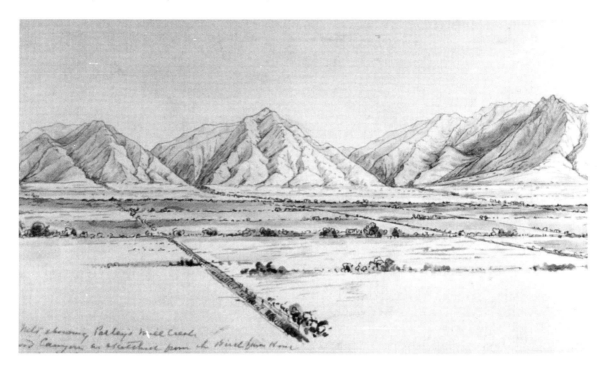

Jackson and Maddern listened politely but they were much more interested in a different topic: southern California. "According to all accounts," Jackson noted in his diary, "[California] is a perfect paradise where perpetual summer reigns." This paradise was made even more heavenly by its many active gold mines where, it was claimed, fortunes were waiting to be made.

Jackson learned that there was an active run of supply wagons between Utah and Los Angeles, some leaving every two or three days. Right after that he received the one hundred dollars he'd asked for from his family, an event that cemented his decision to go. A few days later he also received a large box of much-needed clothing from his father. Maddern had also been sent funds from home, so they agreed it was time to head for California. Now they could actually afford to buy passage with a wagon train—rather than hiring on as miserable bullwhackers.

On December 21, 1866, the pair had a sad final breakfast with the Birches. The wives prepared huge food baskets for them, and Birch accompanied them a little way down the road. Years later Jackson remembered the parting: "Bill and I hated to leave that kind family, and I know they all felt a real affection for us."

The wagon train for Los Angeles, seven hundred miles away, was headed by part owner Ed Webb, a good-natured but hard-drinking man. With him was his wife, who was within several weeks of giving birth. That she was the lone female on a train about to traverse the most treacherous desert in America, accompanied by a crew of fifteen grizzled drivers and half a dozen passengers of undetermined backgrounds, seemed not to bother her. She was, as Jackson commented, "an amazing woman" who walked beside the wagon, cooked her husband's mess, did numerous chores, and then sat up half the night singing and playing cards.

Ed Webb loved Mormon wine at least as much as he loved his wife, and there was hardly a town they passed where he did not stand a round of drinks for whoever cared to enjoy his conviviality—which was about everyone. Often the imbibing continued into the evening, and almost every night Ed's roustabout sidekick, known only as Lousy Al, got falling-down drunk.

Webb's route to Los Angeles followed a well-traveled road that at first headed almost due south through irrigated lands made fertile by Mormon hard work. The road was good during this segment of the journey because the lands were the flat bottom of what in glacial times had been a huge inland sea, of which the Great Salt Lake was merely a tiny remnant. Strung out along the way were thriving little towns, such as Nephi, which Jackson sketched. He also drew Utah Lake, with its placid surface and purple mountain backdrop, where they passed on Christmas Eve. Later that day they stopped at the hamlet of Cottonwood, where they bought fresh eggs. That evening they had a holiday feast with the eggs and steak and onions—probably topped off with Mormon wine. Jackson and Maddern played their instruments, and there was singing, dancing, and general tomfoolery.

By December 30 they had passed Fillmore, a small settlement which had once aspired to be the territorial capital of Utah. The citizens had even started to build a statehouse. But Brigham Young decided that the capital would be in Salt Lake City where he could keep his hand in the government, so the unfinished, two-story brick structure was now being used as a school and telegraph office.

The next evening the wagon train was at Meadow Creek—just in time to usher in 1867 with a dance. There was plenty to drink and "some of the boys got tight," Jackson noted. The New Year's celebration turned rough, so everyone hustled back to camp a little after midnight.

Within a few days the road had turned west to ascend a mountainous area known as the Rim, which the Mormons called Dixie. The Rim marked the boundary between the cultivated lands of Utah and the desert that reached all the way to California. The area was dry and rugged, but Jackson was thrilled by its very desolation:

> Some 8 or 10 miles over the pass [there was] a complete change in scenery. Prickly Pear and Soap Weed became almost as prevalent as the sagebrush was. As we descended into "Dixie," everything was as broken & wild as one could imagine. Everything appeared upheaved, torn asunder & burnt to cinders. The rocks were black, scarred & scoriated & the whole surface appeared washed to fragments. (*D*, 101)

Jackson hurried ahead of the slow-moving mule train and ascended some hills to make a sketch of what he called "the most wonderful scenery I've ever seen."

The destitute Paiute Indians roamed this inhospitable place.[1] Food was scarce, and they were reduced to eating anything that wiggled, including snakes, mice, and grasshoppers. The wagoners once witnessed a large group of Paiutes dashing through the prickly cactus on foot searching for rabbits. When they found them, they killed them with sticks.

Soon the train was making its way along the turbid creek the Spanish had named the Rio Virgin. Paiutes were always in the vicinity, and on January 16 a number of them crowded into camp, eager for whatever goods the white men would spare. But they were not begging—in return they offered firewood, a valuable commodity in the sand barrens, where the nights grew very cold. The Indians had hauled the logs considerable distances.

Jackson liked the Paiutes. "Little & big, old & young came in [to camp] and we had great times with them," he wrote. The Indians were skillful traders, and Jackson could have learned from them. He gave up a slightly frayed shirt and a not-too-worn blanket for a useless bow and a dozen crooked arrows.

As the wagon train neared the Vegas River, the desert became even drier:

> The ground was a mixture of sand & gravel that looked as if it had been rolled & packed down hard. The only vegetation was what they called the desert weed & another small plant that is at present leafless & of which I cannot learn the name. Besides these there is not so much as a spear of grass. (*D*, 112)

The Vegas was such a tiny stream that one could easily jump across it, but it was deep and had a clear current. Because it provided one of the few water sources in the desert, there were many Paiutes nearby. The women had papooses strapped to their backs, presenting such an unusual appearance to the pack mules, used to men only, that the animals became unruly and the drivers had to shoo the women away from camp.

The valley of the Vegas had no permanent population. The only building was a deserted Mormon structure built of mud. Although the early Spanish had named the area Las Vegas, or fertile plain, it was obvious that no settlement was possible in this sterile place. The land was utterly worthless.

On January 18 the travelers crossed a range of hills into California. Beyond lay the great Mojave Desert, almost two hundred miles of wind-seared, virtually water-less wasteland. The wagon train would continue following the Old Spanish Trail, which had once connected Santa Fe with the missions around Los Angeles.[2] Stories abounded concerning the hardships that had been endured and the lives that had been lost crossing the Mojave. The only plants able to survive were scraggly creosote bushes, low-growing prickly pear cacti, and yuccas. Many yuccas consisted of clusters of dull green, spear-shaped leaves, sharp as bayonets. Others grew taller than a man, with massive trunks and armlike branches. The Mormons thought these plants resembled biblical Joshuas urging them on to the Promised Land, hence they called them Joshua trees.

Inhospitable as the desert usually was, Jackson's party traversed it during one of the rare interludes when the weather was beautiful—even a little cool in the mornings. During the day tepid breezes blew gently and the air was so wonderfully transparent that Jackson could enjoy a vista of many miles. When they camped, after building a roaring fire one of the men would usually get out his fiddle, whereupon Billy Maddern might begin whacking rhythm on some cattle bones. The men would sing, and even Mrs. Webb, still pregnant, sometimes joined in with a lively Scottish song.

The wagon train proceeded slowly around the ridge of Nopah Mountain, with Death Valley's Funeral Peak in the northern distance. "There is not the first particle of vegetation," Jackson wrote in his diary, "except a few stunted weeds. The hills & mts are very rough, broken & barren, not a particle of soil on them & the rocks all crumbling."

Ever so slowly the group moved on. In an hour they would cover no more than a couple of miles. At last they reached the Mojave River. However, the so-called river was a severe disappointment because, as Jackson recorded, "the bed of the stream is as dry as the deserts we have crossed." But when rains fell in the distant San Gabriel Mountains, the river's source, it was a different story. Then the river became so full that it was impossible to ford. The Spanish had located their trail along the Mojave River to take advantage of the water, chancy though it was. Later the Mormons had used the river route as the main artery between Deseret (Utah) and the sea at San

Diego. It was now a mail route between the eastern states and the California gold country.

On January 27 Jackson and his companions crossed between the San Gabriel and San Bernardino Mountains through Cajon Pass, which was "fearfully wild [and] so narrow in some places as hardly to leave room for the road, while the high pure granite cliffs went away above our heads." Then, ten days after entering the Mojave, they rolled into the green land near San Bernardino. They spent the night near the Cucamonga ranch, where two hundred acres were devoted to grapes. The men consumed a great deal of the vineyard's wine that evening while they played cards. Jackson "lay on the grass & rolled around in pure enjoyment," he wrote. Later one of the wagoners, probably Lousy Al, "got most awfully drunk & . . . made the night hideous with his yells."

At dawn, Jackson awoke to a stage coachman's horn, feeling happy. He wrote that "musical birds made the air melodious & everything seems in calm pleasant repose." California was as beautiful as everyone said. The grass "was as green as emerald. . . . On the plain were large herds of horses, thousands in all."

On the last day of January 1867 Jackson reached the hills outside Los Angeles. Paradise at last.

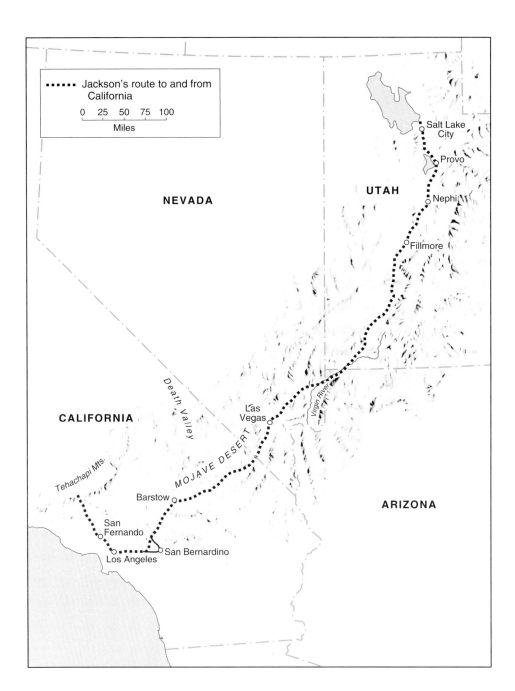

This map shows the route Jackson took during his stint as a horse driver in 1867.

Turning Back

Driving Horses from California to Omaha (1867)

As the Webb wagon train neared Los Angeles, the men pulled up at the brow of a hill. There, sweat dripping into their eyes, they paused to survey the town that they had traveled so long to reach. Jackson wrote:

> The city presented a long line of low, tiled-roofed, adobe dwellings with a few more modern buildings looming up ornamentally out of the general level; the Court House with its cupola, the old Mission and one or two other churches being the most conspicuous. (*D*, 125)

After the wagoners made camp, Jackson and the others took a narrow log footbridge over the Los Angeles River and sauntered downtown along a street lined with orange and lime trees. The boys looked tough — their clothes tattered and dusty, their beards grubby. But their appearance fit Los Angeles, a rough place of five thousand motley inhabitants. Downtown consisted mainly of shops and warehouses filled with goods freighted in from the port of Wilmington, twenty miles south. The buyers of these goods were mainly cattle ranchers, grape farmers, and citrus growers, most of whom had to eke out existences in the nearby hills that, unlike lush Los Angeles, had no ready supply of water.

Aside from a few merchants and their families, the town's population was mostly ne'er-do-well Americans and Mexicans, along with a smattering of Chinese laborers who had given up slaving on the Central Pacific Railroad. Violence was close to the surface, fueled by the resentments that the Americans and Mexicans held against the Chinese, who would work for paupers' wages. Four years later the tension would explode into a riot in which nineteen Chinese men would be murdered.

Once in town, Jackson headed straight to the post office, where he waited anxiously as the postmaster fingered the greasy pile of general delivery letters, most of which would never be claimed. The postmaster shrugged. Nothing. Jackson could not believe it — a month since he left Salt Lake City and no letters from home? Had they all forgotten about him — his family, his friends, Caddie? That evening, Ed Webb took Jackson and his cohorts to a dive called the Cafe Francais, where he treated them to a couple of bottles of California wine. The alcohol served only to enhance Jackson's distress.

The next day was enlivened by a traveling circus. But the gaudy clowns and silly animal acts could not shake Jackson's homesickness. The circus had a noisy band, with brassy trumpets and trombones. Bill Maddern tried to pick up some quick money by getting a temporary job playing his horn with the circus, but he was told there was no vacancy.

Despite the effort it took to get there, neither Maddern nor Jackson found Los Angeles appealing, so they decided to try San Francisco. There was bound to be plenty of work in that bustling city, which lay several days to the north. Once they had the funds, they would equip themselves and head for the goldfields there, where they would soon strike it rich.

To get to San Francisco, the two decided to start in Wilmington, Los Angeles's port, where they expected to pick up jobs on a boat sailing north. As it happened, Webb's wagon train was bound for Wilmington to get goods for the return trip to Salt Lake City, so Jackson and Maddern hopped aboard. The route took them through a level prairie where sea breezes ruffled through a vast expanse of grass while huge flocks of geese wheeled through the clear air above.

Wilmington was not much. The Wells Fargo stagecoach office and a couple of flimsy saloons were the only significant buildings. Since there were no ships headed their way, Jackson and Maddern loitered around the wharf the next day watching Webb's wagons being loaded. After Webb moved out, the pair paced the waterfront and scanned the horizon for schooners, but none appeared. "Time lays upon our hands most oppressively," Jackson noted in his diary. "Feel so indolent that I care not to go to writing or drawing. Am restless and somewhat 'blue' & want to be on the move. . . . Went to bed at 8 just to get rid of myself." (*D*, 129)

Eventually the two gave up waiting and trudged back to Ed Webb's house in Los Angeles. They hit him up for food and overnight lodging—which turned out to be blankets on the floor. As they prepared to leave the next morning, Mrs. Webb, who must have found Jackson a most curious person, asked if she could read his journal, which Jackson thought an odd request. Jackson reluctantly gave it to her, apprehensive because he had written that she was an amazing woman and made other private observations. Whatever her impressions, she returned the journal without comment. Then Jackson, Maddern, and a new companion—a roustabout Webb teamster named McLellan—set out on foot for San Francisco.

The three walked north along the stagecoach road, spending the first night under the stars near what is now the Hollywood Bowl. With barely $1.57 among them, they made a meal of cheese and crackers, which Jackson called "my old familiar delicacy." The night was cold and as they had no matches for a fire they had a frigid time of it.

The next day they reached the mission of San Fernando, founded seventy years earlier when California was a Spanish province. The ancient building was almost in ruins after treasure hunters had poked and pried everywhere seeking valuables supposedly hidden by the padres. After buying more crackers at the mission, Jackson and his companions struck off up the canyon. There they met a Mexican woman who spoke no English but from whom they bought a cake of cheese. After their usual "feast," they continued along the dirt road and at the next house were able to obtain matches, a prize more dear than cheese and crackers.

Continuing northward the men entered dry country where finding water became a problem. Although they were thirsty, what with the cracker diet, they had hiked thirty miles that day and were too tired to look for water. They made camp in a gully for protection from the wind that howled about them. They built a roaring fire and slept soundly.

The next morning they located a little pond after marching seven miles into a wind that Jackson called devilishly cold. Toward evening they encountered an ox team at a way station. The team needed another bullwhacker and McLellan eagerly accepted the job. Jackson and Maddern continued without him.

Crossing a broad valley, the two spotted a large herd of cattle. Quickly they saw danger:

> We noted that the animals were moving toward us. Soon the thudding of their hoofs had increased to an ominous rumble and we realized that the longhorns were preparing to stampede. With no mounted herdsmen in sight to cut them off, Bill and I would have to stop them—or else.
>
> We shouted and waved our hats and jumped into the air. On came the herd. We yelled and whirled our coats and jumped even higher. Still they came on until not more than a hundred feet lay between the animals and ourselves. Then the herd leader, a black bull, slowed. At fifty feet he was dubious about continuing—but the pressure behind forced him to within fifteen or twenty feet of us before we felt even moderately safe. Taking no chances, we continued our dancing and shouting until we had turned the whole herd to one side. (*TE,* 53)

Stampeding cattle, like stampeding bison, were extremely dangerous and could trample to death many men at once, even men on horseback. Sometimes firearms were necessary to protect oneself from speeding herds.

The next day Jackson and Maddern crossed the blue rampart of the Tehachapi Mountains by way of Tejon Pass and descended to Twenty Mile Station, at the foot of the mountains. The station was owned by an elderly couple named Ward, who lived with their son and his wife. The elder Mrs. Ward graciously set a table for the weary travelers. The food, thankfully, was not cheese and crackers. There at the station stagecoaches were constantly stopping for food, a change of horses, and overnight accommodations.[1] The Wards told Jackson and Maddern that they could use extra hands at a dollar a day plus board. Maddern was not interested—he still had his mind set on reaching the northern goldfields. But at this point Jackson was ready to reassess his plans, and he decided to stay. When Maddern left the next morning, the two friends promised to exchange letters, but they soon lost touch.

Jackson enjoyed working at the busy station. "Somebody was always hungry," Jackson wrote. "Somebody was always wanting to go to bed—or get up. Usually the house was filled to the rafters, with never less than two persons to a bed. Often the overflow slept in the barroom, or in the barn."

During his brief stay in California in 1867 Jackson worked at a stagecoach inn that was probably much like this. —Courtesy Scotts Bluff National Monument

Jackson, as an able-bodied young man of twenty-three, was expected to be available for any kind of job, from hauling manure, cleaning rooms, and planting cactus fences to building fires on cold evenings. The Wards were nice people and he enjoyed their son, Nels, with whom he often worked. Since he also had a certain amount of free time, he began sketching again.

The Wards, for their part, found the sensitive, intelligent young man a welcome change from the usual roustabout laborer. They were particularly fascinated by his artistic abilities. On days when the weather was too raw and bitter for outdoor work, the Ward family would sit around the fire with Jackson while he made sketches of people, including Nels's pretty young wife and some of the frazzled travelers and big-boned freighters who passed through.

Still, Jackson had a gnawing discontent with himself. "When O when," he confided to his journal, "shall I get out of this [and be] among friends and dear old

acquaintances? Sometimes when I allow myself to wander back to the scenes and associations of one year ago it seems as if I should go crazy. . . . I endeavor to think as little as possible of my [present] condition, keeping hard at work all the while to accomplish my purpose of getting back east with plenty of money." He now realized that even though he had wandered across the entire breadth of America, he had never really left home. He continues:

> My only salvation from perpetual blues & homesickness is in a strict avoidance of all thought of matters that concern me most intimately. Once in a while I cannot help a vague wondering desire to know how C is, what she is doing & what she thinks, whether she ever received my letter or whether she has written to me. If I could only get a letter from her it would solve every doubt that oppresses me the heaviest.[2]
> (*D*, 135)

During his six weeks with the Wards, all desire to work the gold diggings left him. Suddenly he was in a great hurry to leave California and return to Vermont. On the last day of February 1867 Jackson said farewell to the Wards, leaving them the sketches he had made of them and their bleak ranch, which was almost lost amid the desert rocks and cactus. He set off for Los Angeles to find a job with a wagon train headed east, where the hills were green velvet and the air smelled of growing things.

Within a few days Jackson was back with the Webbs, who now had a newborn child. From them he learned of an Omaha-bound horse drive headed by a gruff, self-centered frontiersman named Sam McGannigan. Jackson knew almost nothing about McGannigan except that he was going in the direction Jackson desired to travel. So he signed on, ignoring the vagueness of McGannigan's promise about wages.

Jackson spent the first two weeks at the horse camp near the San Gabriel Mission as McGannigan made preparations to leave. The boss had Jackson doing the most difficult work, including shoeing many of the one hundred and fifty wild horses he had just purchased at auction. Jackson wrote:

> This shoe business was equally hard on horses as well as men; after lariatting, the horse was thrown by casting a rope around its feet, and once on its back the trick was to gather all four feet crosswise, in a bunch, so that the shoer could get in his work; here is where the rough stuff came in—the protesting bronco usually did some lively kicking before the trick was turned and some hard knocks were had before the shoes were all on. It goes without saying that there was no particular 'fitting'—the shoes, furnished in a few assorted sizes, were nailed on and clinched with as few strokes as possible. Only the more tender footed were shod before starting out; some that were thought to have sound feet soon became lame and as others were occasionally casting their shoes, it became almost a daily operation while traveling. (*TE*, 154)

Jackson did other work around the camp as well, such as branding the mules that were to draw the supply wagon. One animal in particular was a wild devil—it threw Jackson to the ground and dragged him over the dirt, ripping his pants and skinning his shins. Yet for this labor McGannigan paid Jackson nothing.

While Jackson and his group were making preparations to leave, they encountered another bunch about to embark on the same trek. Headed by a scruffy old

plainsman named Jim Kellar, the outfit had fifty wild horses and three horsemen who would give added muscle to McGannigan's five-man team. So Kellar and his group were welcomed, as was Kellar's wife, a pale-eyed young woman, who was naive in the extreme. Jackson, who almost never made fun of his contemporaries, described her as barely intelligent enough to distinguish bright objects. But she was pretty and McGannigan's lustful glares at her hinted at interesting entertainment possibilities for what otherwise promised to be a laborious and boring cross-country journey.

The horse drivers left camp on May 2, heading toward their first major destination, Salt Lake City. Their route was along the same trail that Jackson had taken in the other direction half a year earlier. But herding two hundred wild broncos was substantially more difficult than accompanying a wagon train, as Jackson quickly learned.

Jackson's most immediate problem was that he was not an experienced horseman. The very first day he lost control of his horse and it galloped off without him, dragging its saddle over the rocky ground until the thing was knocked to pieces. McGannigan was so furious that he told Jackson he was fired—although the next morning, as Jackson prepared to return to Los Angeles, McGannigan muttered that he could stay. Jackson knew this was no special favor—it was simply too late to find a replacement.

Jackson helped drive wild horses from California to Nebraska in 1867. —Courtesy Scotts Bluff National Monument

The wranglers made Rancho Cucamonga by midday, and they rested the herd there during the afternoon heat. Jackson went to the top of a hill to do some sketching and he felt better when he returned. Later that day Jackson proved valuable to McGannigan when the latter developed an impacted tooth and Jackson yanked it out using a rusty bullet mold as forceps.

Two days later the drive team inched through Cajon Pass and descended into the Mojave Desert. Jackson had had it easy crossing the Mojave the previous winter. Now it was almost summer, and the desert was in a far different mood. "Lying fierce and defiant in its torture of heat," a traveler described the desert several years earlier, "it was a desolation whose vastness was terrifying, whose bounding rim of slashed and broken hills seemed to hem in some mysterious menace."[3]

In addition to the almost unbearable heat were the sandstorms, which could bury entire herds and, worse, cover water holes. "Many indications of the dreadful sufferings of emigrant parties and drovers still mark the road," wrote a journalist in 1863. "[There are] the wrecks of wagons, half covered with the drifting sands, skeletons of horses and mules, and the skulls and bones of many herd of cattle that perished by thirst on the way or fell victims to the terrible sandstorms that sweep the desert."[4]

The men had canteens to help assuage their thirst, but the animals had nothing. The group was still some distance from the Mojave River when the horses got a whiff of moisture. Instantly they were off in a stampede that not even the most seasoned cowboy could control. Jackson's horse, as wild as the rest, carried him into the very midst of hurtling horseflesh. Dust billowed up around him until he almost suffocated. When the river came into sight, the pace increased until the herd crashed into the water, sending a blinding cascade over Jackson's face and body. As the lead animals stumbled, others fell over them until the whole outfit, horses and men, became a thrashing mass of confusion and panic. Afterward, everyone was bruised and shaken, but they knew that such incidents were to be expected and took it with a shrug.

The next day a potentially deadly situation developed when a group of heavily armed Los Angeles ranchers overtook McGannigan's outfit. Ordering them to halt, the ranchers examined the herd for stolen horses. McGannigan, Kellar, and the other men had guns and were prepared to use them if need be. They watched tensely as the ranchers passed through the herd. Everyone breathed easier when the ranchers said they were satisfied and rode off.

And so the drive continued. The desert heat was oppressive during the day, and although the herders drove the horses at night, there was often no shade amid the torrid desolation when they rested at midday. McGannigan urged them on unmercifully. Often they would cover forty miles at night, guided only by starlight. The pace was so fierce that more and more horses became lame, while Jackson and the others struggled to keep up with the shoeing. Such difficult work in the desert heat left the men sweltering and made it almost impossible to sleep afterward.

But the desert travel was even harder on the horses. Some died. Others became almost unmanageable.

> It was almost impossible to drive them. They were foot sore & some didn't want to travel at all & others wanted to take to the smooth washes on the side of the road & between the two we had a most vexatious time. Some pretty expressive language was used. While feeding, a regular stampede took place. Jim K's team succeeded in smashing up things so that they could take the wagon no farther until repaired. (*D*, 163)

Perhaps the only man enjoying the trip was Sam McGannigan, who was hitting it off just fine with Mrs. Kellar. She, for her part, was angry with her husband for tipping over the supply wagon in which she was riding. It had bruised her body as well as her fragile dignity, and she found solace in McGannigan's arms. McGannigan made no attempt to hide their affair from the men, only from Kellar himself, whom Jackson found astonishingly naive. Whenever Kellar was on horse-guard duty McGannigan found Mrs. Kellar. He even became so brazen as to offer to let her ride in his own supply wagon, which was more comfortable than Kellar's jerry-built vehicle. Jackson could not believe it when Kellar consented.

For the next few days they skirted one of the driest places on the planet. It had earned the disquieting title of Death Valley two decades earlier, after only one wagon out of a group of twenty-seven survived a trek across it.[5]

After traveling for nearly three weeks in the Mojave, the group passed through the Las Vegas Valley. The weather was even hotter now, so it was with elation that they reached the Rio Virgin, brimming with water from recent thunderstorms. But the desert gave no favors—the rambunctious river now careened from one canyon wall to the other, and the group had to ford it not once but twenty times. This was no easy task, since the horses resisted being driven into the gushing stream. Once, when one of the men galloped his pony into the water to try to make the others follow, the horse hit an unseen hole and the man was carried far downstream by the churning water before he could swim to shore.

Rivers continued to be a major problem as the horsemen made their way eastward. In Utah they encountered a particularly pesky stream called the Spanish Fork, near the town of Provo. Although McGannigan and Kellar reluctantly paid a fare to send the wagons over on a toll bridge, they were determined to save further expense by having the horses swim across:

> I think we labored two hours to get [the horses] into the water . . . & soon a big crowd congregated. It required all this help to crowd them into the stream. Had to, in the first place, catch about a dozen tame ones & push them in by main force. Such a time I never saw. The horses seemed determined not to go in & it was only [accomplished] by getting a sufficient number of men around to close every avenue of escape. (*D*, 178)

Although this task was difficult, a far more harrowing experience awaited them at Wyoming's Green River, at flood stage and stretching more than one hundred yards

from shore to shore. A cable ferry carried the wagons, but again McGannigan decided to swim the horses to save the fare. So the men got behind the herd and with whoops and hollers and the snap of whips, stampeded them into the water. The horses did not even make it to midstream before the swift current swirled them backward. After several more exasperating failures, Jackson volunteered to swim his own horse across the frigid river hoping that the rest of the herd would take courage and follow him.

> Stripping to one garment only and mounting old Bally bareback, I plunged into the river, while everybody on shore crowded the horses in right after me. . . . As soon as I struck deep water, my horse rolled over backwards, submerging me completely. He started to return as the others were doing and all I could do was to swim back among the floundering mass as best I could. Twice more I tried Bally with the same disheartening result; then I changed to old Whitey. My first attempt on him resulted as before, but on a second trial Whitey and I got entirely across. None of the band, however, followed our lead. (*D*, 191–92)

Finally McGannigan relented, paying the ferryman's fee, and eventually the herd reached the other side.

Jim Kellar and his outfit were not with McGannigan's group at the Green River, for McGannigan's affair with Mrs. Kellar had reached its climax a few days earlier. It happened on the night of June 26, when Kellar and Jackson were on herdwatch. McGannigan, seizing the opportunity to dally with Mrs. Kellar, had ordered Jackson to fire two pistol shots if Kellar was returning to camp. The night was calm and so Kellar grew bored and told Jackson to handle the watch alone. After he had gone, Jackson gave the warning shots, but purposely aimed his pistol at the ground to muffle the sound. After all, McGannigan was no friend of his and everyone expected a lively incident when the discovery was finally made.

That the two were sleeping together evidently caught Kellar by surprise. When he came upon them, all he could do was roar curses and threats. He immediately cut out his horses from the herd and continued on his own, but his anger smoldered.

Since the two outfits had to proceed on the same trail to Omaha, it was not surprising that they met the following day. Kellar, who had a reputation as a good shot, came rushing toward McGannigan, pistol in hand. McGannigan, long anticipating this moment, coolly reached for his own weapon. Jackson and the others watched expectantly. The two men eyed each other, each taking the measure of his adversary. But then Kellar evidently decided that the damage had been done already, so what could be gained from a shoot-out? "It was about the saddest end to weeks of suspense that anyone could imagine," Jackson recalled years later. "All the boys felt cheated."

After Jackson's group crossed the Green River, everyone believed that the hardest part of their trek was behind them, so they were not prepared for the next hardship that befell them. The same rains that had swollen the rivers gave rise to a monstrous horde of mosquitoes.

O my God!! What musquitoes [sic]. They swarmed by millions & tens of millions. They followed you in swarms & as soon as you ceased active hostilities they covered every portion of you. We tried smudges, but they didn't mind the smoke as much as we did. We rolled up in blankets, but the heat was suffocating and they would manage to get in some way, do the best we could. . . . My hands are all blotched & swollen, & face & neck ditto. . . . They swarmed in [my] mouth, eyes, nose, up pants legs, down shirt collar, in fact they were everywhere. (*D*, 186–88)

The men even cheered when a violent windstorm stung them with sand and dirt for it was heaven to have no mosquitoes. But the insects were soon back. They bothered the horses even more than they did the men. Jackson saw one of the animals so covered with mosquitoes that he could not tell what color it was. Sometimes the horses became almost insane to escape the insects and actually stampeded just to be rid of them. Fortunately the mosquitoes vanished when the group reached the dry plains.

As the wranglers approached the Nebraska border, they encountered what Jackson called "a regular avalanche of men" traveling to the Union Pacific work site. They were a seedy lot who all carried firearms, supposedly for protection against the Indians but more likely for use against one another. The transcontinental railroad was fast approaching completion, with the eastbound Central Pacific already cresting California's Sierra Nevada and the westbound Union Pacific laying tracks in the Rocky Mountain foothills. Clearly within a couple of years the two would link up in Utah.

With the rapidity of the white man's advance, it was no wonder that the Indians were bewildered. Some tribes that had been age-old enemies were beginning to consider the idea that perhaps they should be united against the whites, not pursuing ancient, and now irrelevant feuds. Others held fast to old ways. Still others allied themselves with the whites. Jackson noted that he "met frequent batches of Pawnees in the garb & service of U.S. . . . They are well mounted & of course excellent riders. Had a long talk with one, chiefly by signs. [He] told how many scalps he had taken from the Sioux & Cheyenne." (*D*, 200)

On July 30 Jackson and company reached Julesburg, which had a well-deserved reputation for violence. The shantytown served as the Union Pacific railhead at this time. Later the tracks would reach Cheyenne, Wyoming, and at that time nearly the entire town of Julesburg would be bundled up, put on flatcars, and reassembled in Cheyenne. But while it existed, Julesburg was a fiery Gomorrah with "more gambling, drunkenness & fighting going on than in any place I was ever in," was Jackson's terse summation.

At Julesburg, McGannigan engaged six boxcars to carry his horses to the market at Omaha. Getting them loaded was a major effort for the men, and Jackson and the others had to sleep in a car close by the horses to be sure they did not panic. In a day and a half they arrived in Omaha. The trip was over at last! Now to collect his wages.

PART III
Photographing the Frontier

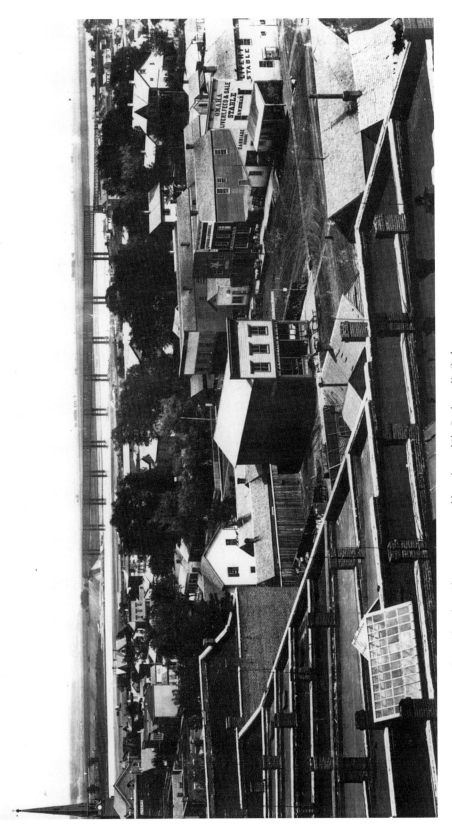

Omaha, Nebraska. This was presumably taken while Jackson lived there. —Courtesy Douglas County Historical Society

A New Beginning
Settling Down in Omaha (1867–1869)

When he arrived in Omaha in August 1867, Jackson eagerly presented himself before McGannigan to collect his wages. He had worked hard and performed his duties well and without complaint, so he was utterly shocked and enraged when McGannigan gave him a paltry twenty dollars for his three-month stint. He had little recourse, however, aside from calling in the sheriff, although a fellow horseman advised him to take what Jackson ominously called "extreme measures." Instead he accepted the twenty dollars, bought a new suit of clothes, then pampered himself with a shave, which took his last fifty cents. It was worth it, for as he noted in his everpresent diary, it "made me feel [like] a man once more."

Now he must get a job immediately. Inspired by his new suit and clean shave, he called on Omaha's two foremost photographers, E. L. Eaton and Edric Hamilton. Both were impressed by the crisp, confident young man with artistic abilities and experience in photographic shops. Jackson was so sure he would get a job with one of them that he and a better-heeled buddy from the horse drive hit the saloons that afternoon.

Two days later Hamilton not only hired Jackson at a fabulous twenty-five dollars a week but even gave him one week's advance for lodging. Jackson was exuberant. "I cannot begin to tell how good my new life begins to feel to me. I just laugh aloud to myself sometimes in pure enjoyment." Perhaps the best part, he recalled, "was not wearing the same clothes until they fell off me." (*D*, 205)

Jackson more than proved himself to Hamilton and by late fall had become such an expert that Hamilton, planning to return to his farm in Iowa, offered to sell the business to him. Hamilton's price was fair and he would accept a low down payment, so Jackson wrote home for financial help once more. His father said he would furnish the money if Jackson would take on his bumbling brother, Ed. Jackson agreed, and in early 1868 the firm of Jackson Brothers hung its shingle.

Jackson had crossed a bridge. In choosing not to return to Vermont he had at last admitted to himself that his affair with Caddie was over. His year on the trail had been rigorous and he made it through with virtually no money. He had truly proven himself. No longer a lost and callow youth, he was ready to create his own future in Omaha.

Omaha at this time was the most exciting town in all America, perhaps in the entire world. Only a decade and a half earlier the site had belonged to the tattered remnant of the Omaha tribe.[1] But now, as the Union Pacific Railroad began building westward, it had become an American boomtown. The city was the transshipment

point for the enormous amounts of equipment, materials, and supplies needed by the railroad builders. The most immediate requisite was timber, since the plains offered very little. Wood was needed for a multitude of items, including twenty-five hundred ties for each mile of track. As lumberjacks razed the woodlands along the Missouri River for two hundred miles, steamboats pushed the giant log rafts to Omaha, where noisy mills sawed them into the products needed. Other items, such as iron products from Pittsburgh, came by train into Omaha.

The dream of a transcontinental railroad had beguiled America for many years. Although by the time of the Civil War railroads were fairly common east of the Mississippi, the idea of flinging a pair of steel tracks across the treeless Great Plains, over the towering Rocky Mountains, and through the bleak deserts to California seemed both thrilling and wildly impractical. Yet the dream would not die, and midway through his term President Lincoln signed the act creating the Union Pacific Company. Because completion of the project would be difficult, Congress had been exceedingly liberal in its incentives to the Union Pacific as well as to the Central Pacific, which would build eastward from California. Among the incentives were cash loans of up to $48,000 per mile and land grants along the route that exceeded all the acreage of several New England states. As money poured into the Union Pacific's treasury, graft among railroad officials and suppliers flourished.

By the time the Jackson Brothers opened their studio the railroad was already almost across the Rockies, and Omaha's population, barely two thousand people in 1861, had soared to twelve thousand. America was moving west and Omaha was at the heart of it all. There was even talk of transferring the nation's capital from Washington to Omaha, placing it where many thought it should be: in the center of the continent.

Omaha's streets were usually jammed with men involved with the railroad and the people who catered to them. Among the smartly dressed bankers and railroad officials were sawmill hands, ironworkers, surveyors, and brawny laborers, including the masses of Irish and other European immigrants who laid the track. Muscular cargo handlers sweated in the freight yards and along the waterfront unloading crates of food and gear to supply the rail workers once they got beyond civilization.

To serve this raucous influx of men, flophouses, saloons, and brothels burgeoned, and Omaha developed a reputation for drunkenness and sin. An 1869 issue of *Harper's Magazine* ran this ditty:

> Where whiskey shops the livelong night
> Are vending out their poison juice;
> Where men are often pretty tight
> And women often pretty loose.[2]

During the four years Jackson was in Omaha, the city was in a confused state of becoming. The unpaved streets were mires of mud, manure, and garbage when it rained and worse still when the Missouri flooded. In dry weather swirling dust choked

every avenue. The railcar repair shops on the north side of town reverberated with the rat-a-tat of rivets, the thud of hammers, and the rasp of saws. Everybody and everything was in motion.

At the center of it all was the Union Pacific, headquartered in the Herndon House at Douglas and Ninth Streets. The building, at four stories, dominated Omaha. Jackson's shop was just a few blocks from the Herndon House, so he was easily able to observe the flurry of activity there. In a way, the construction of the Union Pacific was like a military campaign. There were Indians to battle, buffalo to clear out, and natural hazards to conquer. In this respect Omaha was a wartime cantonment, with the Union Pacific in command.

Jackson got to know the mushrooming town intimately. When he bought out E. L. Eaton, Omaha's only other major photographer, his was unquestionably the most prestigious photo gallery in Omaha. While brother Ed was the front man in the office and Ira Johnson, a boyhood friend, did the portraits, Jackson was photographing Omaha and its people. He roamed everywhere, from the downtown hotels to the rail yards to Fort Omaha, four miles north of town. Many times he paused to watch construction of the great eleven-span bridge across the Missouri from the rail terminus at Council Bluffs, Iowa. When the bridge was finished a few years later, a freight car could roll from Omaha to New York without stopping.

Photography had increased in popularity recently, helped by the excellent job Mathew Brady had done capturing the Civil War on film. Now it seemed as if everyone with cash wanted to be photographed.

> Omaha was a fine location for business [Jackson recalled]. . . . For the first year we stuck pretty closely to the usual work of studio photographers—straight portrait jobs, group pictures of lodges, church societies, and political clubs; and outdoor shots that gratified civic pride. There were many commissions to photograph shop fronts and, occasionally, interiors. Now and then, too, somebody would order pictures of his new house; or of his big barn, and along with it the livestock. We were kept busy. (*TE*, 172–73)

But Jackson saw photography as more than taking pretty pictures. He had an inner sense of history, of the restless flow of time, which he longed to explore on film. He had just crossed America from coast to coast, mostly on foot, and had witnessed the vast wilderness being tamed, the plains yielding to farmlands, the rivers increasingly harnessed by dams. He had seen the United States suddenly expand to the Pacific as huge territories were won in the war with Mexico and in negotiations with England. California and Oregon were already states, soon to be linked by rail to the rest of the nation.

Jackson had also witnessed the darker side of history. He had seen the white men's pollution as they dumped refuse into the streams, causing cholera epidemics among both Indians and whites. He had seen huge piles of buffalo hides being shipped East—each representing a carcass left rotting on the plains. He had seen once-proud native tribes reduced to begging.

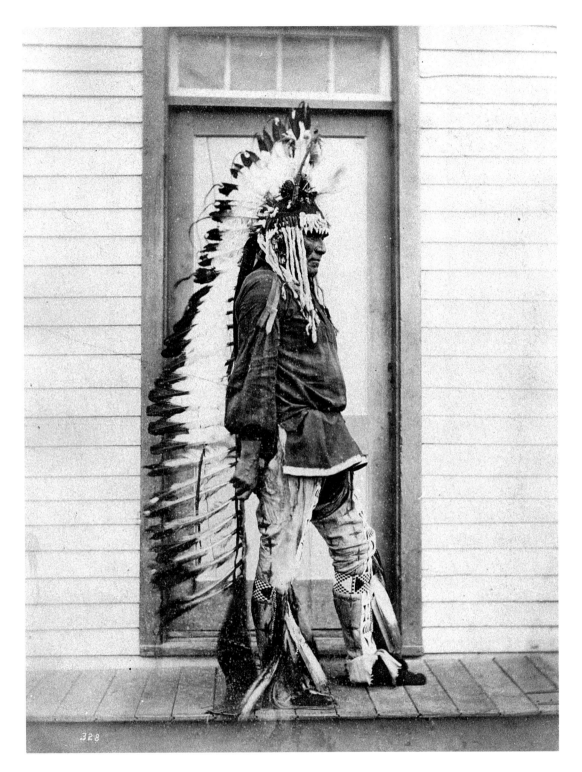

This Pawnee chief posed in full regalia beside Jackson's studio in Omaha. Many Pawnees were valuable army scouts. —Courtesy Amon Carter Museum of Western Art

From his earliest days Jackson had felt compelled to chronicle his changing world. His mother taught him to draw, and during the Civil War he had kept a pictorial record of camp life. He'd constantly sketched the scenes while bullwhacking across the West, realizing that soon they would change. He also wrote in his journal, even when he was gut tired, even when he was discouraged, for he had a near obsession with capturing the fleeting present. Clearly photography had great potential to satisfy that obsession.

Wandering the streets of Omaha were often Pawnees, gawking at the white strangers with their odd habits and wondrous stocks of manufactured goods. Jackson was able to persuade some of the Indians to come into his studio, where he took their pictures using a few rocks and tree branches as backdrops. When they did not want to pose inside, Jackson considered himself lucky to photograph them standing in front of his doorway.

Despite the pictures' artificiality, they told their stories. Many Pawnees wore army clothes, indicating their occupations as scouts. Some sported large metal disks around their necks, gifts from the U.S. government in recognition of their considerable services in helping hunt down the Sioux. The expressions on the Pawnees' faces revealed the range of emotions this uprooted tribe was experiencing. Sullen bewilderment played about their eyes. Their jaws were set with a kind of desperation, as if they were drowning in the white man's world and did not know how to save themselves.

It did not take Jackson long to see that studio pictures were incomplete portrayals. So in the summer of 1868 he decided to go directly into the Indian villages for pictures. This required considerable effort given the cumbersome nature of the collodion process. To take photos on location, he had to cart with him the bulky and fragile glass plates upon which the negatives formed; heavy containers with the sensitive colloids he used to coat the plates; a water tank, sink, and pan for developing the photographs; and of course, the large camera with its awkward tripod. He also needed darkroom tenting in which to prepare and develop his plates. Then, too, there were the essentials of everyday living such as food, water, and bedding. In order to meet these needs, he converted a wagon into a kind of mobile studio. It was a ridiculous-looking contraption, which, he admitted, "scared the daylights out of all the livestock." But it served its purpose. At first the Indians called his mysterious wagon "bad medicine," but soon they grew to accept it.

Jackson took some of his best shots in the villages of the Pawnee, a tribe quite different from most of the Plains Indians. They did not speak Siouan or Algonquin but a strange tongue that linked them with Aztec cultures far to the south. Because their economy was based more on cultivating corn than hunting buffalo, their villages were permanent settlements, not transient tepee hunting camps like those of the Sioux and other Plains tribes. Their homes were substantial lodges of earth heaped over wood frames. These dwellings were large, circular affairs so strong a family could sit on the roof.

Jackson got many shots of the Pawnee villages, and it was well that he did, for barely eight years later the entire tribe, despite their having earned many of those

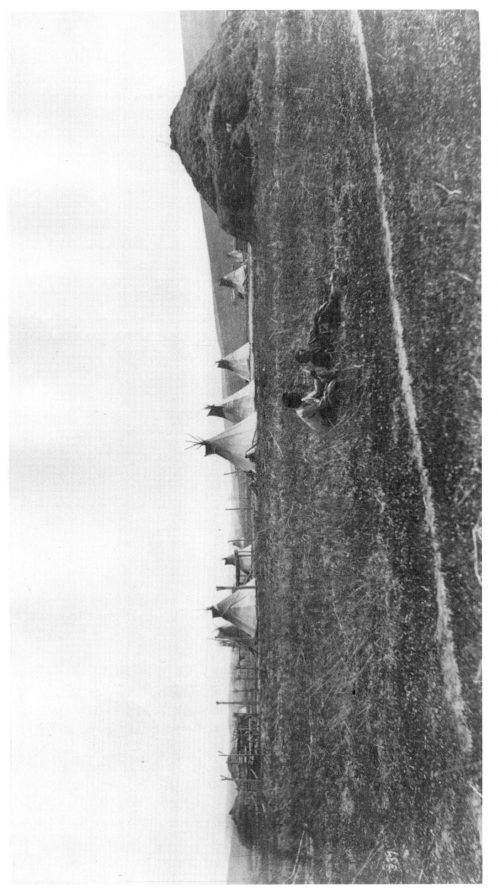

In 1868 Jackson started transporting his bulky photographic equipment into the Pawnee villages near Omaha. This photo shows their substantial earthen lodges, which gave shelter during the winter, as well as the tepees used during warmer weather and during hunting expeditions. —Courtesy Amon Carter Museum of Western Art

shiny presidential friendship medals, was shipped off to a wasteland in Oklahoma. Their lodges were destroyed and the land turned into American farms. Soon all evidence of Pawnee life vanished except what had been captured in Jackson's photos.[3]

Jackson also visited the Omaha tribe on a reservation sixty miles north of the town that bore their name. The Omaha were a small, Siouan group who originally dwelt in Virginia and the Carolinas. They were friendly toward the whites—although given the extent of the whites' presence and power, they had little choice—and Jackson wandered freely among them. His photos immortalized another tribe at the sunset of its existence.

But Jackson was not solely in the business of recording history. He realized he must earn a living so as not to end up destitute like fellow photographer Mathew Brady. Therefore he decided to take advantage of the new stereopticon craze. Stereoscopic pictures were taken by cameras with two lenses two and a half inches apart, the distance between human eyes. These cameras took two pictures of the same image, each from a slightly different angle. When the photos were mounted side by side on cardboard and inserted into a handheld stereopticon viewer, they gave a startlingly realistic illusion of three dimensions.

Jackson saw that the new railways of the Union Pacific offered opportunities for such photos. Taking these pictures would be a labor of love because to him the completion of

Many of Jackson's photos were taken with a double-lens camera. Here each shot shows Corinne, Utah, at a slightly different angle. When viewing them through a handheld stereopticon one saw a surprisingly convincing three-dimensional image. —Courtesy U.S. Geological Survey

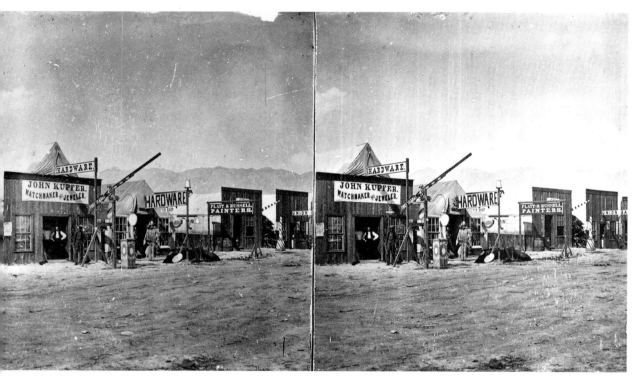

Jackson married Mary "Mollie" Greer in 1869. She made him forget his crushing love affair with Caddie Eastman. —Courtesy Colorado Historical Society

the Union Pacific was, as he wrote later, "something truly earth-shaking, and whether or not there had been a dime in it for me, sooner or later I would have been out on the grade with my cameras."

The spring of 1869 was the exact time to hurry to Promontory Point, Utah, where the formal joining of the Union Pacific and Central Pacific tracks—symbolized by driving in a golden spike—was to transpire on May 10. More than anything, Jackson wanted to be there. But two things prevented it. First, he had no ready funds. Second, and far more important, he had made a promise to Miss Mary Greer. Mollie, as she was called, was visiting friends in Omaha when Jackson met her. She was the first woman to drive Caddie from his mind, and he fell in love with her almost immediately. Before she had time to return to her family in Ohio, they were married. The wedding took place on May 10, at almost the same moment that the Golden Spike was being driven in Utah!

During the rail ceremony, the pompous railroad officials had actually missed with their swings at the Golden Spike. Nevertheless, the impatient telegraph operator tapped out an affirmative, indicating that the long-awaited rail connection had been successfully completed. The premature announcement set off parades and boisterous celebrations across the nation.

The Jacksons spent their honeymoon on a leisurely river cruise to St. Louis. "We had six days together," Jackson reminisced, "six idling days, on a boat that moved little faster than the current, a boat that tied up along the bank each night to avoid shifting sand bars. Six wonderful days on a slow boat! No, there is nothing like a Missouri River steamer." (*TE*, 175)

When they reached St. Louis, the couple had a sentimental parting as Mollie took the train to Ohio to stay with her parents for the summer and Will boarded an Omaha-bound train. Just before the wedding, he had received a commission from the Union Pacific to take promotional photos of the West, and he had to make immediate preparations to depart. Although the Union Pacific would not pay him until the company received the photos, and even then it would not be much, it didn't matter to Jackson. The lure of adventure was drawing him on once more.

Riding the Rails

The Union Pacific Commission (1869)

Accompanying Jackson on his Union Pacific assignment was Arundel Hull, an itinerant photographer whose main qualification was a strong enough back to help Jackson lug his glass plates, colloidal containers, cameras, tripods, and general paraphernalia. Although Jackson had lightened the load by devising a lined canvas tent to replace the burdensome wooden darkroom that he used at the Pawnee and Omaha villages, the men still had to transport so much equipment that they looked more like peddlers than photographers.

With insufficient funds to sustain themselves, they planned to be "tramp photographers" (to use Jackson's phrase), bumming their way along the Union Pacific line by selling pictures to workers, passengers, townsfolk, and whoever else was within shouting range. In late June 1869 they boarded a train at Omaha and were off. The route was over much of the territory Jackson had traversed as a bullwhacker just three years earlier. But what a difference in comfort! The train glided easily over creeks and gullies that had caused the oxen and men hours of tremendous effort. There was no stopping to cook rancid bacon over fires of buffalo manure. And that night, while Jackson relaxed in his seat, the soft clickety-clack replaced the wild wails of wolves and dreams of angry bulls. A trip that had taken five grueling weeks was over in twenty-four hours. He stepped off the train at Cheyenne, Wyoming, a town that did not yet exist when he tramped westward as a bullwhacker.

Cheyenne had been established as the next primary division point, or section headquarters, on the Union Pacific line as the construction continued west. This was evidenced by the impressive two-story station, which Jackson photographed. Cheyenne was a wild town, home to almost every prostitute, pimp, gambler, and outlaw west of Omaha. The railroad workers were welcomed by those unsavory citizens, and Cheyenne took from Julesburg the coveted title of "hell on wheels." It became so bad that the army eventually declared martial law and vigilantes in black headgear began meting out frontier justice.

The town was still largely untamed when Jackson and Hull arrived. It seemed to Jackson as if the whole place was nothing but saloons, gambling halls, and brothels. Usually the three enterprises were grouped together, showing the proprietors' concern for their customers' convenience. "Of all these," Jackson recalled, "positively screaming with elegance and refinement, the establishment of Madame Cleveland stood first."

Since it was Jackson's job to sell photos, and since the denizens of Madame Cleveland's establishment were more than a little solvent, Jackson and Hull began

there. The "girls" gathered around the operation, curious. But these ladies were hardened to slick talkers who tried to part them from the money they had worked so hard to obtain, so at first there were no takers.

> Undaunted . . . I called for a bottle of wine, and soon after they began to show considerable interest in having their picture taken. Had another bottle, and then they were hot and heavy for some large pictures to frame and began to count up how many they should want. (*TE*, 176–77)

It is difficult to imagine how the saucy lasses captioned the pictures they sent home, but they posed for a good many shots. When it was over, Jackson and Hull were probably the only men ever to emerge from Madame Cleveland's with more money than when they entered.

The pair spent a week in Cheyenne photographing buildings as well as prostitutes. When they departed, they had an impressive profit of sixty dollars. However, the kitty quickly took a hit when Jackson had to spend fifteen dollars for supplies. From Cheyenne the two men took the train headed west. On board they struck up a conversation with the "news booster," who told them he was sure everyone on his route would want to buy souvenir photos. When Jackson said they were going to shoot along

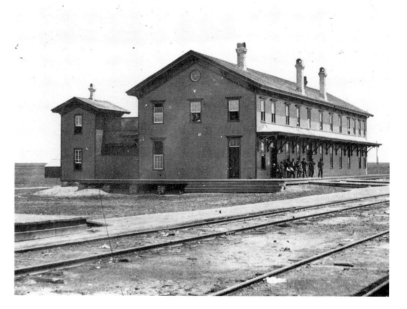

Cheyenne, Wyoming, was a major stop on the Union Pacific line, as this substantial two-story station demonstrates. Jackson took this and the other photos in this chapter while he was a self-described "tramp photographer" along the just-completed railroad in 1869. —Courtesy U.S. Geological Survey

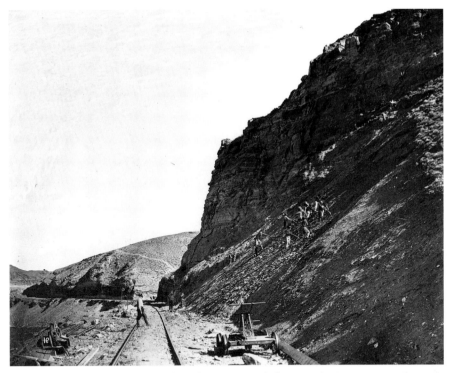

Workers try to control a rock slide along the Union Pacific line at Echo Canyon. In exchange for personal photos, the foremen would sometimes let Jackson and his companion use a handcar, like that in the picture, to explore scenic locations along the tracks. —Courtesy U.S. Geological Survey

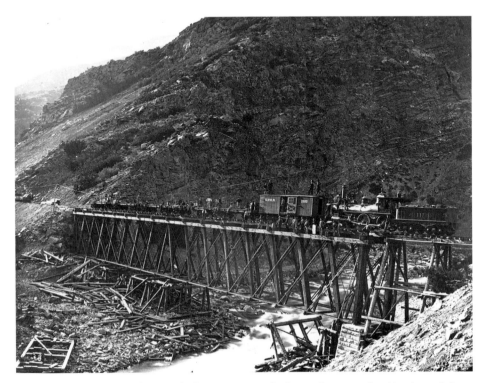

The engineer apparently stopped the train especially for Jackson to take this photo of the Devil's Gate Bridge over Utah's Weber River. The slow shutter speed of his early camera blurred the cascading water. —Courtesy U.S. Geological Survey

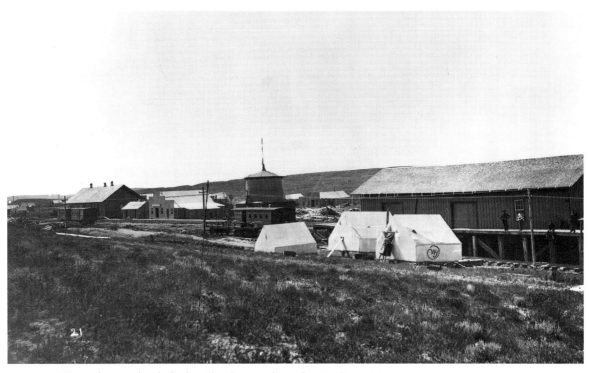

Wasatch was a lonely little railroad town almost lost in the prairie. —Courtesy U.S. Geological Survey

the Echo and Weber Canyons, the vendor placed an order for a thousand stereos. It was a nice piece of business, and in gratitude Jackson bought a package of the man's "portable lemonade," which was sugar with a few citrus shavings. It was not a bad drink when mixed with mountain water.

During the sultry days of July the train crews became used to the two men with the strange luggage. Because Jackson and Hull took photos of the workers for free in exchange for rides, the crews would stop the train wherever the two wanted and gladly picked them up again when they flagged the train down. Often the workers lent them handcars for more leisurely jaunts along the rails. Sometimes the trainmen even allowed them to sit right out in front of the engine on the cowcatcher.

Jackson got marvelous photos, like one that he took of a steep railroad cut beside Wyoming's Green River, where a work crew was moving the talus so rocks would not slide onto the rails. How well he remembered the effort he had spent trying to get McGannigan's horses across that swollen current! His shot of Wasatch, Utah, showed a bleak place on a treeless summit near Echo Canyon. He also got pictures of Devil's Gate Bridge, where two train crews and an entire work detail posed for him. Later he took a photograph of Pulpit Rock, beneath which, it was said, Brigham Young had once addressed his flock.

On the way to Promontory Point, Jackson paused to get a shot of a picturesque hamlet called Corinne. Promontory Point was deserted now, and his photo of the place showed nothing more than an empty stretch of rail, which he conceded "is in itself a dull subject." But just three months earlier it had been, for a few moments, the most famous place on the planet.

Jackson was enjoying his assignment, yet in many ways it was frustrating:

This was a period of great experimentation for me. The art of timing exposures was still so uncertain that you prayed every time the lens was uncapped, and no picture was a safe bet until the plate had been developed. Working in a fully equipped studio was hazardous enough. Going at it in the open meant labor, patience, and the moral stamina—or, perhaps, sheer phlegmatism—to keep on day after day, in spite of the overexposed and underdeveloped negatives, and without regard to the accidents to cameras and chemicals. (*TE*, 178)

It was all worthwhile, however, because when Jackson returned to Omaha on October 1 he proclaimed, justly, that he had "the finest assortment of negatives that had yet come out of the West."

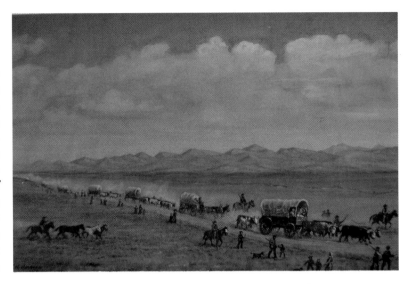

The paintings on these pages were done later in Jackson's life from sketches and from memory of scenes he witnessed as a twenty-three-year-old bullwhacker on the Oregon Trail in 1866. All are courtesy of Scotts Bluff National Monument. This painting shows a pioneer wagon train moving slowly past the dreary sandhills bordering the Platte Valley.

Indians, pioneers, and supply wagons like Jackson's forded the South Platte River at the same place. Colorful scenes such as this would soon vanish forever when the Union Pacific offered Americans a much faster route to the Pacific coast.

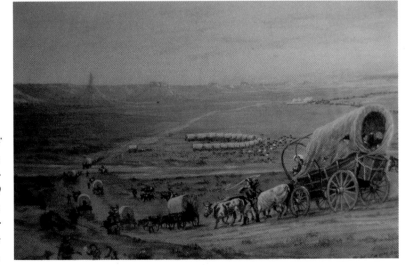

Chimney Rock was one of the most famous landmarks on the Oregon Trail. For wagon trains toiling forward only fifteen or twenty miles a day, the rocky pillar remained elusively on the horizon for a long time.

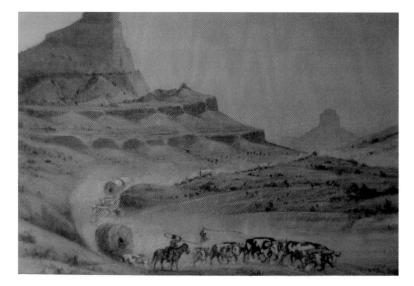

Jackson remembered Mitchell Pass through Scotts Bluff quite well because his wagon nearly overturned on top of him there. As an old man Jackson returned to drive a ceremonial stake at the site where he'd made camp.

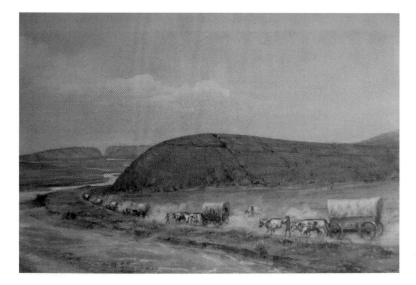

The Oregon Trail skirted Independence Rock. Most wagon trains paused here to let the pioneers inscribe their names on the rock. Many of the inscriptions can still be seen today. Jackson's train had a schedule to meet, so the wagon boss permitted no such frivolity. The distant, notched mountain is Devil's Gate.

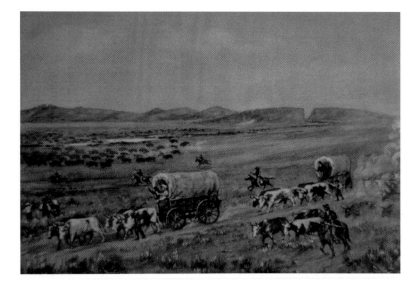

Beyond Devil's Gate the Oregon Trail began the smooth ascent to South Pass.

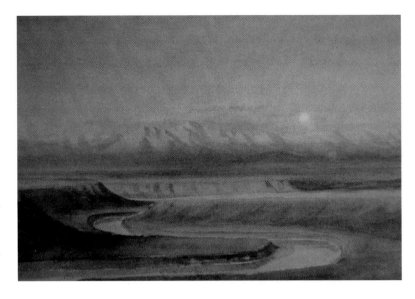

The lofty Wind River Mountains were snowy even in summer. Wagons circumvented the icy rampart via South Pass.

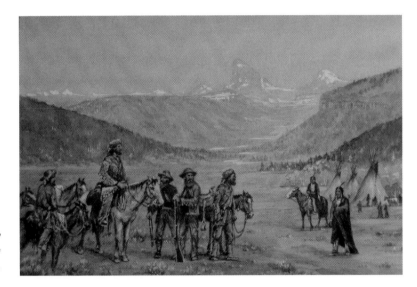

Most frontier travelers tried to maintain friendly relations with the Indians.

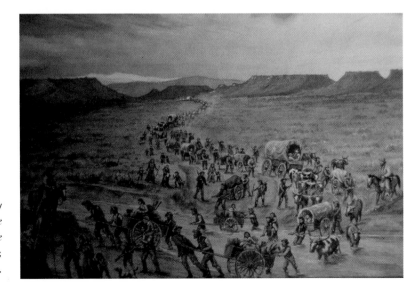

Jackson encountered many Mormons on the trail. Here emigrating Mormons are pictured near Fort Bridger, Wyoming.

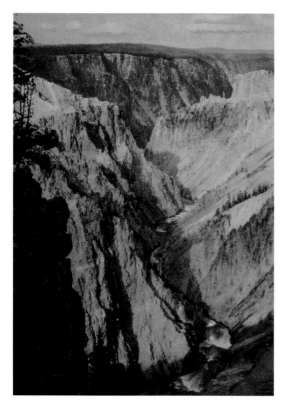

This is one of the Detroit Photographic Company's picture postcards, made from a photograph of the Grand Canyon of the Yellowstone most likely taken by Jackson, though this can't be verified because individual photographers were not credited. Photo technicians transformed the black-and-white shots into color for the postcards. This slide is courtesy of the Colorado Historical Society.

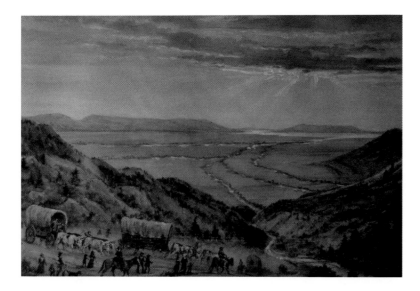

The trail could be cold, wet, and miserable, so the greenery of the Salt Lake valley was a welcome sight.

Opportunity Knocks
The First Scientific Survey with Dr. Hayden (1870)

When Jackson returned to his photographic shop, he quickly discovered that his brother Ed had been woefully incompetent in running the business. So it was a relief when Ed shuffled back east to work on his father-in-law's farm. Taking Ed's place as Will's assistant was Mollie, who had just returned from her stay with her family in Ohio. Mollie was a joy to be with—her smile was like sunshine and her laugh was pure music. The newlyweds had been apart nearly five months.

In the summer of 1870 Jackson had a surprise visitor who would completely change his life. Suddenly appearing in his shop was Dr. Ferdinand Hayden—one of the foremost geologists on the continent. Genteel and well-mannered, Hayden was the epitome of a cultured eastern professor, fitting perfectly his position at the University of Pennsylvania.

Yet Hayden was a complicated man. Many thought him haughty. But he was not so with his friends, nor with the photogenic ladies of Madame Cleveland's gaming house in Cheyenne, where Jackson had spotted him the previous year.

Hayden could have been an eminent surgeon, as he had a degree in medicine. But the newly developed science of geology had captured his imagination. While still in his mid-twenties he worked his way up the Missouri River as a steamboat deckhand, then jumped ship in the midst of Sioux country and hiked (he could not afford a mule) the long distance to the fossil-rich badlands. All he carried was a knapsack with food, a geologist's pick, and a bag for his precious rocks. The Indians did not interfere with him; they thought the man was crazy, always in a hurry to grab some dusty old rock, which he always seemed to find immensely interesting. They grinned and called him "He Who Picks Up Stones Running." Yet as early as 1854 Hayden found the first dinosaur teeth ever identified as native to North America.

In 1865 Hayden was back in Sioux country, intrigued by their legends about "ghost horses." He found they were based in fact—at the bottom of a Badland turret he unearthed the rib cage and legs of a strange horse. It was a type never documented before. The animal had been no larger than a sheepdog and had toes rather than hooves. Hayden's discovery became important evidence supporting Darwin's recently published theory of evolution.

Now here was this renowned scientist in Jackson's shop, looking intently at his photographs. Hayden was quiet for a while, then he nodded to himself and offered Jackson a proposition. He said Jackson was just the person he needed for the group

Ferdinand Hayden, head of the Geological Survey expeditions on which Jackson served as photographer from 1870 through 1878. The Indians thought Hayden was crazy and called him "He Who Picks Up Stones Running." —Courtesy U.S. Geological Survey

he was assembling to survey parts of Wyoming and adjacent territories. He was working under a government grant and the politicians wanted illustrations to go with his text. But, he quickly added, while the Congressmen were lavish in their plans, they were stingy with their pocketbooks—the entire 1870 expedition was allowed a pitiful budget of twenty-five thousand dollars. All Hayden could offer Jackson was to pay his expenses—no salary. Jackson would have to be content with the satisfaction of making a significant contribution to understanding the West. And, of course, with the adventure of exploring the largely uncharted wilderness.

Mollie came into the office at that moment. She saw her husband's eagerness but also the indecision on his face. They both knew that if he took the summer off, the burden of running the shop would fall almost solely on her shoulders. "Mollie looked at Dr. Hayden for a moment," Jackson recalled, "then at me. Then she laughed—and I knew that everything so far as she was concerned was arranged." (*TE,* 188)

One week later Jackson was in Cheyenne, and on August 7, 1870, the expedition moved out. In addition to Jackson there were nine scientists and two artists. There

Survey hunters such as these provided fresh meat on the expeditions. —Courtesy U.S. Geological Survey

was also a cook, a hunter, and eight teamsters to drive the quartet of heavy supply wagons and the pair of lighter vehicles called ambulances, which were to be used for side trips. Mules pulled the wagons while the men rode on horses. The horses were government-issued cavalry rejects, deemed adequate since the expedition was not for war but, according to bureaucratic reasoning, merely for science. Nevertheless, the ragtag steeds served their purpose.

One of the wagons transported the food and cooking gear, including a portable cast-iron stove. The others were reserved for the rock, plant, and animal specimens they would collect on the expedition. The lighter goods such as rubber rainwear, bedrolls, and tents were carried on muleback. Jackson's equipment, most of which was also strapped to a mule, took up a great deal of space and weighed around three hundred pounds. It included a pair of cameras (one with double lenses for stereo photos), a cumbersome dark box for developing, a full stock of chemicals, and enough glass for four hundred plates. So despite their skimpy budget, the group was well equipped.

The survey's route was over terrain that Jackson knew from his earlier trips. Only a few years before it had been Indian domain, but it was now earmarked for

The odometer showed how far the survey traveled each day by recording the revolutions of the wheels. —Courtesy U.S. Geological Survey

white settlement. Indeed, the survey's purpose was to discover exactly what resources the territory held: what meadows might be useful to the farmers, what prairies to ranchers, what mineral deposits to miners. While the still-marauding tribesmen might have regarded them as harmless rock pickers, Hayden and his crew were probably the most dangerous people the Indians had yet encountered, for the information they were gathering would help to guide the deluge that would follow.

The survey members rode along the Platte to Fort Laramie, site of the tense Indian council two years earlier. In the months following that conference, Red Cloud believed he had been victorious: the forts along the bloody Bozeman Trail had been closed and the Sioux had been granted an exclusive territory in the Dakotas larger than the state of Pennsylvania. But Red Cloud's victory was not what it seemed. The American commissioners felt they were giving away desert land nobody wanted. Besides, if it suddenly became desirable, the treaty could be scrapped. After all, they reasoned, it was made with Indians.

Nonetheless, Red Cloud and the Sioux thought the devastating wars were over. The chief was not above making state visits to Washington D.C., which is where he was when the survey pitched their tents near the fort. Fort Laramie would remain active until 1890.

The party explored the scenic natural bridge near Fort Laramie, long known to pioneers on the Oregon Trail. Jackson photographed its 150-foot span while members of the survey posed informally beside it. Several days later, Hayden's party camped near Fort Caspar at the picturesque Red Buttes. Here Jackson set up his camera so

Members of the 1870 Geological Survey examine the wonders of Wyoming's natural bridge not far from Fort Laramie. Every man had a gun for protection against the Sioux and Cheyenne. —Courtesy U.S. Geological Survey

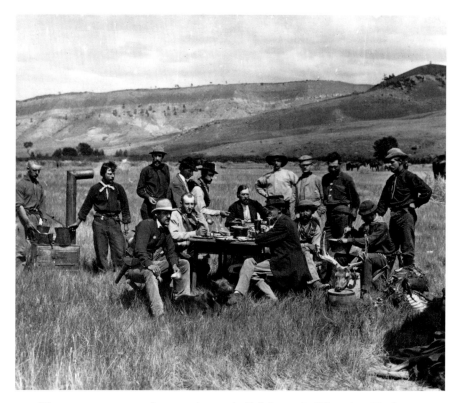

The survey team stops for a meal near the Red Buttes in Wyoming. Hayden is the hatless man seated at the far end of the bench. Behind him to his left is James Stevenson. Jackson stands with a hand on his hip at the right. The cook nicknamed Potato John is at the extreme left. —Courtesy U.S. Geological Survey

one of the survey members could take a photo of him and the others at dinner. The Red Buttes marked the place where the Oregon Trail left the Platte River and headed overland to the Sweetwater River, which led to South Pass. When the group reached the Sweetwater, Jackson took a picture of the famous Independence Rock, the Register of the Desert, where so many pioneers had once stopped to leave their autographs. Now an eerie silence surrounded the scene. Few wagons paused at the rock now that the Union Pacific rail was finished.

Although the route so far was familiar, Jackson saw it with new awareness. "I was constantly departing from the high road," he wrote. "For every mile on the map, we covered between two and three on the ground—up mountainside, down stream bed, across country—to gather rock specimens, to survey and map, and to paint and photograph." When they reached South Pass, Jackson, seeing it through the eyes of

the geologists, realized the pass was studded with agates. When he'd come through this way four years earlier, he had noticed only a lonely telegraph shack. Now he found a thriving mining town called South Pass City.

Every morning Hayden conducted informal conferences in which he outlined the goals for the day. He was a superb field marshal, making every person feel that his particular investigations were vital to the success of the survey. At these sessions Jackson and the two artists would generally be assigned to make images of the natural formations Hayden wished to illustrate. The scientists would be divided into groups of twos or threes and given other assignments. One group might be called on to map the course of a stream and calculate the flow of its water to determine if it could support a ranch. Another might sound the depth of a lake, determine what kind of fish were in it, and observe the type of plants growing on its margins. A third might scout out mineral deposits.

As the survey moved along, the wagons were loaded with fossils and unusual rocks—the total would ultimately fill sixty crates. Many contained shells and the

South Pass City was a lively mining town when the survey team reached it in 1870. Four years earlier Jackson, slogging by as a lowly ox-train driver, had found only a telegraph shack. —Courtesy U.S. Geological Survey

remains of crustaceans that could have lived only in a primordial sea. This, Jackson wrote, "may have been commonplace to the geologists; but to me it was novel and exciting." But Jackson was wrong. It was not commonplace to the geologists. The West, with its surface bare of topsoil and undisturbed by farmers' plows, was to reveal the first of what many scientists felt was one of the greatest treasuries of exposed rocks in the entire world. Exciting—yes! Jackson was far from alone in his feelings.

The survey followed the Oregon Trail as far as Fort Bridger, then turned into the Uinta Mountains. This was new country for Jackson and he made the most of the experience. With Hayden's enthusiastic approval, he and a fat mule, which he named Hypo, took long photographic excursions along the rocky slopes.

> Hypo was almost as indispensable to me as his namesake, hyposulphite of soda, was to dark-room chemistry. Carrying my cameras, tripod, dark box, chemicals, water keg, and a day's supply of plates, all loaded in big, brightly painted rawhide containers called parfleches, Hypo was good for as many miles as my horse was, and together we covered an enormous amount of ground off the road from the wagon party. (*TE*, 190)

Mules were essential in transporting Jackson's cumbersome photographic equipment over terrain too rough for the wagons. If the case on the mule's back held Jackson's heavy glass plates, the animal's reluctance to move is understandable. —Courtesy U.S. Geological Survey

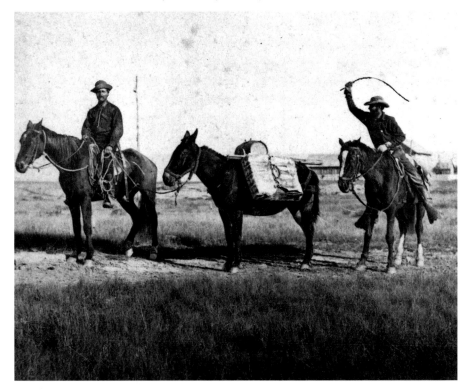

After two months, the survey retraced its route along the Oregon Trail to Fort Sanders, around which the town of Laramie was sprouting. Here they disbanded. At this time Hayden told Jackson how pleased he was with his photographs—Jackson's would be the first published pictures of the area. Then Hayden asked him to become a permanent member of the survey, which he expected would be going out each summer for several years. When he added that next time Jackson would actually receive a salary, Jackson was elated. "For me," he wrote, "the expedition was priceless—it gave me a career."

Although the survey was now officially over, Jackson felt that his career as a chronicler of the West could be furthered by heading south to take shots of Colorado's Front Range, particularly the spectacular Pikes Peak. Leaving Fort Sanders, he and Jim Stevenson, Hayden's second in command, made the trip in one of the survey's horse-drawn ambulances.

> That side trip was my introduction to the country below Denver, and, apart from valuable additions to my growing collection of negatives, it was important to me in that it was just about the last chance anyone had to see the "old" Colorado, for the Denver Pacific was just coming in. There was as yet no city at Colorado Springs, but by the following autumn, when I again happened to be there, men were at work plowing the lines for its streets. At Colorado City, just west of the springs, I was able to see the log cabin that had formerly served the territory as its capitol. (*TE,* 192)

When he finished taking the pictures, Jackson boarded the Kansas Pacific Railroad bound for home. He expected a fast trip across the Great Plains, but he had not counted on the buffalo, which were migrating south for the winter. First, a thousand of them stomped leisurely across the track, forcing the train to slow down. A little farther along, several thousand more blocked the rails. Then, around a bend, there were ten thousand of them, snorting and milling about. The train could not move until they had all sauntered past. More and more buffalo appeared—twenty thousand, then thirty, forty, fifty thousand.

> All that day [Jackson recalled], with the cars seldom moving faster than twenty miles an hour, often slowing down so that we could have walked alongside, occasionally stopping dead, we saw buffaloes. I cannot estimate the number we saw . . . that day, but I would guess not less than half a million. (*TE,* 192)

Jackson had never witnessed such a sight. The buffalo moved in an uncountable mass, grunting and bellowing, enveloped in clouds of dust and grass that had been churned into powder by their hooves. He could only gape in wonder:

> A great buffalo herd was an extraordinary thing to see. A mile-wide valley would be filled from side to side, and as far ahead as the eye could reach, with buffaloes so closely packed together that they looked like a moving carpet. . . . A herd crossing the Missouri could, and did, stop steamboat traffic for hours, and passengers on the early railroad trains were quite accustomed to waiting for the buffaloes to pass—and to shooting them from the car windows just for fun. (*TE,* 193)

Killing buffalo had been a patriotic act ever since Civil War hero General Phil Sheridan told the nation that the best way to get rid of the Indians was to destroy the animals upon which they depended for survival. It was a wonder what a repeating rifle could do to a herd. A single young hunter named William Cody had killed nearly five thousand of the shaggy critters in a single season to feed workers building the Kansas Pacific Railroad. Even as Jackson's train moved down the tracks of the Kansas Pacific two years later, Cody's exploits were catching the public fancy as an eastern fiction writer was running a series of greatly embellished accounts in the *New York Weekly*. The writer transformed the rather modest Bill Cody into the flamboyant Buffalo Bill.

Finally back in Omaha, Jackson found that his wife had run the shop as best she could. She was not a photographer, however, so Jackson had a lot of catching up to do. Throughout the winter and spring his schedule was crowded with portrait taking. Mollie and he accumulated a comfortable sum because, thanks to Hayden, his income was now being supplemented with one hundred and fifty dollars per month from his new position with the Geologic Survey.

It was well that Jackson was becoming established, because the following spring Mollie told him that she was expecting a child. They made exciting plans for the future: they would sell the business in Omaha — certainly there would be a nice profit — then Mollie would spend the summer with her parents in Ohio while Will went out on Hayden's next survey, due to leave in June 1871. When the survey was over, the Jacksons would move to Washington D.C., where Will's ongoing position with the survey and his growing fame as a western photographer would enable them to live what he called "a gold-braided life together."

The future never looked brighter.

Launching a Career

On the Hayden Survey in Yellowstone Country (1871)

As the time to join Hayden drew closer, the business did not sell. Mollie, good-natured as always, insisted that her husband continue with his plans while she handled the shop again. All she asked was that they make a trip together to Ogden, Hayden's point of departure, since she had never seen the Rockies.

Their journey on the Union Pacific was a dream. Mollie was as excited as a school-girl by the glittering peaks and the echoing chasms where streams ran like quicksilver. The trip was over too soon. She boarded the train and rode back to Omaha alone.

As Hayden's crew assembled at Ogden, it was like a reunion of old friends. Nearly everyone from last summer was there, even Jackson's special chum, Hypo the mule. The party had expanded to thirty-four with the addition of the sons of some important politicians. That year's goal was to survey the mysterious Yellowstone country, which had long been a near-mythical area. The first non-Indian to see it had been John Colter, one of Lewis and Clark's men, back in the winter of 1807–08. His tales of sulfurous scalding water and fountains of steam had received a lot of guffaws, and soon the place became known derisively as Colter's Hell.

Over the years other explorers stumbled on this hell, but the descriptions they reported were as ridiculous as Colter's, so very few people took them seriously. Even when Henry Washburn and Nathaniel Langford, both reputable men, explored the place just a year earlier and verified the incredible reports, the public remained skeptical. Although Langford had written about Yellowstone in *Scribner's Monthly*, the accompanying sketches had been so primitive that a professional artist had been hired to redo them. That artist, Thomas Moran, had never seen the region, so his renditions were immediately suspect.

Now Hayden, with his impeccable credentials, was being dispatched to Yellowstone to determine exactly what was of substance and what was whimsy. Yet, given the public's skepticism, even Dr. Hayden's sterling reputation might not have been enough, so Congress hired Jackson to photograph the alleged phenomena. Also tagging along as a latecomer was artist Moran, curious to see what the pictures he had painted actually should have looked like.

Tom Moran was a strange addition to this company of experienced explorers. Born in England and brought to America as a child with his parents, he had always enjoyed a flair for art and as a youth loved to sketch idealized Indians on the margins of his school papers. But he had never seen a live Indian, at least not of the formidable western variety. The artist was thin, almost emaciated, with flowing yellowish hair

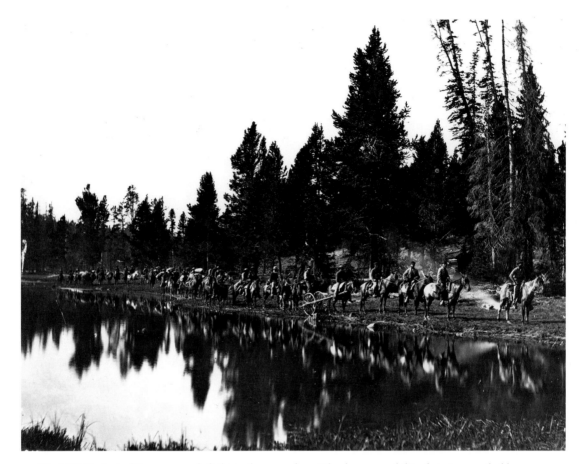

The 1871 Geological Survey team had thirty-four members. The sharpness of this photo is remarkable.
—Courtesy U.S. Geological Survey

and a disposition toward reading. His real love was painting quiet landscapes, particularly around the gentle hills near his home in Pennsylvania. The farthest west he had been was Lake Superior, and he yearned to see more.

Moran had not been put off when he learned the Hayden expedition was full, because he had a backup plan. He was an acquaintance of Jay Cooke, one of America's most powerful financiers. Cooke was involved with the planned Northern Pacific Railroad, whose route through Wyoming would make an ideal tourist line if the stories of Yellowstone's wonders were even half true. To find out, Cooke lent Moran part of the money he would need to join the expedition as an unpaid observer. The rest came from *Scribner's Monthly,* which expected a good article from Moran about his experience.

When the thirty-four-year-old artist joined the survey at Virginia City, Montana, everyone saw immediately that he was green. On the stagecoach up from Ogden he

wondered why the driver and guard were so heavily armed and was surprised to learn that the term *road agent* meant robber. Upon arriving in camp, Moran confessed that he had never ridden a horse. Once in the saddle, his rump hurt so much after the first day that he used a pillow for some time thereafter. He could not stomach greasy food such as the bacon they served in camp. He was, according to Jackson, "as poorly equipped for rough life as anyone I have ever known."

But Moran was determined to make a go of it. Soon he had his own rifle, although when he practiced shooting everyone ran for cover. And he gradually hardened to his

Artist Thomas Moran outfitted himself with a fancy broad-brim cowboy hat when he went to the Grand Canyon in 1873 with John Wesley Powell, seated at the far left. This is not a Jackson photo. —Courtesy U.S. Geological Survey

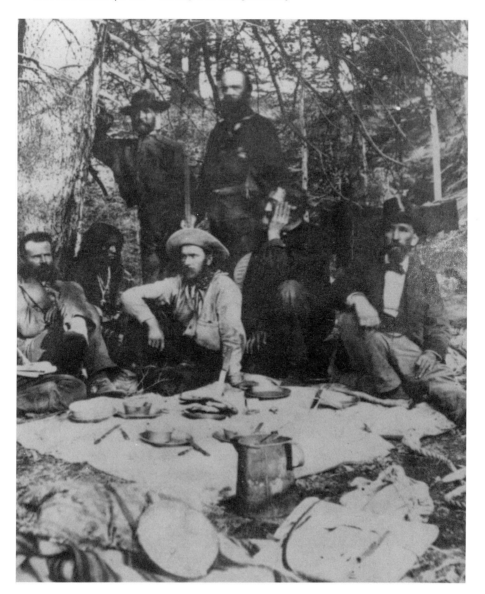

saddle until he could ride with the best of them. At last he even achieved the ultimate: he learned to swallow the horrible bacon.

Not surprisingly, Jackson hit it off with Moran. The two were similar in many ways. Both were self-taught artists. Both were introspective and loved music. Each valued nature for its beauty as well as for its use to man. And both were married to women named Mollie.

Jackson was happy finally to be in Virginia City. He wrote later, "No one could understand what I found to interest me in Virginia City, by that time nearly played out as a mining center; but, of course, no one knew how hard I had worked to go most of the way there five summers before." Virginia City's glory days indeed had faded quickly. Its gold was mostly played out now, and only a few tired-looking Chinese men, who stayed on after construction ended on the Central Pacific, were left, doggedly reworking discarded mining gravel. Jackson would have found no fortune had he made it here as planned.

The survey group spent three days in Virginia City, much of the time being consumed by repacking their essential gear from wagons onto the backs of unwilling mules. Jackson took great care to be sure that his own irreplaceable equipment was not injured. He had three cameras: a small stereo, a medium-size one, and one that took pictures on large, eight-by-ten-inch glass plates. These plates were about the thickness of window glass and extremely fragile. Jackson had refined his shutter-speed adjustments since the previous expedition. Instead of the usual five- to fifteen-second exposure, which he counted out and hoped was accurate, he now had attached to the shutter a rubber band that he could use to lower the exposure to one-tenth of a second—excellent for the period, but a far cry from modern cameras where two-hundredths of a second is a common exposure time.

When the survey members were ready to start, they were joined by a small detachment of U.S. Cavalry, since Indian unrest was still a threat in the region. Excitement ran high. Everyone had heard plenty of wild tales about Yellowstone's strange features from wandering trappers and mountain men, most of whom had never actually been there. "While they gave their imaginations free rein, Dr. Hayden, whose nerves were usually keyed to the limit, relaxed . . . and said nothing," Jackson observed. "He was satisfied to let the wonderland tell its own story—to himself as well as to the rest of us, for most of it had not yet been seen by the eyes of white men."

Working their way down from the north end of the Yellowstone area, they reached Mammoth Hot Springs, which the Langford expedition had not seen. It was awesome. Vapor steamed in the air while hot water cascaded over a series of simmering pools bounded by weirdly encrusted rocks. Jackson took the first photos ever of the springs, which were also some of the best pictures he would take in his career. In several of the photos a solitary figure contemplated the unearthly scene. This most certainly was Moran, who was not above the mundane job of assisting Jackson. Jackson needed the help, for picture taking was an ordeal:

I was particularly fortunate that first day [at Mammoth Hot Springs]. The subject matter close at hand was so rich and abundant that it was necessary to move my dark box only three or four times. My invariable practice was to keep it in the shade, then, after carefully focusing my camera, return to the box, sensitize a plate, hurry back to the camera while it was still moist, slip the plate into position, and make the exposure. Next step was to return to the dark box and immediately develop the plate. (*TE,* 198)

Under average conditions a negative could take up to three-quarters of an hour to complete. But at Mammoth Hot Springs Jackson reduced the time to about half an hour because he could wash the plates in the hot spring water, cutting the drying time.

Hayden was enthusiastic about Jackson's pictures and believed they would be essential in depicting the region to the congressmen, as well as to the general public. The photos would be instrumental in ensuring continued support for Hayden's project. In addition to the photos, articles in influential magazines would help the cause, so Hayden wrote descriptive pieces for the popular *Scribner's Monthly:*

> The steep sides [of Mammoth Hot Springs] . . . were ornamented with a series of semi-circular basins, with margins varying in height and so beautifully scalloped and

Yellowstone's Mammoth Hot Springs. Today's cameras can hardly improve on this photo. —Courtesy U.S. Geological Survey

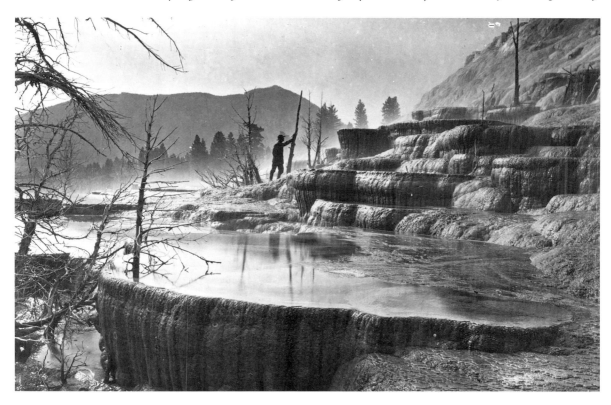

adorned with a sort of bead-work that the beholder stands amazed. Add to this a snow-white ground, with every variety of shade of scarlet, green, and yellow as brilliant as the brightest dyes.[1]

After exploring Mammoth Hot Springs, the survey party rode their horses to the top of Mount Washburn, named by the leader of the expedition that preceded them a year earlier. The hundred-mile view from the summit was dazzling. The ruffled basin of Yellowstone Lake lay immediately south, with its graceful bays and surrounding mountains. Beyond, almost lost in the blue distance, rose the majestic Teton Range, tipped with snow. To the north was the deep canyon of the Yellowstone River. The panorama, declared Hayden, was "one of the finest I have ever seen."

As the men made their way down Mount Washburn toward the Yellowstone River, their route was encumbered by pine groves so thick they could hardly force their way through. Soon they could hear the muffled sound of the river's great falls. As the men drew closer to the water, the rumble reminded many of a wartime cannonade. At last they broke out of the trees and came upon the wondrous chasm. Again Hayden was enchanted. He wrote, "Standing near the margin and looking down the canyon . . . the mind of the onlooker is seized with impressions of grandeur." The party pitched

Jackson's photo of Thomas Moran's inspiring, if overly dramatic, painting of the Grand Canyon of the Yellowstone, which is regarded as one of the artist's best. The line on the right of the photo was most likely caused by a crack in the glass plate. This was an ever-present problem during the early days of photography. —Courtesy Colorado Historical Society

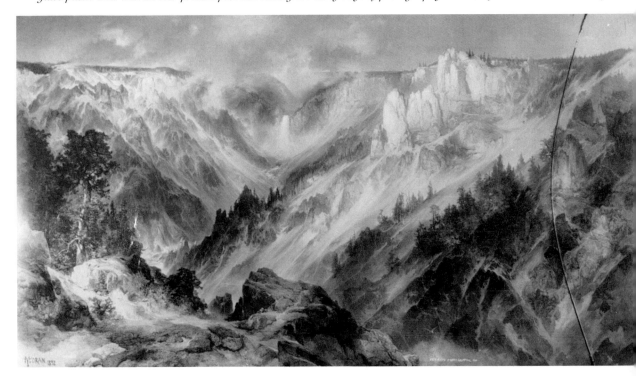

their tents at the place where Cascade Creek flowed into the river. When the main group moved on to Yellowstone Lake the next morning, Jackson and Moran remained four extra days, clambering up and down the sides of the canyon. Each stunning vista called for its own set of photos and sketches.

Moran's best work came at the location called Inspiration Point. He spent hours absorbing the brilliant panorama of rocks gleaming with hues of saffron, maroon, and ocher. The landscape changed minute by minute as the sun and shadows played over it. At one point Moran despaired of ever capturing the subtle tints on canvas. He contented himself with making sketches and memorizing the colors. Letting it all ferment in his mind, he created several months later in the comfort of his studio a tremendous seven-by-twelve-foot painting. Helped by Jackson's photos, he came close to capturing every gorgeous detail. The painting became his masterpiece—such that Congress purchased it for the princely sum of ten thousand dollars and hung it proudly in the Capitol itself.[2]

Jackson regarded the time spent with Moran at the Grand Canyon of the Yellowstone as "the climax of the expedition." Exploring nature's wonders and recording them graphically for the first time in human history was achievement enough for a lifetime. In the evenings, camping close to the thunderous river, the two men shared their feelings. Often they spoke of their Mollies, who waited for them at home. The deep friendship they formed would last the rest of their long lives.

After completing their work at the canyon, the pair moved down what became known as Hayden Valley and joined the rest of the party near Stevenson Island, where Hayden and the others were exploring Yellowstone Lake in a collapsible boat brought along for the purpose. Immense flocks of pelicans skimmed the water, and hundreds of birds darted through the trees along the shore. At one end of the lake the survey team visited mud pots and more hot springs, and Jackson enjoyed taking pictures from dawn to dusk. Then, heading north, they moved into the Upper Geyser area, pausing before many spouts that still bear the names that party gave them: the Castle, the Beehive, the Giant, and the Giantess. They especially enjoyed the geyser that Langford called Old Faithful, which Hayden found "most accommodating" for its regular eruption each hour or so.

The science of geology was in too early a stage for Hayden to venture any theory as to why the Yellowstone area was so thermally active. But no doubt he would not have been surprised to learn that Yellowstone lies atop an immense underground volcano, which generates enormous amounts of molten material from deep inside the earth. The immeasurably hot material seethes just below the surface, turning the rainwater that seeps down into steam. The steam in turn jets back to the surface in the form of geysers and hot water springs.

The hot springs were an unexpected pleasure, and when the men had time for relaxation, they frolicked like boys in the warm water, or, as the more reserved Hayden put it, they "enjoyed the luxury of bathing in these most elegantly carved natural bathing pools."[3]

The survey crew spent forty days at Yellowstone making the minute observations and taking the photographs that would present this fantastic region to the nation. Already Hayden was suggesting to Congress that Yellowstone be made into a national park, a whole new concept at the time.

When the Yellowstone survey of 1871 was completed that fall, Jackson returned to Omaha and the loving arms of Mollie. She had run the business in her own competent way despite the fatigue caused by her pregnancy. Jackson was quite pleased with the results of the summer's expedition. "Within the next few months," he wrote, "I was to begin to taste that little fame which comes to every man who succeeds in doing a thing before someone else."

As usual, Jackson was being too modest—he was to achieve more than just a little fame. At the age of twenty-eight he was well on his way to becoming America's premier photographer of the West.[4]

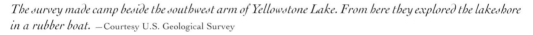

The survey made camp beside the southwest arm of Yellowstone Lake. From here they explored the lakeshore in a rubber boat. —Courtesy U.S. Geological Survey

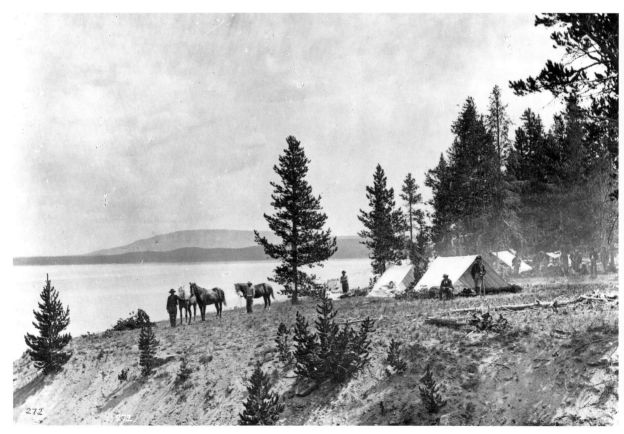

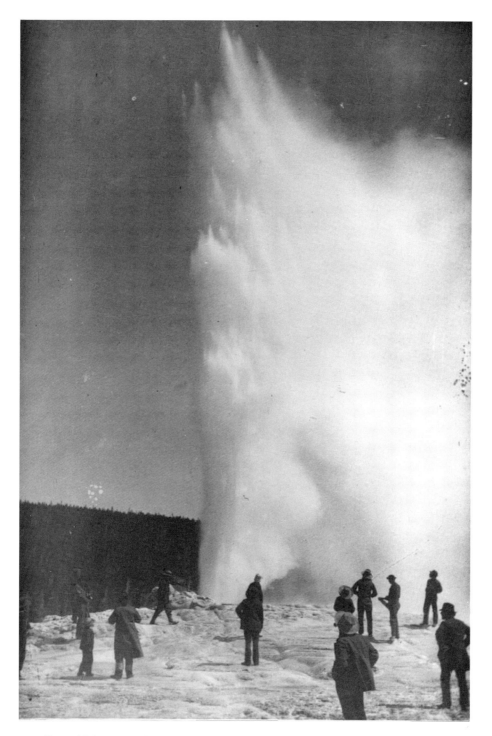

Old Faithful was one of the most spectacular of Yellowstone's many amazing phenomena.
—Courtesy U.S. Geological Survey

Tragedy and Triumph

Grieving; Working on the Yellowstone Bill; the Hayden Teton Expedition (1872)

A buyer for the photography shop finally materialized, and in the fall of 1871 Will and Mollie Jackson headed east to start a new life. Their plan was to stay with Will's parents at Nyack, New York, where they would await the birth of their child. Then they would go on to a permanent residence in the nation's capital. That way Jackson would be close to the survey headquarters and to Congress, where Hayden was doing constant lobbying to make Yellowstone into a national park as well as to secure larger appropriations for his western explorations.

Mollie was glad to rest in Nyack, as she had become very tired supervising the studio in Omaha. But the Jacksons had hardly gotten settled when Hayden wrote saying that he needed the photographer in Washington right away to help promote the Yellowstone bill, which was approaching a final vote in Congress. So Jackson left his wife in Nyack and hurried to Washington.

Jackson's parents adored Mollie and were overjoyed that she was remaining with them. No one expected a problem with the birth of her child, since Mollie was young and appeared healthy. But such was not the case. "She was not ever to join me again," Jackson mourned. "In February, when her baby was born, Mollie died. Our child, a daughter, survived but a short while." The birth apparently had been premature. Jackson was devastated, grieving that he wasn't at her side. Sorrow and guilt dogged him for the rest of his days, and as an old man he confided, "these are matters about which, even now, I can write no more." (*TE*, 205–6)

Working to promote the Yellowstone bill helped to distract Jackson's mind from the tragedy. There was a great deal of public opposition to withholding any area from the westward surge of land-hungry men and women, and many congressmen were undecided on how to vote. There were also powerful interests who wanted to build cheap hotels throughout the Yellowstone area. Others would buy individual geysers and hide them behind circus-style billboards, charging admission to see them. Congressmen were being swayed by promises of tantalizing contributions to their campaign funds. Furthermore, the federal treasury would benefit from the sale of Yellowstone acreage.

And what was a national park? There was no precedent for such a thing. Even if Congress did set aside some land for public use, why make it as large an area as Hayden proposed? Wouldn't a couple of geysers and a few mud pots do? After all, the place was so remote it wouldn't attract many visitors.

But Hayden, aided by Nat Langford and Bill Clagett, the newly elected congressional delegates from the Montana Territory, presented a good case for the park.

Yellowstone was utterly unique and must be preserved for the benefit of the nation. As Hayden saw it, future generations also had a claim on the area—some day the frontier of the 1800s would no longer exist. America would be populated from coast to coast, and parks like Yellowstone would be all that remained of the era when the country was wild and known to nature alone.

As the day for the vote approached, Hayden made a final push to convince wavering congressmen of Yellowstone's bounteous assets and appeal. They had seen Moran's paintings, but they needed more evidence to appreciate the area's wonders. For this Jackson's photos were vital. So Jackson went to work at the survey offices reproducing his best pictures: of steamy Mammoth Hot Springs, of spouting Old Faithful, of the magnificent Grand Canyon of the Yellowstone, and many others. Hayden wrote captions in his flowing prose, then bound them in a handsome folio and had a copy placed on the desk of every senator and representative.

The campaign was successful. The bill passed, and on March 1, 1872, President Ulysses Grant signed the landmark act. Henceforth Yellowstone belonged to the people.[1]

By July Jackson was back on the frontier with the survey, now composed of sixty-one men. Hayden divided the unwieldy group into two parties. The main body,

Jackson took one of his most successful photos while camped beneath the Teton Mountains in 1872. Clouds were difficult for his camera to catch. —Courtesy U.S. Geological Survey

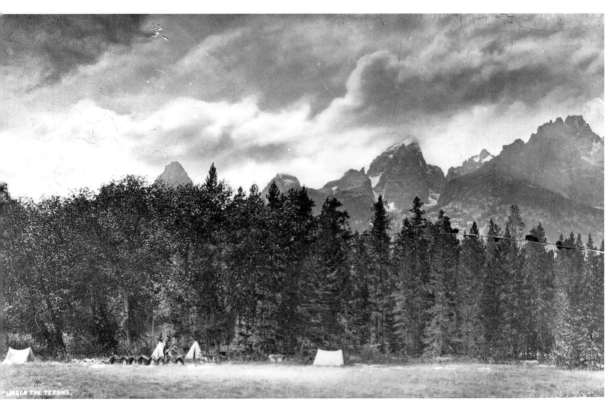

led by Hayden himself, would make its way to what was now Yellowstone National Park for further study. Jackson went with the smaller group, headed by his friend Jim Stevenson. They would go first to the Teton Mountains, then rejoin the main survey at Yellowstone, not many miles north. With them was Langford, who had the honor of being appointed Yellowstone's first superintendent.

The Teton Range was a spectacular formation whose jagged peaks had been a favorite landmark for the early French trappers. The trappers had named the sharp pinnacles the *tetons*, for women's breasts. On either side of the mountains were valleys called holes. Pierre's Hole was on the west, and on the east was the one named for David Jackson, a prominent early fur trader. Many years back, mountain men and Indians held annual fur-trading fairs in the Tetons. Later, whenever old mountaineers got together they would recall with great pleasure the whiskey-guzzlin', squaw-ticklin', horse-racin', bare-knuckled tradin' that went on during those debaucheries.

The survey hunters have strung up two moose in this camp three miles above the mouth of Teton Canyon. The honeycomb-shape marks on the right side of the photo resulted from bubbles in Jackson's liquid colloidal mixture. —Courtesy U.S. Geological Survey

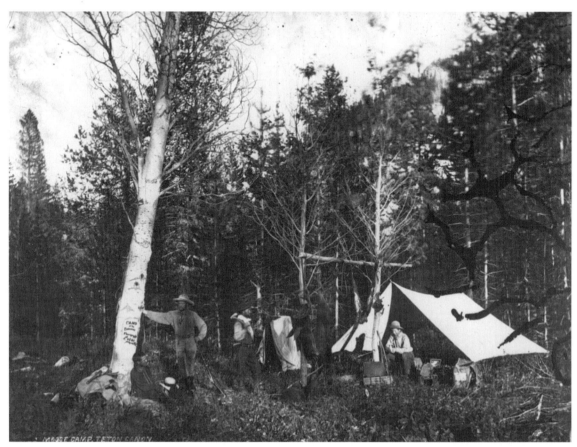

It was considerably quieter when the survey group pitched their tents in Pierre's Hole. The mountain men were gone now. Despite their brawn and bravado, they had been easily eliminated when fickle fashion changed men's hats from beaver to silk.

The Tetons presented a challenge to the outdoorsmen, and Stevenson, Langford, and twelve others soon set out to scale the tallest peak, the Grand Teton. It was a foolhardy idea, as they had no true mountaineering equipment, only alpine staffs. It is still a question of debate as to whether Langford and Stevenson were the first Americans to reach the top. Langford claimed that, although the other men had given out, he and Stevenson made it to the wind-blistered summit. According to his account

High in the Teton Mountains, Jackson, kneeling, prepares to coat a glass plate with chemicals. When he is ready his assistant, Charley Campbell, will surround him with the dark canvas to keep out light. —Courtesy U.S. Geological Survey

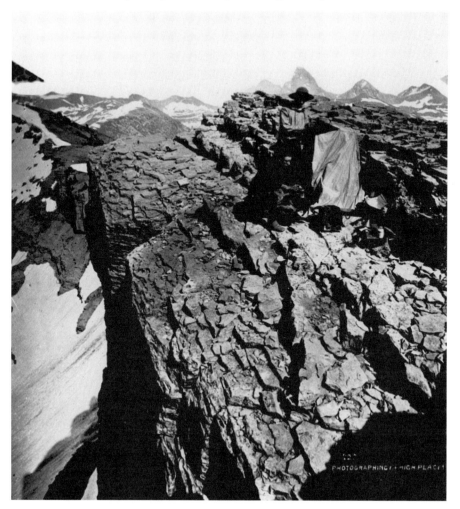

they found an Indian enclosure at the top, presumably used either as a lookout or for religious rites. Later explorers found such a structure not at the summit but five hundred feet lower down. Nonetheless Langford and Stevenson stuck to their story, and Jackson for one accepted it.

One day, while Stevenson, Langford, and most of the others were busy examining rocks, plants, and animals, Jackson and four assistants set out on some mountain climbing of their own. Although they were ascending the less precipitous side of the Tetons, the going was rough. The weather became increasingly frigid and soon they encountered snow.

> But we made it, and almost immediately we were rewarded with one of the most stupendous panoramas in all America. Thousands of feet below us lay the icy gorge of Glacier Creek, while on the eastern horizon the main range shimmered in the mid-morning sun. Above all this towered the sharp cone of the Grand Teton, nearly 14,000 feet above sea level. (*TE*, 207)

Jackson was thrilled. So, too, were his companions, one of whom was Charley Campbell, Mollie's eighteen-year-old cousin, whom Jackson took along as much for sentimental reasons as for any skills he might have had.

Large pictures were much in demand at this time, and because it was not yet possible to make enlargements from small negatives Jackson had to transport eleven-by-fourteen-inch glass plates. Not only were such plates bulky and heavy, but they had a far greater tendency to crack or break as a mule stumbled under the weight. On top of this, because the larger plates did not fit into Jackson's developing dark-box, he was also forced to carry an extra tent as a darkroom.

The darkroom tent was a strange contraption in itself. Although its exterior was a commonplace gray, the inside was a gaudy orange calico to cut out the ultraviolet light that would spoil the developing plates. Within the tent Jackson would coat a glass plate with chemicals, then put the glass in a dark satchel and carry it to his prefocused tripod camera. After inserting the glass in the camera and snapping the photo, he would put it back in the satchel and hurry to the tent to develop the picture. Taking one picture consumed most of an hour.

Jackson spent three weeks in the Teton country, photographing what are arguably America's most scenic mountains from many angles and reflecting their many moods. His were the first photographs ever of the Tetons. The expedition was an experience Jackson would remember fondly as he wrote his memoirs many years later:

> [It] began one of the busiest picture-making days of my whole career. It was one of those rare days when everything I wanted could be had with hardly a shift of the dark tent. Everything, that is, except water. While Charley and Aleck went off to fill their rubber water bags from a trickling snow bank, I crept under the small tent and started to coat a plate.
>
> When I pulled aside the flap a little later I looked up and saw upon a rock ledge not twenty feet beyond me a mountain sheep in a dignified contemplation of the

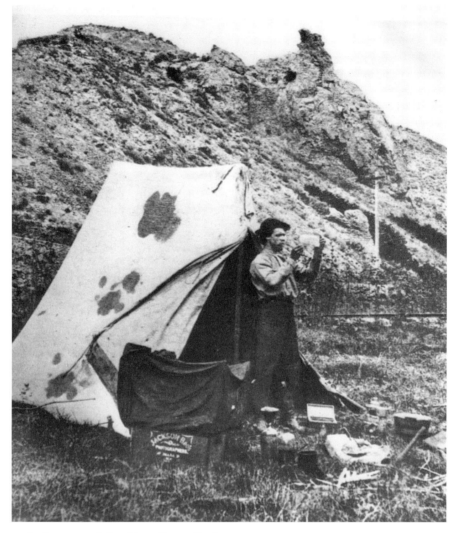

Jackson poses before his well-worn darkroom tent. —Courtesy Colorado Historical Society

strange scene before him—a bewhiskered man under an absurd covering of orange-hued canvas. With a high-speed miniature camera, I might have snapped him a dozen times. (*TE*, 207–8)

When his work was done, Jackson and the rest of Stevenson's Teton unit moved north to join the main survey at Yellowstone's Lower Firehole Basin. When they arrived, Jackson assembled the entire group together for a picture. Most of these men were valued companions and close friends. It was a photograph he would keep with him always and one which, as he stated in his autobiography, "I prize more highly with each passing year."

The survey team had tripled its original complement to sixty-one when Jackson took this photo in 1872. Every man was a friend, and as the years passed Jackson grew to treasure this photo. —Courtesy U.S. Geological Survey

Mount Moran in the Tetons. Ferdinand Hayden named it for the artist who had accompanied the survey the previous year. Later he changed his mind about the name, but it was too late. —Courtesy Colorado Historical Society

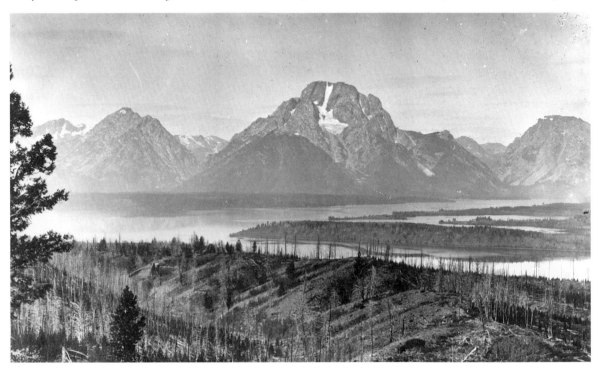

It was here that Stevenson proposed calling the largest of the Tetons Mount Hayden. It was an exciting moment, naming one of nature's wonders. Hayden accepted, then he proposed that the next highest peak be called Mount Moran, after the artist whose paintings had helped make Yellowstone a national park. Hayden had asked, almost begged, Thomas Moran to accompany the expedition this time, but the artist regretfully reported he had too many demands on his time.[2] So even though Moran had never seen the magnificent peak on the eastern face of the Tetons, the mountain was named in his honor.

Oddly, Hayden later wavered and wished to attach the name Moran to a lesser peak and call the original one Mount Leidy after a fellow geologist. It was too late, however, since a magazine article had featured Mount Moran and it would have looked too capricious to change it after that. In retrospect Hayden should have kept the mountain called Moran for himself, because his own name could not displace the appellation Grand Teton, a peak too glorious to be linked to a mere mortal.

Jackson passed the winter of 1872–73 in Washington D.C. Certainly memories of Mollie and thoughts of the life that could have been haunted him. But he kept busy

After his first wife, Mollie, died, Jackson became reacquainted with friend Emilie Painter, seen here on horseback at the Omaha Indian Reservation, where her father was the American agent. Jackson married Emilie in 1873. —Courtesy U.S. Geological Survey

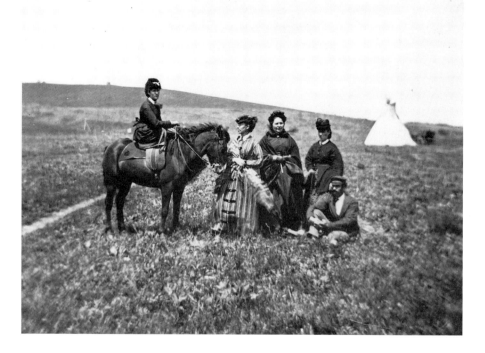

helping to produce the survey report as well as cataloging his pictures and providing friends in and out of Congress with what he called "endless" copies of his photos. He was also kept occupied answering the letters sent him by a certain Miss Emilie Painter.

He had met Emilie at a most unlikely location: on the Omaha Indian Reservation, where he had gone to take photos several years earlier. Emilie's father was the American agent in charge, and he and his wife entertained Jackson during his visit. Although Emilie had been there, no spark had flashed between them — he was married then. Nevertheless, Jackson and the Painters kept up a correspondence regarding his Indian pictures. When they learned that Mollie had died, they sent a letter that Jackson recalled "was far more than a perfunctory expression of sympathy."

The letter prompted Jackson to visit the Painters the next time he was in Omaha. After that, letters between Emilie and him began to flow. Sometime early in 1873 Jackson asked Emilie to marry him. He was not confident she would accept, given his tendency to be on the road. But "even knowing the worst — that I was a traveling man — she accepted my proposal and set the wedding for October." Strangely, the preparations were all made by mail and arranged so as not to interfere with Jackson's travel plans.

Hayden had wanted to return to Wyoming and Montana for the 1873 survey, but Indian hostility in the area prevented it. Most serious was the danger from the Sioux. The Treaty of Fort Laramie had guaranteed the Sioux a large province around the Black Hills of South Dakota, but they were sure that the advancing Northern Pacific Railroad would bring a new influx of irksome whites, and they were angry. Already, heavily armed prospectors were nosing around the Black Hills looking for the gold that was rumored to be there. With such trouble brewing, Congress assigned the expedition to the Colorado Rockies instead. As the terrain was far more difficult there than in the Tetons or Yellowstone, they started in May, much earlier than usual.

Touching the Heart of the West

The Hayden Colorado Expedition (1873)

When Jackson and the surveying team began their exploration of the central Rockies in the late spring of 1873, the mining frontier was in strident full swing. The surveyors gathered at a cottonwood grove along the banks of Clear Creek, just outside of Denver, then a rip-roaring town of one hundred thousand people, most of whom were incurable victims of gold fever.

Hayden again split the survey into separate divisions, and promoted Jackson to leader of one group of six men.[1] "I felt like a general in command of an army," he recalled proudly. Jackson's unit had its own itinerary, which included some of the most scenic areas in Colorado. Each of the other units also had a separate itinerary,

The expedition leaders plan the day's activities over breakfast. Ferdinand Hayden is seated on a log in the left foreground. Beside him is Jim Stevenson, his second in command and a close friend of Jackson. Directly across from Hayden is William Holmes, later head of the National Gallery, and on Holmes's right is William Whitney of Yale University. —Courtesy U.S. Geological Survey

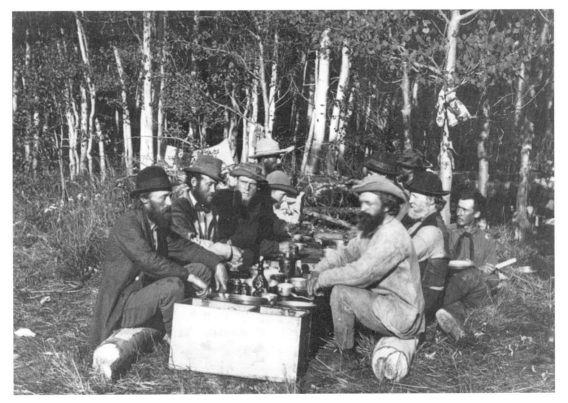

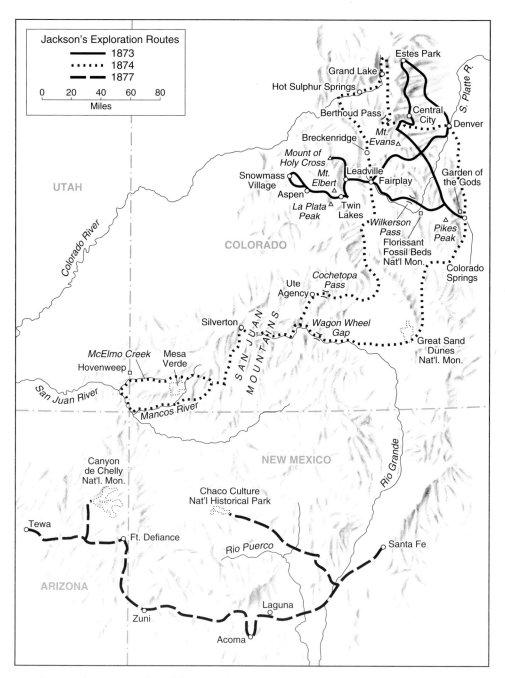

These are the routes Jackson followed on his 1873 and 1874 trips with Ferdinand Hayden and the Geological Survey, and on his solo trip through the southwest in 1877.

and all would rendezvous at the town of Fairplay in a month and a half to pick up supplies, compare findings, and decide what the next leg of the survey explorations would be.

Jackson was in charge of some good men. Fresh out of college was John Merle Coulter. Coulter's main interest was in flowers, and he was on his way to becoming one of the nation's leading botanists. Another upcoming young man was Lieutenant W. L. Carpenter, a naturalist on leave from the Army. After the survey was over, not only would he write three major papers about his findings, but the specimens he brought back would form seven valuable collections. There also was a lad named Cole, son of a senator from California, who specialized in birds. Rounding out the group were two rugged muleteers named Tom Cooper and Bill Whan, and the cook, Potato John.

Every group has its klutz, and apparently Potato John Raymond filled the role here. No one ever let him live down how he got his nickname—by making a bunch of hungry survey men wait for dinner while he attempted to boil potatoes at twelve thousand feet when as every westerner knows, water does not boil at that altitude. From that point on it was one mishap after another. But there was always humor when Potato John was around, so the men enjoyed having him as their cook.

Although the men rode horses, they also had six pack mules: four to carry grub, utensils, and tents, and two especially for Jackson's cameras, chemicals, and plates, and the gaudy orange tent he used for his darkroom. The lead mule had a bell so the others could follow in fog or darkness.

On May 24 Jackson and his team headed toward Longs Peak, their first destination, about fifty miles northwest of Denver. The peak had been named for Major Stephen Long, who explored Colorado and the western plains in 1820. His report characterizing the area as the Great American Desert created a psychological barrier to settlement for half a century.

That first day of the survey was beautiful and clear, and in the distance the mountains spiked into the blue. At first they traveled over sandstone, then over shale studded with shells. By May 29, when they reached Estes Park, near Longs Peak, they were amid the tough granite that formed the core of the Rockies. A cold wind blew that day, so forcefully that Jackson could not work.

Estes Park was not a park in the usual sense but a flatland in the midst of mountains. Joel Estes, who had settled there thirteen years earlier, had long since fled after a few settlers impinged on his solitude. Jackson encountered a log cabin there from which two women watched him pass. Noticing that "one was quite young and good looking," he somehow wrangled a dinner invitation and spent the evening in most agreeable conversation with the farmer, his wife, and the pretty lass. Late that night he returned to his drafty little tent and the same chill, fierce wind that had prevented him from taking pictures of Longs Peak during the day.

He did get some photos of the peak from Estes Park the next day, but he wanted closer views. So the group moved south along the edge of the peak until they came to

the Ward mining camp. From there Jackson and Whan headed up the mountain. This was not a pleasant experience, for they'd missed the miners' trail and entered an area of deep snow. It took them six hours to push three miles. They finally reached a small lake, where Jackson got his photo. But going back was just as difficult. By the time the pair returned to the Ward camp their feet were very wet and cold. Nonetheless, they tramped ten more miles south to the main camp, reaching it at dusk. They were by then "a couple of the most fatigued mortals that ever was," as Jackson put it.

Finished with Longs Peak, the expedition continued south along the Snowy Range. At one point they were surprised to see a little town that wasn't on any of their maps.

Loading a mule with mess boxes and bedding. It seems almost impossible that the animal's legs could have supported such a load, but this was routine. —Courtesy U.S. Geological Survey

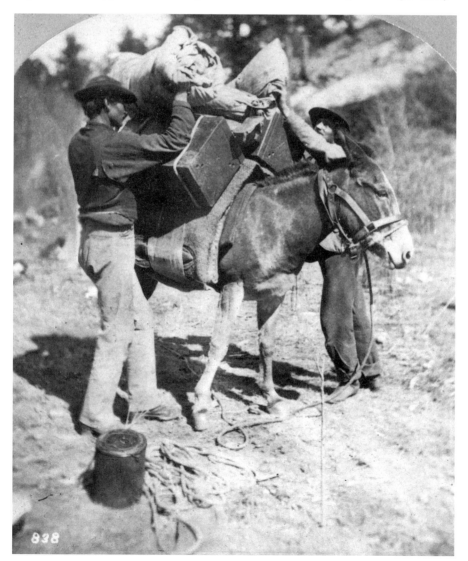

But there was no smoke rising from the chimneys. It was a true deserted village, another ghost town. Prospect holes, ore dumps, and the ruins of three stamp mills bespoke its origin—and its end. But though we searched for an hour we found no trace of evidence to tell us the dead town's name, or who had lived there, or when. (*D*, 219–20)

The next day they met some real live people at Castle Rock. They were on a pleasure outing. Jackson took their photos, which he traded for three bottles of claret wine—a transaction approved by everyone.

By June 9 Jackson and company were in Central City, deep in the mining belt. Mountains loomed all around them. The rocks were composed of granite and gneiss,

Exploring Colorado's Rocky Mountains in the late spring often involved dealing with deep snow. —Courtesy U.S. Geological Survey

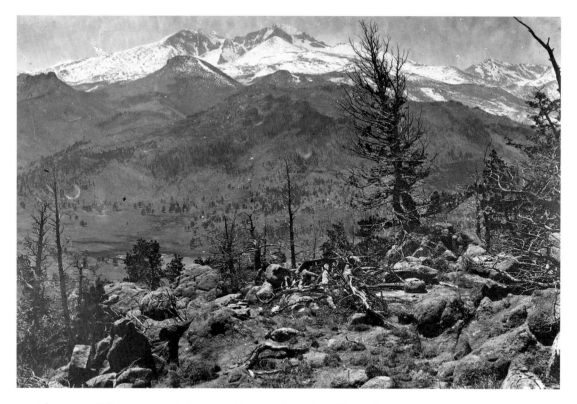

After a very difficult climb, Jackson got this marvelous shot of Longs Peak. —Courtesy U.S. Geological Survey

formed far underground long before life existed on earth. Gold had collected in the quartz veins in the granite fissures, and it was now exposed by erosion. One of these erosional cuts at Central City was named Gregory Gulch, after prospector John Gregory, who discovered one of Colorado's richest gold veins here in 1859. Thereupon miners and sharpies invaded the gulch, which soon became famous as the "richest square mile on earth." Central City's population shot up to ten thousand.

Not only gold but silver also abounded. When President Grant came to inspect the city that had such an astounding reputation, he walked over silver ingots laid in the street for the occasion. Jackson was there around the time of Grant's visit and found Central City boasting a spit-and-polish hotel, the Teller House, which cost more than one hundred thousand dollars to build. A few years later a splendid opera house would be built, and Sarah Bernhardt herself would perform in it.

Jackson had arrived in town in the midst of an icy rainstorm. He and his companions, wet and miserable, corralled their horses and mules at an abandoned graveyard. Soon enough, all was well again. Jackson had an enjoyable dinner with Jim Stevenson

and his wife, who had taken the narrow-gauge train up from Denver. Even more enjoyable were the letters Stevenson had picked up for the group at the Denver post office. Five were from Emilie.

Jackson and his men soon left the pleasures of Central City and on June 16 were in Georgetown. Founded only half a generation earlier, Georgetown had already gone through a typical Colorado boom-and-bust cycle and was now on its second boom. The town, called the Silver Queen, was the leading producer of that metal in the state. Although Georgetown was still accessible only by wagons, a few years hence a narrow-gauge railroad line would reach it, and the famed Georgetown Loop would be constructed. The Loop was a series of three full circles that allowed the line to ascend the steep grade to the nearby town of Silver Plume.

Georgetown, Colorado, as Jackson and his six-man contingent of the U.S. Geological Survey found it in 1873. —Courtesy U.S. Geological Survey

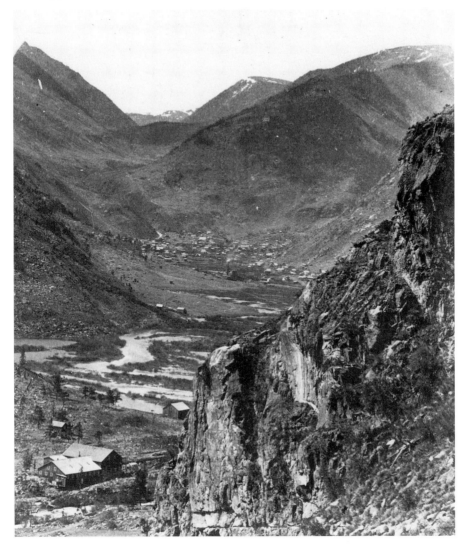

129

For some unaccountable reason the mules in Jackson's party were even happier than the men to reach Georgetown. They romped out of control down the streets and on the sidewalks. Some even poked their heads into the stores, to the startled amusement of the shoppers in this slapdash mountain metropolis.

Georgetown was surrounded by many spectacular peaks. The loftiest, Grays Peak, was named in honor of the eminent botanist Asa Gray. It so dominated the landscape that Jackson and young Cole felt impelled to climb it. At the blustery top they estimated by their barometer that it was 14,274 feet high. Nearby Torreys Peak looked even a little higher, so Jackson climbed that too. It was just for the boasting privilege, however, for later he found that it was actually ten feet lower than Grays. But what did that matter? He had enjoyed meeting the challenge. The expedition moved out of

Jackson and a companion toted heavy photographic equipment through snow and frigid winds to get this shot of Grays Peak. Afterward the pair climbed nearby Torreys Peak merely because they thought it was higher. It wasn't. —Courtesy U.S. Geological Survey

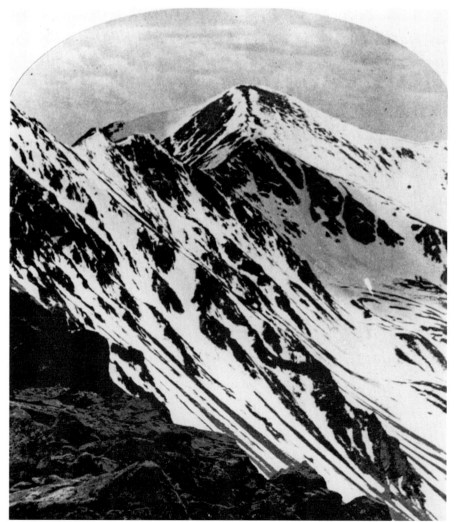

the granite mountains on June 23, pitching their tents amid sedimentary rocks on Bear Creek. They had no way of knowing that they were then atop debris from the age of the dinosaurs. Entire skeletons were buried almost at their feet in what would become world-famous as the Morrison Formation. Just three years hence some of the dinosaur bones would be unearthed by chance by a British clergyman.

The group trudged south over the flatlands beside the Front, or Rampart Range. By the first of July they were camped near Colorado Springs, with Pikes Peak looming in the west. Colorado Springs had suddenly become popular with the genteel set when the Denver & Rio Grande Railroad reached it two years earlier. But the town was not all that new — Rufus Cable and Colonel M. F. Beach laid it out during the Pikes Peak gold rush of 1859. Near Colorado Springs were the spectacular rock formations that Colonel Beach believed would provide the setting for a nice beer garden. Cable vehemently disagreed. He called it the Garden of the Gods, and the name took hold.

Jackson and his crew moved south along the Rockies' snow-covered Front Range, seen here from near Boulder. —Courtesy U.S. Geological Survey

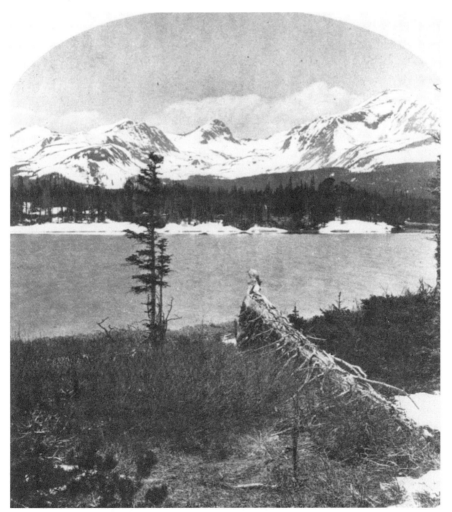

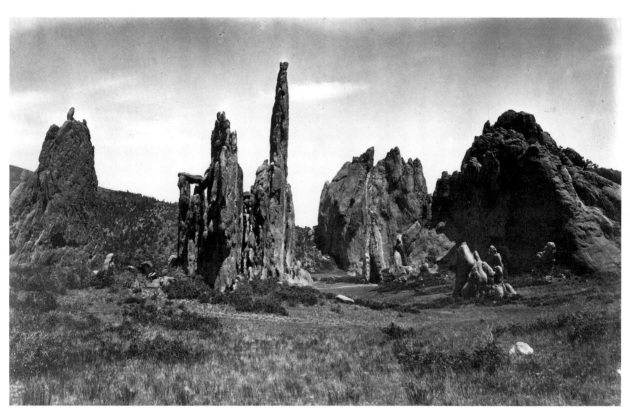

This may be the first photograph ever taken of the Garden of the Gods. —Courtesy U.S. Geological Survey

Pikes Peak hovers over the Colorado landscape. —Courtesy U.S. Geological Survey

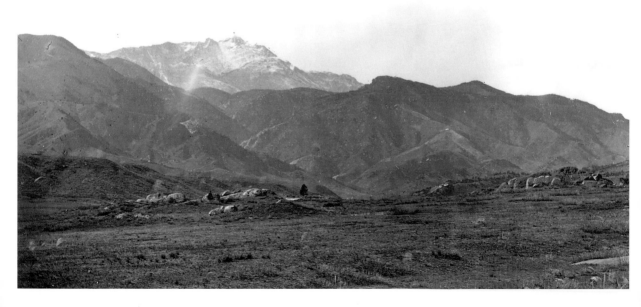

Jackson, along with John Coulter, spent the better part of two days photographing the Garden of the Gods. Huge sandstone slabs had been tilted upright as the mountains rose. Tinted various shades of red by iron oxide, the rocks had been eroded into cathedral-like spires, weird animal shapes, and many other fantastic formations.

On July 4 Jackson and his team were on the trail, skirting Pikes Peak, which had frustrated young Zeb Pike when he tried to surmount it back in 1806.[2] Now they were back in gold country, and twenty miles west, on the far side of the peak, was the future site of Cripple Creek. In a couple of decades the spot would become the richest gold camp in the United States.

Their route was a constant zigzag as they went on exploratory tangents. "My companions were as busy as I was," Jackson recalled. "Carpenter with his bugs, Cole with his birds, and Potato John, as always, with his bacon and biscuits."

Potato John had another duty besides providing greasy bacon and tough biscuits. He had the unenviable job of waking everyone early in the morning—and early meant 3:30 A.M. Naturally John had to rise even earlier because the men expected breakfast almost immediately. One day he roused them with his usual enticing announcement of breakfast: "Grub pile! Grub pile!" "We all leaped up at the first sound

Each morning the men cleaned up in an icy mountain stream. It was a quick eye-opener. —Courtesy U.S. Geological Survey

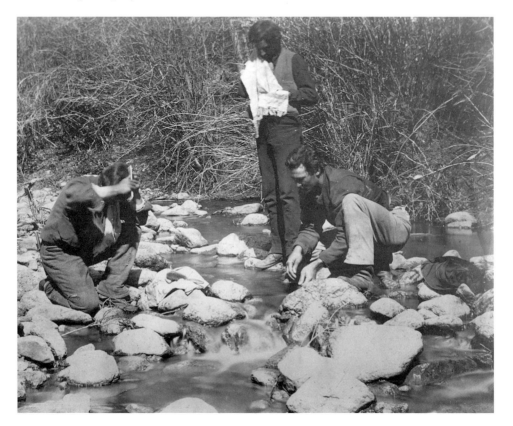

133

of his voice," Jackson wrote. "It was not until after breakfast that we realized why it had been so easy: none of us had yet sunk into a deep sleep. In his zeal John had called us at 1:00 A.M., with the result that we had to loaf around for nearly three hours until dawn gave us enough light for traveling!"

The surveyors had been following an ancient path the Ute Indians used when they made their periodic forays down from the mountains to hunt buffalo, in spite of the harassment they had to endure from the Cheyenne and other plains tribes. The trail eased Jackson and his men down toward the valley of the South Platte River. Soon they were passing just north of what are now called the Florissant Fossil Beds. Here, 35 million years earlier, lava flows had blocked a stream to form a shallow lake. Surrounding volcanoes subsequently erupted ash that trapped many insects and fish. The lake eventually dried up, but the impressions of ancient life remained: delicate traces of wings and fins preserved forever in stone.

Jackson's group unknowingly bypassed the amazing fossil beds, and it was left to another of Hayden's expeditions to make the discovery one year later. There was no stigma attached to this oversight, however, since no one in Jackson's party was a trained geologist.

On July 6 they crested Wilkerson Pass and from there had what Jackson called "a glorious view" of South Park, perhaps the most scenic of Colorado's four intermountain parks. To the west lay the Mosquito Mountains and beyond them the sawtooth outline of the mighty Sawatch Range. On the southern border of South Park was the Thirtynine Mile volcanic field, possibly the source of the ash that filled the lake at Florissant.

The journey across South Park was over almost perfectly level land. It had once been the bottom of a series of salty lakes, and some of the salt remained as white deposits. There were sulfur springs along the trail where an enterprising family had put up bathhouses. Jackson and his crew had no time to enjoy the baths, but they did stop for pie, which Jackson found tasted like shoe leather. He was sick later that afternoon, most likely from the food.

Traveling along the South Platte River, the party reached the town of Fairplay by eight o'clock the next morning. This was the rendezvous point for Hayden's and the other divisions. That afternoon two more groups came in and within a few days most of the others were there. Hayden sent word that he would be delayed, so the men had some free time to swap tales of their adventures on the expedition thus far.

Many of the adventures were almost incredible. Some of the men had been threatened by forest fires that roared around them. Others had almost died from lack of water in the dry southwestern portion of Colorado. Still others had become lost in an uncharted labyrinth of canyons. But perhaps the most bizarre incident of all was when one group was caught on the peak of a fourteen-thousand-foot mountain during an intense electrical storm. As the clouds swirled about them, the air became heavily charged and from the stones nearby they heard continuous popping sounds.

Their hair stood on end and began to emit a sound like frying bacon. Then there was a strange smell and a humming that in itself was frightening. Grabbing their metal instruments, they ran, slid, and crawled down the peak in near panic. At that moment, with a tremendous crash, a bolt of lightning blasted the place from which they had just fled! Jackson's group had nothing so exciting to report.

The men also took the opportunity to explore the town until Hayden arrived. Fairplay was a rollicking mining town that Jackson found nearly as lively as Cheyenne. There were other mining towns around, too—like Alma, founded just the year before. Alma's raucous dance hall was famous throughout this part of the gold belt.

After a bit of recreation, Jackson began to feel that even in Hayden's absence he should get back to business. So on his own initiative he made photographic jaunts into the surrounding mountains. Several times he ascended Hoosier Pass, more than 11,500 feet high, where he snapped pictures of the lofty peaks around Breckenridge, which would eventually become one of Colorado's oldest continuously occupied mining towns. One day he climbed Mount Lincoln and took some of his best photos of the Montezuma Silver Mine at the summit.

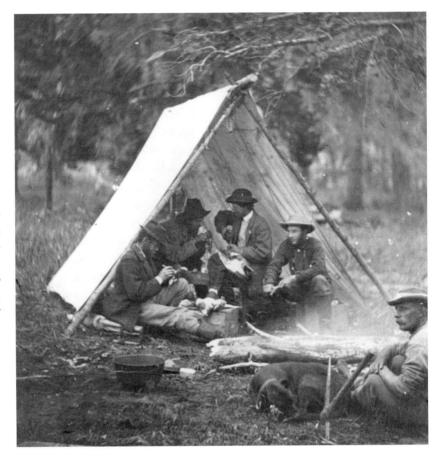

In the evening the men would gather in groups to discuss the day's events. Potato John sits in the foreground as his cooking fire turns to embers. —Courtesy U.S. Geological Survey

Meanwhile letters from Emilie kept coming. They were certainly welcome here in this wilderness inhabited by mainly rough miners and dance-hall girls. Emilie reminded him that there was a genteel civilization east of the rugged mountains that surrounded him.

When Hayden arrived around July 13, any larking that the earlier arrivals had enjoyed was over. Hayden had a well-deserved reputation for working his men harder than his mules. Immediately Hayden sent Jackson and some of the others up Buckskin Canyon, just west of Alma, site of Buckskin Joe's early mining camp. With them was A. C. Peale, who would discover the Florissant Fossil Beds the following year. The canyon was heavily timbered and tough going. Although it rained for a while that evening, they built a huge campfire when they reached the mining camp and had a good time.

A few days later the survey left the vicinity of Fairplay to push even deeper into the mountains. Jackson had with him a mule that became his favorite:

> Dolly was a white mule with cold eyes and a haughty manner. I selected her as a temporary mount in Fairplay after my horse became badly injured, but soon I found her the most docile as well as the most sturdy and surefooted of beasts. For the next five years, as long as I was with the Survey, Dolly was mine, and I rode her in preference to any horse. (*TE*, 214)

Jackson caught an impressive interplay of light and shadow in this shot of Upper Twin Lake. The men spent several days here enjoying both the scenery and the fishing as they mapped the area and examined its natural resources. —Courtesy U.S. Geological Survey

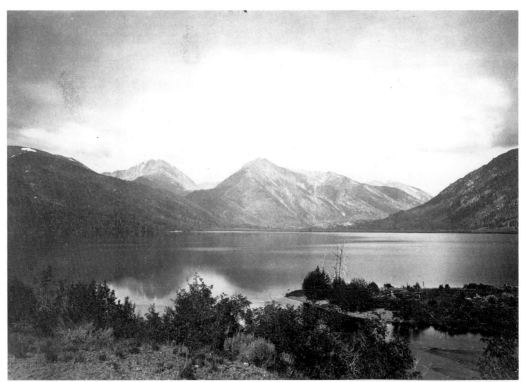

On July 20 the party camped beside Twin Lakes, oddly situated between a sage-brush desert on one side and the breathtaking grandeur of Mount Elbert, Colorado's loftiest peak, on the other. Although the place was about as remote as it was possible to be, there was a settler here. He quickly made his presence known by demanding a twenty-five-cents-a-head pasture fee for the horses and mules. The men refused to pay the fee but did rent his boat for two dollars. They more than recouped the cost with a large haul of fish, which they promptly finished off in their skillets.

The survey team remained on the lake for several days, enjoying the fishing as well as the magnificent scenery, while each man examined the terrain according to his specialty. John Coulter particularly found the area to his liking since wildflowers grew there in profusion. In some places dozens of unusual species thrived within several feet of one another. Jackson picked a few and included them in a letter he sent to Emilie.

During their various explorations the surveyors passed through the little mining town of Oro City. When, a decade earlier, gold was discovered in California Gulch, Oro City suddenly found itself housing five thousand rowdy miners. But as soon as the surface metal petered out, most of the miners drifted off. By the time Jackson passed through, about all that remained were rotting cabins, abandoned sluice boxes, and a decrepit general store run by Horace Tabor.

Miners hopefully working a sluice. —Courtesy U.S. Geological Survey

However, the cycle was not over. Within a few years Tabor would find that the heavy sand that made it almost impossible to mine the gold was itself a rich source of silver. A new town, called Leadville, would replace Oro City and fill with thirty thousand miners. Soon Tabor would be extremely wealthy.

In a few years, Jackson would witness for himself the little town's transformation. For the moment, however, Jackson's main concern was the trouble he was having with his photographic equipment. First he ran out of large glass plates. Extra glass would take several days to come all the way from Denver. Then, while he was coming down from a mountain called La Plata, he took a nasty fall and broke his large developing dish. His worst moment came a week later when an obstreperous pack mule named Gimlet lost his footing and rolled down a hill. With him went many of Jackson's most treasured negatives, the glass cracked or broken beyond repair.

Hayden had seen Gimlet's fall and his famous temper was flaring as he approached Jackson. But he quickly cooled when he saw the acute dismay on the photographer's face. "I think I have never been so distressed in my life," Jackson recalled, "my finest negatives lost before anyone had even seen a print. Nothing could be done to repair the damage, nothing."

The season was moving on and Hayden's impatience was beginning to show. There was so much he still wanted to accomplish, but in a few weeks snow would begin closing the passes and halt the expedition. "Hurry, hurry," he kept growling at everyone. "You're losing golden opportunities!"

From Oro City the group headed west down a long valley, deserted now, but often used by the Ute Indians for summer grazing. The Utes had signed a peace treaty in 1859, when the gold rush had just begun, and they held to it despite the encroachments of miners. But the Indians were growing resentful, as Jackson would find when he visited their camps during the next year's survey. By the 1880s the valley would resound with miners' hammers as they erected Aspen, destined to become one of Colorado's largest silver towns.

The file of survey horsemen moved rapidly down the valley to the foot of Snowmass Mountain, where the men pitched their tents. In the morning Jackson, along with most of the company, ascended Snowmass. He found a beautiful lake at the top and snapped some fine views of mountains reflected in it. Yet beautiful as the mountain was, it would remain largely isolated until skiers discovered its appealing slopes a hundred years later.

So far, despite Hayden's trepidations, the survey had been a wonderful success. The teams had penetrated almost every significant pass and secluded valley. The men had a field day naming the peaks. They gave the Rockies' tallest peak the name of Colorado's territorial governor, Sam Elbert. Then, for good measure, they attached the name of John Evans, an earlier territorial governor, to a mountain near Denver even though Evanston, Illinois, had already been named after him.

Many assigned their own names or the names of their wives to the mountains: Mount Wilson, Mount Rosa, and of course, Hayden Peak. One survey man had gone

to Princeton, and he so tagged a mountain. Once, they forgot to pack their coffee-brewing apparatus, so they called the location Coffee Pot Pass—and the name stuck.

Hayden had one last goal: to locate and examine that near-legendary peak whose face was marked with a fifteen-hundred-foot cross. The image of the cross was formed by two intersecting gashes that were deep enough to hold perpetual snow. Fittingly enough, the peak was called the Mount of the Holy Cross.

The survey team set out on August 20 to find the mountain, following trails left by the Ute Indians. Often the way was obscured by fallen timber and they would stumble off the path, eventually finding another one that led in the direction they wanted to go. After two days they reached a point close enough to their still-unobserved objective for Hayden to split the survey. He would take most of the men himself and head directly for the mountain. Jackson, Coulter, and Tom Cooper would take another route, leading to a smaller peak from which Jackson might be able to get a panoramic shot of the cross.

Jackson left the mules behind because the going would be too steep for them. So each man had to tote a heavy backpack of photographic equipment. Jackson lugged the chemicals and dark-tent, Coulter the glass plates, and Cooper the cameras and tripods. Struggling upward, Jackson and his companions had to cut their own path through fallen timber tangled with thick underbrush. It rained much of the day and on into the evening. They ate dinner huddled under a wagon sheet. The rain stopped after that.

They were up at sunrise and hit the trail. Because the rain from the previous night had left the underbrush heavy with water, within minutes they were thoroughly wet. Jackson moved ahead of the others. He followed the course of a mountain stream, and he eventually had to wade through the hip-deep, icy water. As he continued his ascent, the trees became increasingly stunted and gnarled. By the time he hit the timberline, the temperature had dropped and a sharp wind had begun swirling over the rocks. At last he reached the summit.

Before him, across a narrow valley, lay the vast hulk of the storied Mount of the Holy Cross. But dense clouds obscured it.

> [I wrapped] my dark tent about me to keep off the cold—mists, wind & rain—for all the time I was there the clouds were drifting down, around, over me offering me occasional glimpses of the surrounding peaks, & part of the time [isolating me] . . . in space, not being able to see anything except the rock I was sitting on. (*D*, 251)

Sometimes the Holy Cross flashed through the clouds, and Jackson wished he had the rest of his equipment. But for the moment, just seeing the cross was enough.

Jackson sat alone on his mountain ledge for three hours contemplating the eerie scene while he waited for his companions. By the time they arrived it was too late for picture taking. Although they were out of food and had come without blankets or even coats, they agreed that it was impossible to leave without trying for a photo in the morning. So they descended to the timberline, where they built a crackling fire. With no supper, they lay down on the bare rock, hunched close to the fire, and fell asleep.

Jackson felt his most dramatic contribution to the 1873 survey was this photo of the Mount of the Holy Cross. In order to get the picture he and his assistants struggled through thick underbrush and over sharp boulders, then spent a frigid night on a mountaintop without winter clothing or gear. —Courtesy U.S. Geological Survey

The next morning the sun rose in a sky of crystalline blue. Their hunger and the thinness of the mountain air created a feeling of lassitude in the men. "It was only by exercise of considerable will force that we dragged ourselves up to the summit," Jackson wrote.

The cross was dazzling in the lemon tint of early morning. Jackson assembled his equipment as rapidly as possible, since the sun would highlight this portion of the mountain for only a brief period. The picture making could not be hurried, however. To secure each photo Jackson, working inside his dark-tent, had to pour the collodion solution over a glass plate, then immerse it in the light-sensitive silver nitrate solution. Next he had to carry the plate in a dark holder and insert it into the camera, which he had already placed on its tripod and focused on the cross. Opening the shutter by hand, he had to guess at the proper exposure, which usually ran about thirty seconds. Finally he would retrieve the plate, replace it in the holder, hurry to the dark-tent, and wash the plate in developer solution. The image then appeared in permanent form on the glass. Rush as he might, the entire process took around half an hour.

Jackson felt the pressure. He needed the right interplay of sun and shadow to enhance the cross's outline:

> By the time I had . . . developed and washed a few plates, the long flamelike shadows on Holy Cross were rapidly sweeping down into the valley, and, using two cameras, I had made just eight exposures when they were gone. But, with the early sun, those shadows had already helped me to take the finest pictures I have ever made of Holy Cross. (*TE*, 218)

Hayden was "wonderfully pleased," Jackson recorded in his diary.

After conquering the elusive Holy Cross, the survey crew turned back toward civilization. After eleven days of arduous travel they reached Denver, where they disbanded for the season.

Jackson's photographs created a sensation. Never before had the Colorado mountains been so precisely captured. Sketches could not reveal their true majesty and paintings were seldom accurate representations.

Jackson's pictures of the Mount of the Holy Cross were by far the most widely seen of his photographs.[3] Religion was very important in those days, and a vision of so perfect a representation of the symbol of Christianity, particularly on such a grand scale, was seen by many as a demonstration of God's blessing to the settlements in this country. Congress, too, was impressed by the magnificent photographs taken with such effort and so much skill and patience. Hayden found that Jackson's photos were far more effective than his own dry scientific material in convincing reluctant congressmen to fund the next survey.

Another significant result of the Colorado survey was Hayden's *Atlas of Colorado,* a popular compendium of important facts. Those eager to find their way in this exciting place used Hayden's maps to locate the towns as well as the railroads that accessed them. For settlers and prospectors, his economic and geological maps, done in color, were essential for finding the area's best farming areas and ore-bearing regions.

All in all, the Colorado expedition was an enormous success, and everyone eagerly awaited the next survey.

Revealing the Mysteries of Forgotten Peoples

The Hayden Surveys in Southwest Indian Country
and the Discovery of Mesa Verde (1874–1875)

On October 8, 1873, Jackson married Emilie Painter. It was a quiet ceremony at the home of Emilie's brother in Cincinnati. The couple honeymooned in New York City, then took up residence in Washington at a boarding house on H Street near the corner of Seventh.

Jackson's main income now was from the Geological Survey, a modest $175 per month. That winter and spring he helped classify and catalog the vast amount of data gathered during the previous year's expedition to Colorado. But his heart was out West. Thus it was with great joy that in July 1874 he took the train to Denver, where Hayden's group was assembling once more.

As usual, Hayden divided the expedition into half a dozen teams, with Jackson heading the seven-man photographic unit. At only thirty-one, Jackson was the old-

The men of Jackson's 1874 photographic division pose stiffly before the camera. Ernest Ingersoll, the correspondent with the New York Tribune *who would help popularize the survey's discoveries, is second from the right. Jackson's white mule, Dolly, waits patiently for him beside Ingersoll.* —Courtesy U.S. Geological Survey

timer of the group. With him this time was Ernest Ingersoll, correspondent for the *New York Tribune.* Ingersoll was a young, good-natured person who, in addition to being an accomplished journalist, was also a skilled naturalist.[1] He and Jackson soon formed a lasting friendship.

Another friend had been waiting for Jackson at the Denver rendezvous—his old chum Dolly, the white mule. Moving out of Denver on July 20, the expedition journeyed westward through Central City, which was rebuilding after a devastating fire

Jackson caught mountain man Harry Yount in a moment of reflection. Yount became the first ranger of Yellowstone National Park. —Courtesy U.S. Geological Survey

The waters of Grand Lake glow in Colorado's crisp mountain air. —Courtesy U.S. Geological Survey

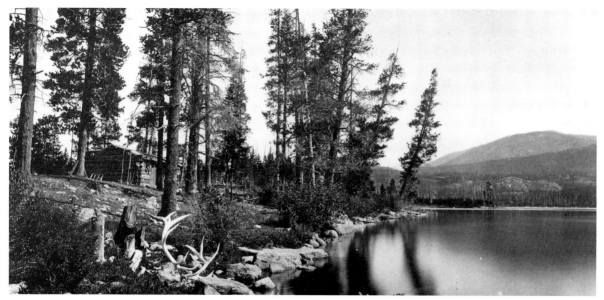

had almost obliterated the town Jackson had known the year before. From there they turned due north to labor up the vastness of 11,300-foot Berthoud Pass, camping at the gusty summit on the Continental Divide. When morning dawned, clear and blue, Jackson shot some photos of his surroundings. One picture, that of mountain man Harry Yount cradling a rifle and looking off into the distance, was destined to become a classic portrait of the Old West.

Working their way north through the mountains, they reached Grand Lake, on the western flank of snow-shrouded Longs Peak. The placid little body of water shined like obsidian, never indicating by its appearance that it was the source of the Colorado River. Here they found a fisherman living in a solitary cabin beside the lake. He had two boats that he rented to excursionists coming here for trout fishing. Jackson and his companions hired both boats and rowed across the lake. "It was a delightful ride," Jackson noted in his diary. "The early morning light shimmering over the surface of the deep dark waters of the lake, the low hanging wreathing clouds clinging about the mountain peaks and the exhilarating air made one feel all the enthusiasm such scenes inspire." When they reached the other side, they climbed to a series of foaming cataracts, beside which they ate their lunch, complete with a bottle of brandy.

By August 1 the men had moved on along the Colorado River to Hot Springs. Here Jackson took shots looking up the river toward Longs Peak, far to the east. They spent several days in the town taking photos as well as enjoying the hot baths.

The Colorado River from the top of Mount Bross. —Courtesy U.S. Geological Survey

Then they were off down the Colorado to where the Blue River joined it. Jackson found the Blue River sullied by a disgusting bile-yellow mud, the result of extensive mining upstream. Nonetheless, he got what he called "a fine set of negatives" of both rivers.

The party followed the miners' road south along the Blue until it ended in the rocky rampart of Hoosier Pass. Here they recrossed the Continental Divide and passed through the mining towns of Alma, which had grown considerably in just a year, and Fairplay, which was already on the decline. At the small village of Granite they met up with Hayden and his group, who were having what Jackson described as "a jolly time." But Hayden, concerned about running out of money, was perhaps not quite as jolly as the others.

Feeling pressed for time as well as funds, Jackson and his men continued south the next morning. They followed the Arkansas River until it turned east, then crossed the Continental Divide yet again at Poncha Pass. Around the hamlet of Saguache they encountered a group of Utes. The Indians surged around them—men, women, and children—kicking up dust as their horses pulled loads of goods strapped to poles behind them. Jackson wrote:

> Our mules were unused to the scene and stampeded all over the side hills, and my own little Dolly was somewhat frightened at the enormous packs surmounted by papooses and the poles dragging behind. In the little valley tributary to the Saguache . . . were 6 or 8 lodges of Indians with some 200 or 300 ponies, making a very picturesque scene. (*D*, 284)

The Utes, related to the ferocious Comanches, could be warlike when provoked. They usually remained peaceful, however, since they were a poor tribe of fewer than five thousand, distributed among seven bands. Sioux and Cheyennes often kept them away from the Great Plains, where the vast buffalo herds could have provided for their needs and permitted their tribe to increase. Instead they were mostly confined to the mountains, where game animals were more difficult to find.

Likewise, because their warriors were few the Ute wise men had directed the hotbloods to avoid violence when whites began appearing in their country during the gold rush at nearby Pikes Peak. But the Indians were still resentful, and Jackson sensed that almost anything could happen.

Leaving the Ute party, Jackson and his men moved westward toward the Los Pinos Indian Agency, set up to distribute food and other supplies to the Utes as part of a recent treaty. Following an Indian trail, they ascended the Cochetopa Pass, which Captain John Gunnison had traversed twenty-one years earlier searching for a transcontinental railroad route. Gunnison found not a route but death from Paiute arrows in Utah.

Jackson reached the agency, around which Utes were encamped in seventy tepees. The agency itself consisted of a dozen buildings constructed of logs plastered with mud and whitewashed. They were arranged in a square, with a one-room schoolhouse at the center. Here it was intended that the Ute warriors would be transformed from wild hunters into model farmers. Jackson was welcomed by the agent, a Unitarian minister named Henry Bond, his wife, and their children. The next day the Bonds

took Jackson and Ingersoll, the reporter, to see Chief Ouray, whose high standing was indicated by his living in one of the whitewashed buildings, not in a buffalo-skin lodge like the others.

Chief Ouray, whose name meant arrow, was a stocky, muscular man with frozen brows and granite eyes. Yet he was essentially a beaten warrior who foresaw the doom of his tribe. In 1868, when he signed a treaty relinquishing Ute claim to all lands east of the Continental Divide (which included Denver), he made it clear that he had not done so from the goodness of his heart. "The agreement that an Indian makes to a United States treaty," Ouray lamented, "is like the agreement a buffalo makes with his hunters when pierced with arrows. All he can do is lie down and give in."[2]

No doubt the chief was not surprised, then, when in 1873 American treaty makers once more came calling. Gold and silver had been found in the San Juan Mountains beyond the divide, so the Utes were forced to give up these lands as well, even though the old treaty had promised them this homeland forever. The town of Silverton had already been laid out with complete disregard for Ute rights, so the treaty would legitimize its existence.

In return for the San Juan territory the Utes had been awarded government food rations. At the same time, Ouray and some of his subchiefs were transported to New York to witness the power and wonder of civilization, including a ballet performance, which for them must have appeared to be a silly and pointless dance. Upon his return Ouray moved into the whitewashed home where Jackson was to meet him. The dwelling had been presented to him, completely furnished, by the U.S. government as a reward for keeping his tribe peaceful.

Ouray usually wore white men's clothes, topped with a derby hat—though he kept his hair long and tied in two braids. But for the photographic session with Jackson, he appeared in his best Ute buckskin jacket, with its long fringes trailing from the shoulders. The jacket was brightly and profusely beaded. "He looked every inch a monarch," Ingersoll was to write in his popular book *Knocking Around the Rockies*.

Accompanying the Chief was his beautiful wife, Chipeta. "She was," Ingersoll wrote, "about the most prepossessing Indian woman I ever saw, and Ouray was immensely proud of her." She was dressed like a queen. "The doeskin of which her dress was made was almost as white as cotton, and nearly as soft as silk. From every edge and seam hung thick white fringes, twelve or fifteen inches long, while a pretty trimming of bead work and porcupine-quill embroidery set off a costume which cost Ouray not less than $125." But he could afford it, since the Americans were paying him an annual pension of one thousand dollars.

Chipeta was shy around strangers and needed the encouragement of Mrs. Bond before she would seat herself in front of Jackson's camera. When she smiled, dimples added to her beauty.

Jackson, like Ingersoll, was tremendously impressed by Ouray: "Of all the Indians I have known," he was to write many years later, "Ouray was quite the most

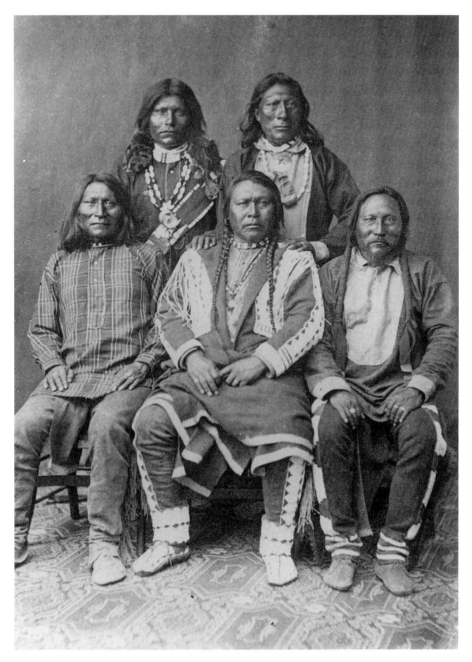

Ute Chief Ouray posed for Jackson with his subchiefs. The proud Indian would die before seeing his tribe broken and humiliated. —Courtesy Denver Public Library, Western History Collection

extraordinary." Jackson had a long talk with the chief, who promised him the tribe's cooperation with his picture taking. But Ouray's authority was not absolute. Many in the tribe resented his close affiliation with the Americans and felt that the only reason for his present status was the fact that he was peacefully inclined and spoke English.

Jackson later visited the Ute village outside the agency, but without Ouray's influence, several subchiefs refused to have their pictures taken, and Jackson could sense their underlying hostility. However, Jackson was skilled at persuading reluctant people to be photographed, and after buying some blankets from a chief named Peah, he got the chief to pose. At about this time a storm came up and Peah invited Jackson into his tepee. Here the two of them talked while Peah's wife tended to three children squirming nearby.

The next day the rations were distributed. As the whole village excitedly congregated around the agency, Jackson prepared for a rich harvest of photos. The Ute women, almost all with children, gathered in a semicircle, chattering and laughing as the agent handed out sugar and other goods. Meanwhile the men were on their horses, drawn up in a line. One beef steer had been allotted to every six lodges. When the cattle were turned loose, the braves urged their horses after them, giving wild whoops just as if they were chasing buffaloes on the Great Plains.

With the men scattered, Jackson took what he believed was a surreptitious photo of Peah's papoose, who had been left in his backpack propped against the side of a building. But Peah spotted him. What ensued was one of the most dangerous situations Jackson ever faced:

> Peah and some half dozen others came up, protesting vehemently, taking hold of the camera and preventing me from either focusing or making an exposure. Peah kept on exclaiming that the Indians "no sabe" pictures [which make] Indians heap sick, tapping his head. (*D*, 289–90)

But Jackson did not sympathize with Peah and had no intention of giving up. He went inside the cookhouse and aimed his camera through an open door. Just as he was ready, the Indians saw him. One rode up angrily and tried to spur his horse right into the building. Unable to get through the opening, he wheeled around, threw a blanket over his arm, and held it in front of the doorway, effectively blocking Jackson's view. With half a dozen warriors brandishing their weapons menacingly and with friend Ouray nowhere in sight, Jackson had little choice except to pack up for the day.

From then on the Utes were hostile. Whenever Jackson set up his camera, someone would toss a blanket over the lens or kick the tripod over. One evening a sullen Ute subchief who called himself Billy approached Jackson:

> He informed me with an air of great condescension [that] . . . this country, regardless of treaties and boundaries, was owned by his people; it would be dangerous for us to proceed farther with my strange box of bad medicine; hunters who had destroyed their game had died; other men who dug in the ground and took away their gold had

also died; it would be better for me and my companions to return at once the way we had come.

I decided it might be well to answer Chief Billy in the way he could best understand. Motioning to Bob and Steve, who were crack shots with both rifle and revolver, I got them to put on a little exhibition of target shooting, which I also joined. After a dozen rounds Billy departed. Neither he nor Peah, who had been audacious enough to demand the exposed plates, tried any further interference with us. (*TE,* 227)

But Jackson had been in far greater danger than he imagined, for the Utes were not yet ready to submit to the whites. Just five years later, despite Ouray's wishes, warriors would kill eleven persons at another Indian agency, then ambush an army relief column and kill fourteen more.

Those actions were to seal the tribe's fate. Treaties or not, the cry went up throughout Colorado's white population: "The Utes must go!" The Indians made a ferocious stand at Snowmass, where they set fire to the forest, creating what still goes by the name of the Big Burn. But they could not win against the overwhelming numbers arrayed against them. The government divided the Ute people into three groups. One was assigned land nobody wanted in Utah, and the others were confined to desolate tracts in the southwest portion of Colorado. There they remain, almost forgotten, to this day. Chief Ouray did not live to see his tribe's final destruction. He died in 1880, at the age of forty-seven.

Leaving the Ute agency, Jackson and his men headed south. They took the Ute trail, which led through a little-known pass in the rugged San Juan Mountains, to the Rio Grande. Upon reaching the river, they wound westward along a mining road until it veered into a maze of obscure canyons. From there they followed an Indian trace to Lost Trail Creek.

Just above the creek was a crude ranch house, where they were greeted by a young lady whom Jackson obtusely described as "extremely good looking (for this country)." She informed them "with many smiles & dimples" that her husband was out fishing, but she could furnish them much-needed bacon and some cans of tomatoes, as well as some very welcome tobacco and whiskey. Jackson and his comrades camped near the lady's cabin, enjoying a pleasant evening of smoking and drinking moonshine. The next morning they moved westward over the San Juans. Although Jackson had a nice array of mountain negatives by now, he was awed by the San Juans, noting in his diary that "each new turn in our zigzag trail [opened] up new vistas that rendered our admiration speechless." The next day they reached Silverton.

Silverton consisted of just a dozen buildings, although soon it would burst forth into such a rib-busting place that the more peaceful citizens had to call in the famous lawman Bat Masterson to hammer the lid on. The hamlet was located in the valley of the Animas River, or "River of Souls." It would be several years before a narrow-gauge railroad would snake up the Animas from the south, so for now Silverton had only horse-trail connections with the outside world. Although Silverton was still

One of Jackson's men takes a surprisingly relaxed position above the raging rapids of the Rio Grande in Colorado. The camera's slow shutter speed has blurred the churning water. —Courtesy U.S. Geological Survey

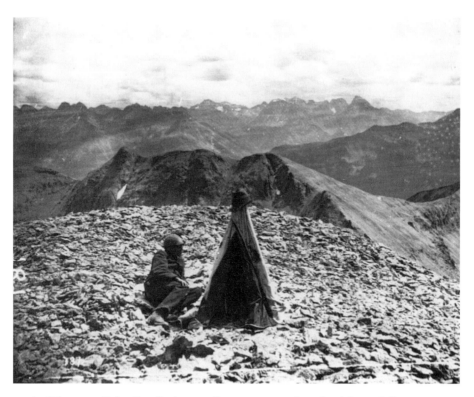

At Silverton, Colorado, Jackson and some companions hauled unwieldy camera equipment to the top of Sultan Mountain. —Courtesy U.S. Geological Survey

being built, the fabulous Sunnyside Mine was already extracting the ore that reportedly gave the town its name: "Silver by the ton!"

Members of one of the other surveying teams were also in Silverton that day, so Jackson and some of his men decided to accompany them on a climb up Sultan Mountain, where they would take altitude and other scientific readings. The way was so rough that the mules could not make it and were tied to trees at the timberline. From there Jackson and his photographic team had to shoulder their equipment and stagger up the last steep and slippery three thousand feet. The weather was bitter cold at this altitude, and Jackson's hands were almost frozen as he worked on the plates with his colloidal solution. "I . . . was shivering all the time," he noted in his diary.

On September 2 Jackson and his crew departed from Silverton and headed down the Animas Canyon along a beautiful route followed by a narrow-gauge railroad. Eventually they came to one of the pine trees burned by Chief Ouray to mark the southern boundary of the land purchased by the Americans. Now they were entering territory where Ute law, rather than American, reigned. It was not a change to be taken lightly, for the Utes were jealous of their sovereignty. Indeed, near a location

that would eventually become the hell-snorting railroad town of Durango, Jackson encountered half a dozen white men who had been brusquely ordered out of the area by armed warriors.

Jackson's team continued nonetheless. This was different country from the sharp-peaked, timbered lands to the north. The mountains had been replaced by flat-topped mesas rising starkly above the surrounding sandy plain, and the only trees were a few gnarled junipers and piñon pines that maintained precarious existences amid the clumps of brittle sage. The group soon began to pass ranches that had been abandoned when the land passed into Ute hands. At one ranch the former residents had left so hastily that they had not even harvested the crops. Here Jackson and his crew took the opportunity to fill their saddlebags with corn, potatoes, and not-quite-ripe melons. Jackson recorded that they "gorged" themselves on the melons.

About this time, Jackson met up with an old friend from Omaha named E. H. Cooper. Trying his luck as a miner, Cooper had roamed extensively over the Colorado Territory. He told Jackson of seeing strange cliff ruins. Jackson realized that those

The land became parched and the temperature torrid as Jackson and his photographic team moved down the Mancos Valley in 1874. —Courtesy U.S. Geological Survey

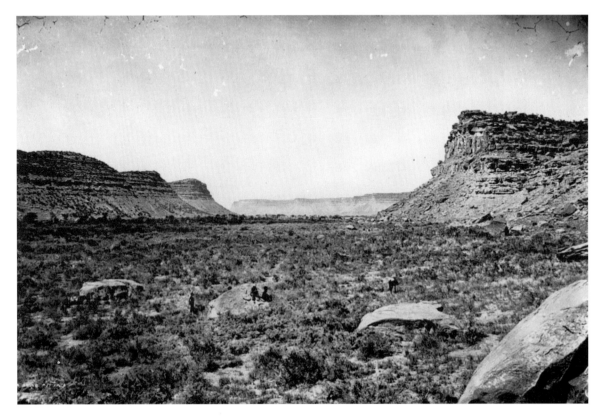

could be an important find. Instantly he decided to head toward the area called Mesa Verde, Spanish for "green tableland." With Cooper was John Moss, a local character and popular intermediary with the Indians, who offered his services as a guide.

There was one minor catch to Moss's offer. He said he was running for local office and insisted that Jackson and his men cast votes for him. After they obligingly did so, Moss abruptly closed the polls and declared himself the winner. Now he was available for guide duty.

Directed by Moss, the Jackson party made its way westward, still within the Ute territory, toward the Merritt homestead—the only white person's dwelling within many days' journey. It was built on the Mancos River, the only creek of any size in this desiccated country. The house was made of logs so carelessly chinked that the firelight shining through them became Jackson's beacon as he approached that night. Jackson and the others were welcomed in to spend the night.

In the morning Jackson could see the long butte called Mesa Verde hulking in the distance. As the party moved toward it, they passed many small mounds, and in some they could trace the foundations of buildings that had long since vanished. Scattered around were numerous shards of broken pottery, mostly white with black designs. A sense of awe descended on the group—they had entered a mysterious realm never before penetrated by a scientific expedition.

They rode slowly alongside the Mesa Verde bluff, impressive with its layers of red and white sandstone. Suddenly toward evening Moss reigned in his horse and pointed far up the mesa. "There it is," he said, indicating a barely visible two-story stone edifice sandwiched into a gap between the rock strata about eight hundred feet up. Their excitement was so great that everyone began scaling the cliff. But at about six hundred feet the ascent became so precipitous that only Jackson and Ingersoll cared to continue at that late hour. Finding some ancient footholds cut in the rock, they climbed slowly in the deepening twilight.

At last they reached the spot. "It was worth everything I possessed," Jackson wrote exuberantly, "to stand there and to know that, with Ernest Ingersoll, I was surely the first white man who had ever looked down into the canyon from this dwelling in the cliff." Ingersoll described the episode in an article for the *New York Tribune*, and before long the entire nation shared their wonder.

Of course, Jackson insisted on taking close-up photos as soon as possible. The next morning, the men loaded themselves with the heavy glass plates, the bulky colloid mix, and the cumbersome camera, tripod, and developing tent, and slowly hunched up the cliffside. Jackson then made the first photographic record of a Southwestern Indian cliff dwelling.

Once their work was done there, the party continued along the Mancos Valley, soon discovering that the structure they had spent so much effort on was just one of many such two-story lodgings along the rocky cleft. The buildings consisted of sand-

stone slabs carefully cut to fit closely together. Many had the remains of cedar timbers that had once separated a lower level from the one above. Some interiors still had pieces of the original plaster adorned with brick-colored paint. Niches in the walls indicated where pottery had been stored, broken pieces of which they found everywhere.

As the expedition continued they encountered some Ute braves on a raiding party against the Navajos to the south. From them the group learned that the tribe had no knowledge of who had built the exotic stone dwellings. They knew only that the Navajos called them "the ancient people who are not of us," or Anasazi.

Gradually the Mancos Valley broadened until it merged with that of the San Juan River from the north. Jackson and his men turned up the San Juan at almost the

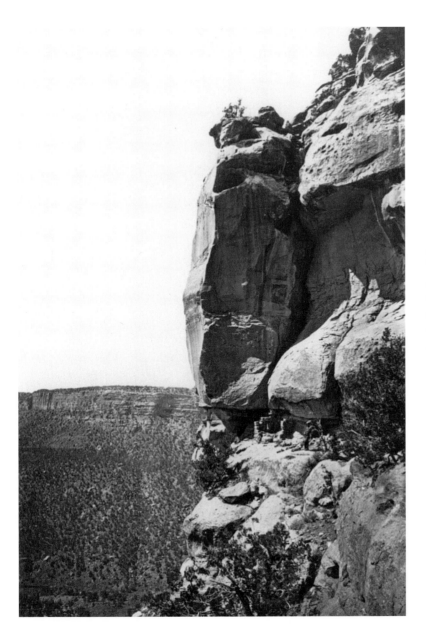

Jackson and New York Tribune *reporter Ernest Ingersoll climbed the steep wall of Mancos Canyon to become probably the first white men to visit these Anasazi ruins.* —Courtesy U.S. Geological Survey

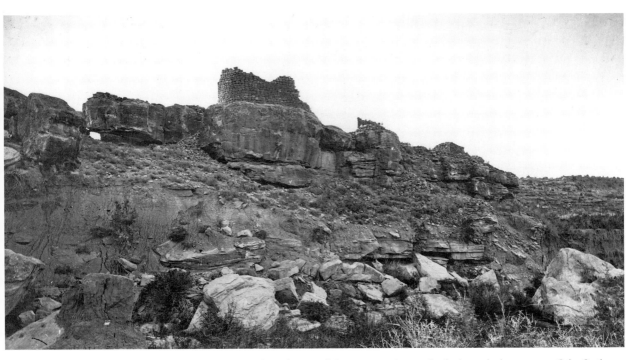

Ruins of the Anasazi tower at Hovenweep greeted Jackson and his men as they trudged through the sun-seared land of extreme southwest Colorado. The heat and lack of water forced them to turn back before discovering the more extensive ruins of Mesa Verde. —Courtesy U.S. Geological Survey

precise point where the territories of Colorado, New Mexico, Arizona, and Utah met. Here the land was so dry that only desert sagebrush and greasewood were able to survive. To Moss's dismay even the springs he had counted on had no water. But the party continued forward, nursing their remaining water.

At the dry bed of McElmo Creek Jackson spied a tall black tower on the bluff. "It wound and turreted among the rocks in a very unusual manner," he noted. "It evidently guards the way to a large city or settlement back upon a higher level. . . ." Aided by Moss, who had passed through the area eighteen years earlier, Jackson located a tall semicircular structure, where he made photos as well as sketches and measurements. Jackson wanted to remain longer at this place, called Hovenweep, or "deserted valley," by the Utes, but time constraints and lack of water forced him to take his crew eastward toward civilization. Returning via Colorado Springs, he was back in Denver by October 11.

Strangely, although Jackson had completely circled Mesa Verde, he never found the truly spectacular cliff dwellings for which the location would become famous. These would be discovered fourteen years later by two local ranchers, Richard Wetherill and Charles Mason. Nonetheless, it was Jackson's photographs, many taken

under difficult and sometimes hazardous conditions, that helped popularize the ruins and ultimately helped to make Mesa Verde a national park in 1906.[6]

The Southwest continued to fascinate Jackson, so the following year, 1875, he was back again with the Hayden survey team. This time he had with him an additional camera, one able to take huge photos, twenty by twenty-four inches in size. Although this meant he had to transport much larger glass plates, he felt he had no choice, for he was convinced that he needed photographs of a grand scale to show the true magnificence of the region.

But the plates posed a significant problem. They were so heavy and breakable that the mules could not be relied upon to carry them safely, therefore they had to be transported on wagons. This meant that when the group encountered terrain too rough for wheeled vehicles, the wagons had to be laboriously disassembled and loaded along with the plates onto the backs of unwilling mules, then slowly and ever so carefully transported over the obstacle. But such was the work of wilderness photography. Jackson later wrote that the camera had been worth all the extra labor it cost.

Hayden was eager to send Jackson and his team back to the Mesa Verde ruins. "Hayden was a dynamic, intense man," was Jackson's description of him, "yet never

In 1875 Jackson was back in the Southwest. Often the terrain was so rough that his supply wagons, overloaded with heavy photographic equipment, had to be disassembled and transported around obstacles on backs of protesting mules.
—Courtesy U.S. Geological Survey

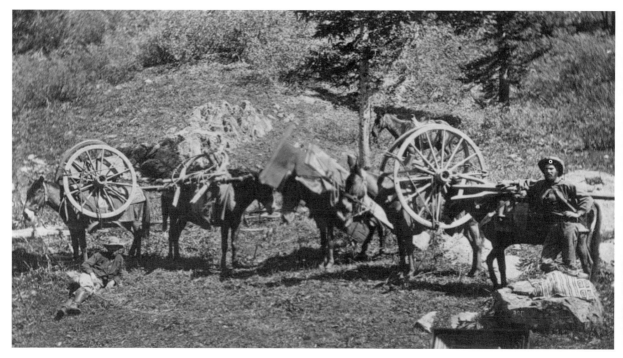

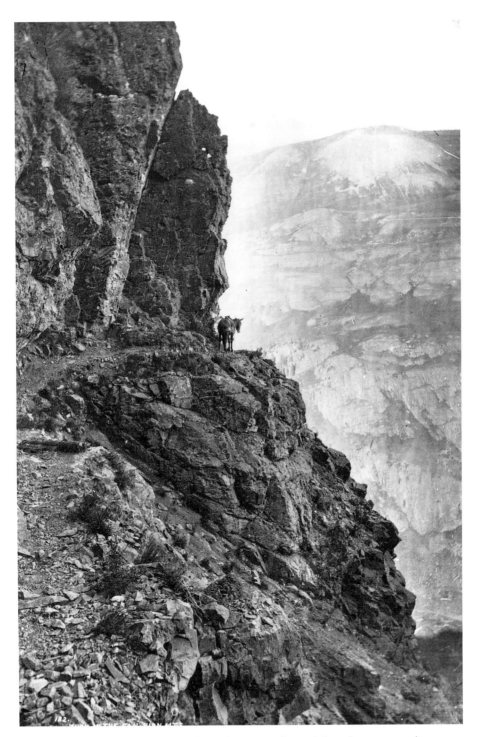

Evidently Jackson thought his audience would not believe how narrow the mountain trails were, so he tied his mule to a boulder and laboriously put up his photographic paraphernalia to get this shot. —Courtesy U.S. Geological Survey

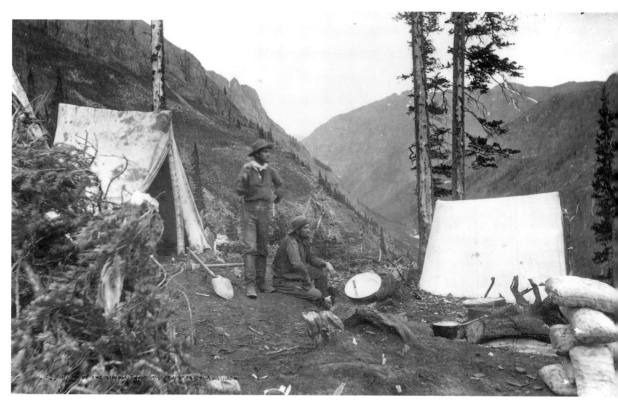

Miners trying their luck in the San Juan Mountains in 1875. Few struck it rich. —Courtesy U.S. Geological Survey

The sandstone pinnacles known as the Navajo Twins were vivid landmarks in the tablelands bordering the San Juan River. —Courtesy U.S. Geological Survey

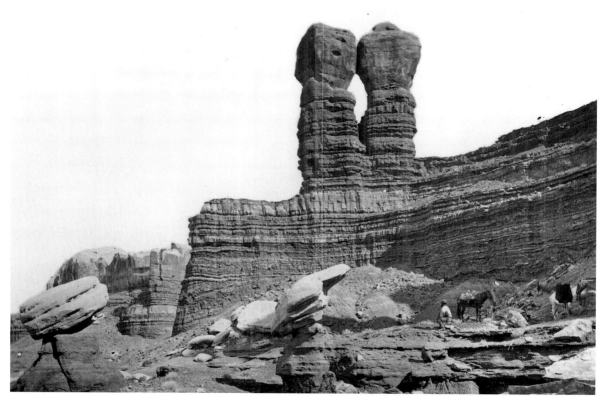

had I seen him at such a high pitch of enthusiasm." Jackson was given a team of five men. Although his friend Ingersoll was not among them, a man named E. A. Barber took his place, a correspondent for the *New York Times*. Thus the explorations continued to receive national exposure.

Once more Jackson passed through the San Juan mining country. Often the mountain trails were hardly wide enough for a mule to edge between the rocky wall on one side and the abyss on the other. But Jackson was accustomed to this sort of danger and even paused to set up his awkward equipment and snap breathtaking photos. They met many miners along the route, most of whom welcomed Jackson and his crew into their grubby camps. Although the miners' expectations were usually high, few would find enough metal even to buy a decent meal in Denver, and eventually most of the camps and shantytowns would become remnants of broken dreams.

Jackson retraced his route to the San Juan River, passing near Hovenweep. On the San Juan was a place where the scenery was accented by an unusual sandstone formation called the Navajo Twins, which made a good picture. But farther on along the river Jackson encountered what he called an "impassable gorge," now known as

In 1875 at the mesa-top Hopi village of Tewa, Jackson was enchanted by a lovely teenage Indian girl named Num-pa-yu, shown here right center. She and Jackson would renew their acquaintanceship at intervals over the next sixty years. —Courtesy U.S. Geological Survey

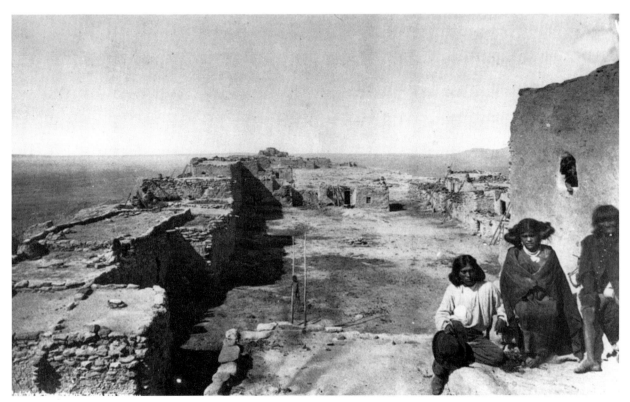

the awesome Goosenecks, a twisting, thousand-foot-deep chasm. Not even these hardened explorers could negotiate that obstacle, so Jackson turned south on the Chinle Wash. The wash had a thin trickle of water into which the men took cooling dips, giving them temporary relief from the torrid heat, which registered 125 degrees on the survey thermometer.

Off the Chinle the men found a trail leading to the pueblos of the Hopis, then known as the Moquis. The Moquis lived atop three isolated mesas in the northeastern portion of the wild Arizona Territory. Long ago they had constructed stone villages there to protect themselves from hostile tribes, chief among them the nomadic Navajo. Because the Moquis were believed to be descendants of the ancient Anasazi, builders of the Mesa Verde cliff dwellings, Jackson had a special interest in them. So just before sunset he and his men climbed the rocky mesa to the pueblo of Tewa.

The Indians welcomed the visitors with a feast of fresh bread and corn. They were served by an Indian girl of about seventeen. Her name was Num-pa-yu and she quite intrigued Jackson. As he wrote years later:

> She was . . . such a remarkably pretty maiden that a dozen years later when in the vicinity I remembered to ask after her; I was told that [she was] still very beautiful and had become the most famous pottery maker of the Moquis. Another forty years passed, and once more I was near the home of Num-pa-yu; to my delight I learned that she was still very much alive and that I could see her. We had a long conversation, and then [she] sent for several young men and women, her grandchildren. (*TE*, 239–40)

A decade after that, and a friend brought Jackson, now an old man, a copy of his book about the Hopi. "In one of the photographs," Jackson recalled, "I instantly recognized Num-pa-yu, still smiling after an interval of some sixty years."

The visit to Tewa was the highlight of the 1875 expedition. By autumn Jackson was back at his home in Washington D.C., where Emilie was expecting their first child. Jackson busied himself planning the survey's exhibit for the forthcoming Philadelphia Centennial Exposition.

On His Own

The Philadelphia Exposition; Revisiting the Southwest (1876–1877)

The centennial celebration of independence from Great Britain was to be centered in Philadelphia, with its main feature a tremendous exposition along the Schuylkill River. Here a series of large buildings would house displays showing America's progress during the last hundred years. Emphasis would be on the nation's expansion from thirteen colonies huddled along the Atlantic to thirty-eight proud states and nine huge territories spanning the entire continent.

Perhaps the most exciting part of that expansion had been the rapid conquest of the mountain frontier during the last few decades. The most thorough report on the riches and resources of that region was the Hayden geological surveys, which William Henry Jackson's exciting photos had publicized. Thus it was no surprise that the centennial committee gave Hayden a prominent location among the exhibitors. Hayden had chosen Jackson to gather all the diverse materials collected by the surveys over the prior six years and organize them into a cohesive exhibit. This was the supreme recognition of Jackson's importance to the surveys, quite an honor for someone still in his early thirties.

Late in 1875 Jackson, aided by four assistants, began assembling the exhibit. It was "as absorbing a piece of work as I ever hope to tackle," he recalled. Jackson carefully sorted and labeled the rocks and fossils that Hayden and his geologists had so painstakingly collected. He did the same for the multitude of dried plants and preserved animals. And, of course, he worked out an impressive display of his own photos of western mountains and deserts, as well as ones of the Indians. In addition, he included pictures of the expedition members and the routine details of camp life that were sure to interest the general public. But his most extensive labor went into making clay replicas of the amazing cliff dwellings he had discovered during the expeditions. These models were works of art, constructed with precise attention to proper scale and complete with surrounding bluffs hand-colored by Jackson.

The Centennial Exposition opened on May 10, 1876, to the peal of the venerable Liberty Bell, dissonantly accompanied by most of Philadelphia's other noisemakers. There were more than thirty thousand exhibits, many housed in the Main Building—claimed by exposition officials to be the most gargantuan museum in the entire world—and nearby were four other buildings almost as large. Many of the exhibits boasted mechanical wonders, all run by a stupendous central steam engine to which they were hooked up via seventy-five miles of belts and shafts.

Visitors were shuttled about the vast fairgrounds on steam trains that ran on an elevated monorail. A popular destination was the 185-foot-high observation platform.

One could ride to the pinnacle in an amazing elevator that lifted up to forty passengers at a time.

Even with the vast selection of exhibits from which to choose at the Exposition, hordes sought out Jackson's display. People gasped at his thrilling pictures of immense, snow-dusted mountains. They were captivated by his Indian portraits. And they could hardly believe his scale models of the cliff dwellings—no one dreamed a civilization could arise in the craggy deserts of the Southwest.

For the entire summer Jackson tended the display, answering questions and giving informal lectures about his experiences in the West. Genial, handsome, and well known for his daring photographic exploits, Jackson himself was as much an attraction as his pictures and models.

Jackson was most pleased with the results of his labor. The Geological Survey display "drew almost as many visitors as Dr. Alexander Graham Bell's improbable telephone," Jackson wrote years later, adding wryly, "and, had a Gallup Poll existed at the time, I am confident that nine persons out of ten would have voted my models the better chance of enduring." Jackson received a bronze medal for the survey's exhibit—an impressive achievement given the strength of the competition.

Jackson still had a restless soul, however. The lure of the West was constantly tugging at him, and he felt he should be out there with his camera, not holed up in Philadelphia. The West was changing ever so rapidly. The Indian tribes were being destroyed even as he stood contemplating their photos. Even the proud Sioux, the last of the major tribes, were being hounded by the U.S. Army and soon would no longer exist as an independent nation. Much of what seemed permanent today would be a dimming memory tomorrow. Only his photographs could capture the essence of the West before it was gone.

Despite the fact that Emilie had just given birth to their son, Clarence, Jackson felt he must return to the frontier. But the itinerary of Hayden's survey team did not suit him this time. Hayden would be going to Wyoming again for the 1877 trip, and Jackson wished to revisit the area to the south that he had seen during his last trip, feeling he'd only scratched the surface there. Obligingly, Hayden arranged to have Jackson accompany Reverend Sheldon Jackson (no relation to Will) as he visited congregations from Santa Fe to the Hopi pueblos.

Jackson was overjoyed to be in a party of only two; it meant that he could travel faster. Furthermore, due to the just-announced invention of dry film, he could do away with much of the burdensome old equipment and could carry all his supplies on his own back. Although the film was still experimental and he had not yet tried it, Jackson ordered rolls sufficient for four hundred exposures to be sent to Santa Fe. Then he was off. "My heart was as light as my burden when I stepped off the train in Trinidad, Colorado, then the closest rail connection for Santa Fe."

From Trinidad Jackson took what he called a "mud-wagon" over the Sangre de Cristo Mountains, along the traders' road long known as the Santa Fe Trail. He met

Reverend Jackson at Santa Fe, capital of the New Mexico Territory and site of Fort Marcy. After several days' wait in Santa Fe the film finally arrived, then the two men left in a buckboard wagon furnished by the army commander at Fort Marcy. They drove down the spacious Rio Grande Valley following the route taken by Francisco Coronado in 1542. After three days the pair reached the pueblo of Laguna, well-known for its Spanish-era church. Here they were entertained by the Marmon brothers, who had a thriving trading post among the Indians. The Marmons were such genial hosts that Jackson and Reverend Jackson remained with them for four days. The high point of their stay was a visit to the nearby pueblo of Acoma, called the Sky City for its lofty perch atop an almost impregnable mesa.

The Acomans had good reasons for building their home as a rocky fortress. They, as well as the other Pueblo groups, were virtually hemmed in by hostile nomadic tribes: the Utes to the north, the Apaches to the south, the Navajos to the west, and the Comanches to the east. Because the Spaniards helped them combat these enemies, the Pueblos had been mostly contented with Spanish rule, established with the founding of Santa Fe in 1610.

The old Spanish church at the Laguna Pueblo in New Mexico represented a heritage far different from Jackson's. All the photographs in this chapter come from later trips. —Courtesy Colorado Historical Society

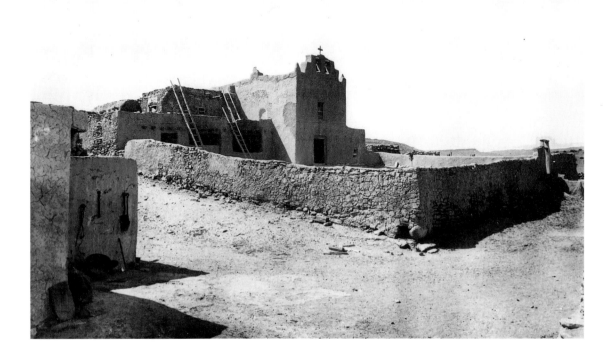

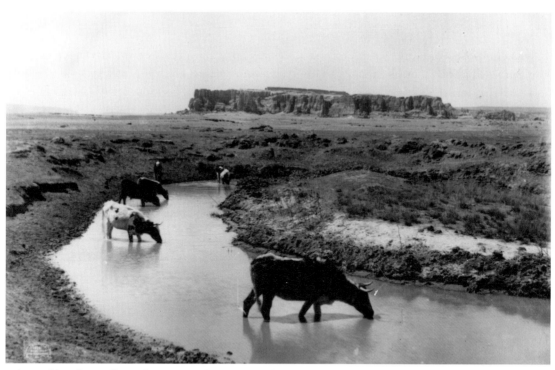

The Pueblo Indian village of Acoma perches atop an almost inaccessible mesa. —Courtesy Colorado Historical Society

Jackson sketched this interior of an Indian home during his visit with the Acomans. —Courtesy Colorado Historical Society

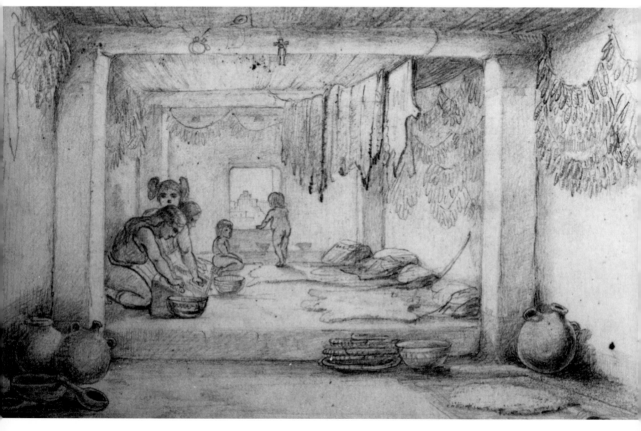

Heading west, Jackson and the minister soon reached Zuni, the initial pueblo encountered by the explorer Coronado, who was tremendously disappointed that it was composed of stone, not gold. Furthermore, the Zuni resisted his advances ferociously. Jackson would capture their warlike character, so different from the other Pueblo tribes, in a photo he took several years later. But on this visit, perhaps because he was with a man of the cloth, he encountered their softer side. He even lingered among them while he sketched three whimsical Zuni drinking mugs shaped like an owl, a spotted bird, and a duck.[1]

From the Zuni Pueblo the two travelers headed north to Fort Defiance, in the Arizona Territory, arriving just as the Navajos were assembling for their annuity distribution. The annuity had been part of an agreement whereby the tribe, conquered by frontiersman Christopher "Kit" Carson during a vicious campaign in 1863, was released from five years' captivity at an army post in exchange for their promise of no further violence. The annuity rewarded them for keeping their promise and living peaceful lives—their aggression limited to harassing the weaker Hopi, their neighbors to the west.

The Zuni Pueblo was home to a warlike population. —Courtesy Colorado Historical Society

Jackson drew this sketch of fanciful Zuni drinking mugs for the U. S. Geological Survey's Tenth Annual Report. —Courtesy Denver Public Library

Will Jackson was impressed by the colorful scene: ten thousand Navajos camped on the Fort Defiance plain in shelters of canvas covered with brush. Children scampered everywhere, closely shadowed by dogs and goats. Sheep and horses grazed on the outskirts of camp. Young braves strutted about in buckskin jackets brightly decorated with beads. That evening campfires blazed, as the air was cold at the fort's altitude of seven thousand feet. Toward evening it began to snow, creating what the photographer called "one of the weirdest spectacles that it has ever been my good fortune to witness."

The snow was falling fast, and through the veil of feathery flakes the innumerable camp fires—thousands of them scattered over the hillsides overlooking the post—twinkled and gleamed redly in varying, fitful intensities. . . . At the same time countless moving figures were shifting in and out of their own little circle of light. . . . The air was filled with the cries of children, the admonitions of squaws, and the shouting of many men, all combined with the barking and yelping of every dog and cur in the encampment. . . . One of the bucks was in a hilarious humor, displaying himself in much riding about the agency and with a continuous fusillade of pistol and rifle shots. . . . Taken all together, it was a scene long to be remembered.[2]

Jackson took many photos of the scene using the new dry film.

A day or two later he had another memorable experience. Leaving Reverend Jackson to wait at the fort and accompanied only by a Navajo guide, Jackson made a hurried forty-mile mule trip to Canyon de Chelly. Arriving in the afternoon, he wandered around the wondrous place until dark. Looking up from the gorge presented one of the continent's most thrilling vistas. The canyon's huge sandstone walls, in enchanting variations of red, rust, and ocher, towered over the riverbed. Vertical streaks of iron oxide, known as desert varnish, reached down from the tops of the chasm, giving the rosy walls additional height and grace.

The mysterious Anasazi had built stone homes in de Chelly's hollows and had planted corn in the valley. They had worked the riverbanks for clay to make their beautiful pottery, shards of which were scattered almost everywhere.

Jackson made a whirlwind trip of eighty miles in two days to photograph the spectacular Canyon de Chelly, which the natives pronounced "D'shay." —Courtesy Colorado Historical Society

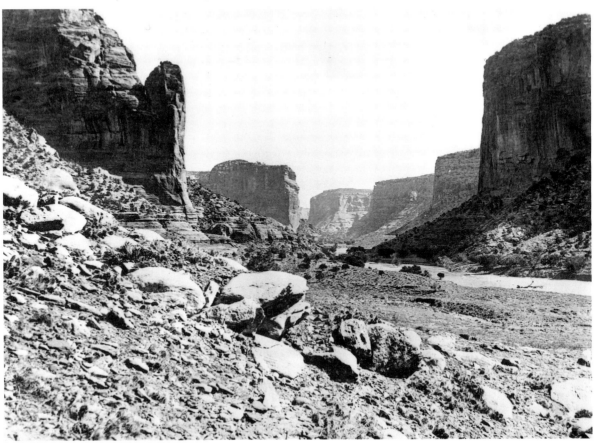

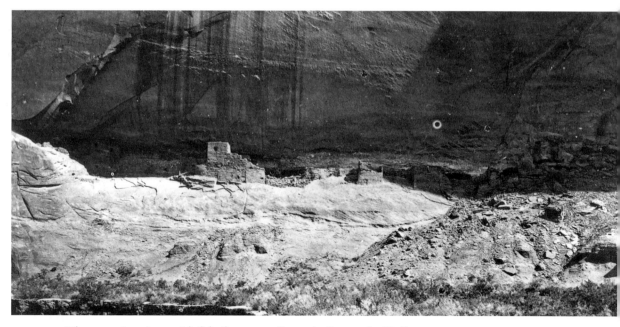

The mysterious Anasazi had built stone residences in Canyon de Chelly. —Courtesy U.S. Geological Survey

The Anasazi had long been gone by the time the Navajos migrated into Canyon de Chelly. When the Navajos came upon the deserted houses of the Anasazi they felt uneasy, for they believed the dead never left the places where they died. Still, that did not deter the Navajos from settling in the canyon.

The next day Jackson rose before dawn to do more exploring and picture taking, then he returned to Fort Defiance that evening. From Fort Defiance he and Reverend Jackson trekked westward a hundred miles to the Hopi pueblos, where the photographer renewed acquaintances with his Moqui friends, including the beautiful Num-pa-yu. He sketched several of the Hopi's wooden kachina dolls. The Hopi regarded the kachinas as real beings who dwelt in the mountains and other sacred places and had the power to bestow blessings as well as severe hardships. Thus the dolls were part of the elaborate ceremonies required to gain the kachinas' favor.

From the pueblos, the two men returned to the Rio Grande, where Reverend Jackson continued on to Santa Fe. Will Jackson, however, had heard about a major Anasazi site known to very few Indians and even fewer whites. Called Chaco, or "white rock," by the Navajos, it had been examined by only two American expeditions, the more important one led by Lieutenant James Simpson almost three decades earlier. Although the site was in a remote canyon, Jackson had an overwhelming desire to explore it. Thus in early May he set out on a mule with only a Mexican

Jackson sketched a Hopi basket lid and wooden kachina dolls for the Geological Survey report.
—Courtesy Denver Public Library, Western History Collection

guide, a nearly blind old Pueblo Indian interpreter known as Hosta, and Hosta's grandson, a lad of around twelve.

The landscape shimmered in the heat. "Looking across its desolate waste," Jackson wrote in his report for the Geological Survey, "a mirage danced constantly on the horizon, magnifying the insignificant sage bushes and the low, rolling hills into great oaks and distant mountains." A person without water would likely die out here.

At last Jackson spotted what he had been looking for. "While yet four or five miles away the ruins loomed up prominently, resembling at this distance a ledge of dark brown sandstone." Soon they reached the Chaco Wash, which was usually dry since it was fed only by rare storms. It contained no water now, although spots of grass indicated that it had been damp not too long before. Jackson had enough water and other supplies for five days of exploration.

The Anasazi had eleven major settlements along the Chaco Wash. Most had been constructed on a similar plan: the dwellings and storage units, several stories high, were close to the canyon wall, and in front of them were large courtyards with many circular evacuations carefully cut into the underlying sandstone. Jackson called these

estufas, or council rooms, although later investigators believed some, if not all, were used for religious ceremonies.

Jackson was especially impressed by Pueblo Bonito, the largest structure, which contained approximately six hundred compartments and whose walls rose four stories in places. The walls were two and a half feet thick and faced with carefully cut stones:

> The masonry, as it is displayed in the construction of the walls, is the most wonderful feature in these ancient habitations, and is in striking contrast to the careless and rude methods shown in the dwellings of the present Pueblos. Those of Moqui, Taos, and probably Acoma, were in no better condition when first discovered by the Spaniards, nearly three hundred and forty years ago, than they are now; and how much older these perfect buildings were then than the rude piles of adobe and uncut stone found by the first conquerors.[3]

Hosta had been with Lieutenant Simpson many years earlier and remembered that most of the buildings in Chaco had been in good condition until the soldiers ripped out the floor timbers for firewood. But there was still a grandeur to this structure. Jackson explored Pueblo Bonito and each of the other sites as thoroughly as possible in his limited time. He crawled through a number of tiny openings that led to rooms where the walls were still coated with adobe plaster. In one room he found that Lieutenant Simpson had inscribed his name along with the date of August 27, 1849, "the impression appearing as plainly as if done but a few days previously."

Sometimes Jackson sat in one of the large circular chambers, many of which could have accommodated several hundred priests or tribal leaders, and mused about what it would have been like when it was filled with the Anasazi dignitaries. What matters of war and peace were debated here? What holy ceremonies made the stones vibrate with chants to the gods that dwelt amid the rocky bluffs?

Jackson found the now-deserted valley redolent with spirits of the past. He spent a great deal of effort taking photographs, carefully arranging his shots to show the magnificent ruins at their best. Jackson also made careful measurements of the nine most important Anasazi settlements in Chaco Canyon. This would be the scientific community's first opportunity to learn the grand scale of the ruins. He sketched Pueblo Bonito and also made a detailed map on which he located each of the individual pueblos. Jackson's energy was a wonder in itself:

> Having a couple of hours to spare before sunset one evening, I set about discovering a way up the bluff. Scanning the walls closely, I saw where there had formerly been means provided for reaching the summit through some of the great crevices which run up to the top, but they now were inaccessible. Back of the Pueblo Chetto Kettle. . . . I saw some steps and hand holds cut into the rock that seemed to offer the opportunity I was seeking. Climbing up a short distance over a slope of fallen rocks, I found in the sides of the crevice an irregular series of stair-like steps hewn into the hard sandstone, each step about 30 inches long and 6 inches deep.[4]

Modern visitors to Chaco gasp at the perilous stairway, still called the Jackson Stairs, that extends up the looming, three-hundred-foot canyon wall. But Jackson,

The walls here are quite ruinous, and almost indistinguishable.

7 8 9

Estufas.

10

3
Estufa.

4
Estufa.

1
Estufa.

2
Estufa.

11

Very ruinous, but clearly indicating circular rooms,
probably estufas.

21

12

20

13

18

19

14

17 16 15

5
Estufa.

6
Estufa.

The walls
here are
quite perfect
and from
three to
four stories
high.

Trail.

PUEBLO BONITO,
Chaco Cañon,
N. M.

10 20 30 40 50 60 70 80 90 100
Scale, 100 feet.

Jackson paid great attention to details, as this diagram of Pueblo Bonito demonstrates.

—Courtesy Denver Public Library, Western History Collection

who had made much more difficult and dangerous ascents than this, only commented about "easily gaining the summit." Once on top, Jackson found a new Chaco settlement, which he named Pueblo Alto, meaning "high town." Nearby he discovered pools of water in deep crevices among the rocks. "In these were thousands of gallons of clear, cool, sweet water, a thing we had not seen for many days." He drank from a pool and found the water "delicious."

Jackson's party camped close to the arroyo near the Pueblo Bonito ruins. Although the Chaco Wash was dry now, when Simpson had been here its water ran a foot and a half deep. During wet periods the Chaco people could have grown corn and other crops in the lowlands. But how did they survive during the typical dry years? he wondered.

Although Jackson did not have time to solve this riddle, subsequent investigators found a system of catchment basins, dams, and stone-lined, nine-foot-wide canals used to store water as well as to carry it to agricultural fields. In addition, supplies could have been brought in over the several hundred miles of roads the scientists discovered radiating from the Chaco Valley. These were real roads, thirty feet wide and graded down to the hardpan, with loose surface rocks piled in hedges to mark the edges. The highways' width, surprising in a civilization without wheeled vehicles, caused later theorists to surmise that Chaco may have been a holy mecca of some sort, the goal of religious processions. If this were so, then Chaco, except on festival days, would have had just a small priestly population, making large sources of food unnecessary.

Nonetheless, it was most likely the dry climate that ultimately caused Chaco's demise. After thriving there for some 250 years, the inhabitants were forced to abandon the site around A.D. 1150. It is believed that the survivors built new settlements at Mesa Verde and other more favorable locations.

When Jackson returned to Washington that fall, he began writing a lengthy treatise on Chaco for Hayden's Tenth Survey report. He had intended to illustrate the article with his photographs, but that was not to be. Jackson experienced one of the most terrible disappointments of his life when he tried to develop his film from the summer's work. He found to his horror that not a single photo emerged! Sadly, reliable dry film would have to wait another eleven years for George Eastman to introduce his revolutionary Kodak products. "It was quite the most costly setback of my career," he wrote many years later. "My feelings were beyond repair. . . . They still are. I can never replace those lost pictures." Nonetheless, his vivid descriptions of Chaco offered the modern world its first glimpse of this distinctive culture. In addition, his detailed diagrams of the various Chaco pueblos helped archaeologists form their first conception of the site's immensity, and his drawings of the Anasazi pottery revealed the human side of this vanished people.

Today Chaco is a highly valued national historical park. Moreover, it has gained such standing among international scholars that it has been designated a World Heritage Site, an honor received by only a few locations in the United States. For this Jackson, in at least a small way, is responsible.

Jackson's 1877 map was the first one ever made of the extensive Anasazi ruins in New Mexico's Chaco Canyon. — Courtesy Denver Public Library, Western History Collection

PART IV

Preserving Memories

Winding Down
Jackson's Last Hayden Survey; Success in Denver (1878–1890)

Although Jackson's glory days with the Hayden explorations had now come to an end, he could not resist joining one last survey the following year.[1] So in the summer of 1878 he was in Cheyenne. From there Hayden planned to explore Wyoming's Wind River Mountains and ascend Fremont Peak. Then the survey would continue to Yellowstone for more work.

The route led over a course Jackson had taken several times. For a while they followed the Oregon Trail, virtually deserted now that the Union Pacific could transport settlers westward with ease and rapidity. Jackson took no photos here, for there was nothing new to shoot. He had with him all his cumbersome old gear, of course.

At South Pass Jackson recalled his thrill when he had first come to it with the ox train, dreaming of the Montana goldfields. That was just twelve years ago—how different his life was now! He thought of Caddie Eastman, and how he had loved her. Even though he had married twice since then, he still carried her picture.

When he had first seen it, South Pass consisted of just a telegraph station. But a few years later miners discovered gold there and a town sprang up, eventually boasting two thousand inhabitants. South Pass City boasted having the first female justice of the peace in the country. The gold, however, had petered out before long, and now the place was just another ghost town. The cycle from renown to oblivion was quick in the West.

The Wind River Range rose just north of South Pass. This had once been Sioux country, but the Sioux were reservation Indians now. The surveyors soon reached the Popo Agie River and began working their way up the canyon. Deep in the mountains they discovered the river's source. Jackson spent an entire day there shooting but developed just two satisfactory photos.

The group proceeded along the sharp spine of the mountains, and at last came to the peak first scaled by explorer John Frémont more than thirty years earlier. At 13,700 feet its eminence was almost lost in the clouds. Since there was no way a mule could clamber up the rocks, and Jackson himself could not carry all his wet-plate paraphernalia, he was forced to concoct his own dry process. So the night before, he coated some glass plates with a bromide emulsion that he dried over a hot shovel. "Then, dreaming of New Mexico and Arizona and all those black films of 1877," he wrote, "I slept."

Early the next morning Jackson and his companions made the long climb. Although the ascent was difficult, the weather was beautiful, and upon reaching the summit Jackson cajoled five surveyors into posing on a rock. There they remained in

On Jackson's last trip with the Geological Survey team, he took this photo of the Popo Agie River at its source high in Wyoming's Wind River Mountains. —Courtesy U.S. Geological Survey

frozen positions for five full minutes, while high winds tugged at them and sneezes, coughs, and itches were suppressed. The pictures Jackson took on the mountaintop were mostly successful; the only detraction was that some had a large, dark oval where the drying chemical had gotten too close to the heated shovel.

With the first part of their mission completed, the team continued northward past the jagged Tetons—where Mount Moran immortalized Jackson's good friend—to Yellowstone. On their first exploration, Yellowstone had been so obscure that Hayden needed Jackson's photos to prove that the geysers, hot springs, and deep-cut canyons actually existed. Now Yellowstone was a national park with uniformed rangers and growing hordes of tourists. Among these tourists were pretty young ladies, whose images would give Jackson's photos added commercial value. He often used double-lens cameras, producing stereo shots for three-dimensional viewing in the popular handheld stereopticons.

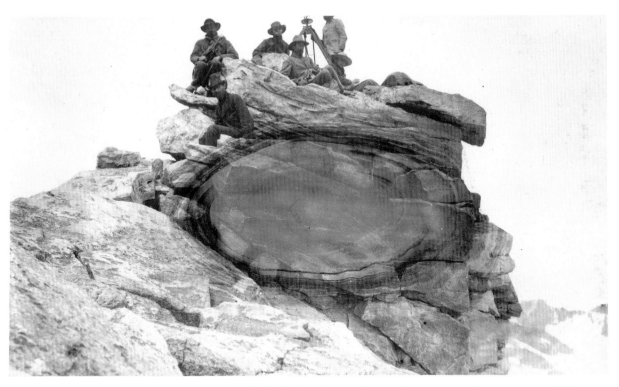

Surveyors at the summit of Fremont Peak. The dark oblong in the photo's center formed when Jackson dried the glass plate against a hot shovel. —Courtesy U.S. Geological Survey

Yet the raw wilderness remained close at hand, as Jackson learned when he and Hayden were riding along the banks of the upper Yellowstone River. They spotted bear tracks and spurred their horses forward to discover what kind of bear it was:

Soon we caught a glimpse of him lumbering ahead through the woods; a few minutes later we were within fifty yards. Tired, and still largely concealed by the dense, snow-covered shrubbery, he took his stand behind a heavy fallen tree. I unslung my rifle and dismounted, while Hayden, unarmed, remained in his saddle. His horse was violently excited. Mine bolted; but I didn't notice that.

I moved slowly toward the fallen tree. When about thirty yards separated me from it, a shaggy head and shoulders suddenly rose up—the head and shoulders of a silvertip grizzly. His eyes glared angrily, and the grip of his claws showed that he was preparing to spring.

It was one of those times when a man acts first and thinks—if he is fortunate enough—afterward. Quite mechanically . . . I threw back the cape of my heavy coat, dropped to one knee, and fired. (*TE,* 249–50)

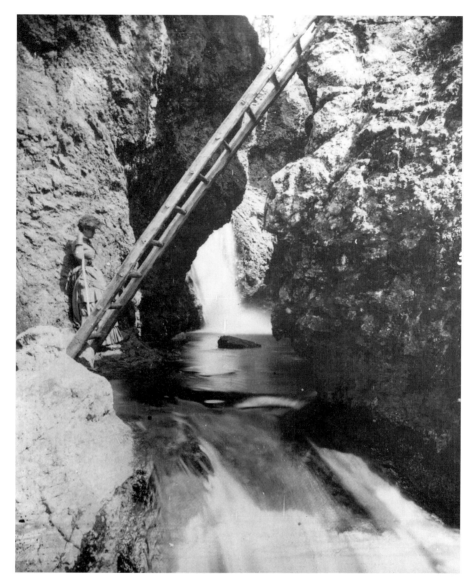

When Jackson returned to Yellowstone on his last survey trip in 1878, the once-deserted land had become a national park and was already frequented by many tourists. This picture is of Crystal Cascade. —Courtesy U.S. Geological Survey

Jackson's first bullet went directly through the grizzly's brain, and the bear crumpled lifeless to the ground. Nonetheless, as Jackson admitted, he and Hayden should have been more cautious following fresh bear tracks, knowing they might lead straight to a grizzly, possibly the most dangerous beast in North America. Later, survey hunters gave Jackson the animal's skin, which he planned to use as a rug in his living room. But when he left the chilly mountains, warm weather ruined the hide before it could be tanned and preserved. "All I took home with me was a necklace of claws — in which my very small son showed remarkably little interest."

Soon after Jackson returned to Washington, Emilie gave birth to their second child, Louise. Her arrival, probably combined with his close call with the grizzly, caused Jackson to rethink his life. He had a family and he was responsible for their welfare. He should not be exposing himself to such danger — whether grizzly bears or climbing steep mountains.

> I was thirty-five years old. I was the head of a family — a growing family. Soon there would be schools to consider. And there was my wife, Emilie, always loyal and comprehending, [who] surely deserved something better of marriage than a husband who was away five, six, seven months every year. (*TE,* 251)

In addition, there was the matter of money. His wages with the survey were only one hundred and seventy-five dollars a month and, even combined with his private photographic commissions, his annual income was less than three thousand dollars — "not a very high scale of living," he mused, "for a man who had reached the front rank in his field."

He had loved the freedom and adventure of working with the survey, as well as the camaraderie of the men. He had grown very close to most of them and would miss participating in the explorations. It would be a difficult life to give up. But he must face the changes that marriage and middle age had brought. He knew he needed a position in his profession with sufficient income to provide security for his family and himself. He hoped this could be accomplished by opening a studio in Denver. "I liked it there, the climate, the splendid mountains. I liked the people, and many of them were my friends. I liked the way the place had grown, from a raw town of 5,000 when I first saw it in 1870, to a flourishing city seven times that size."

But before he uprooted his family, Jackson thought he'd try to secure a contract with a Denver-based railroad for publicity pictures. That would certainly help him during his start-up period. So he went to New York City, where a survey friend took him to meet Jay Gould, one of the nation's foremost railroad tycoons.

Jackson was nervous. Gould had muscled his way to the top by sharp dealings, shrewd genius, and an utter disregard for ethics. When Jackson walked into Gould's office, he found himself in the presence of "the blackest, most piercing eyes in the world." Gould listened silently to Jackson's preliminaries, his mind obviously on more momentous subjects. But Jackson's mention of photography suddenly riveted the mogul's attention. "Are you the man who took those Union Pacific pictures a few

years ago?" he snapped. Jackson admitted that he was, fearing Gould's reaction — the Union Pacific was outside the Gould system. But it turned out that the railroad magnate had been tremendously impressed with Jackson's photography, and he began quizzing Jackson about the Union Pacific and his experiences at specific locations.

Although no one got close enough to Jay Gould to claim a friendship, Jackson talked animatedly with him about the West for nearly an hour. Before they parted Gould promised to write letters to a number of railroad officials in Denver. Jackson could only wonder what those men would think upon receiving personal communication from this almost legendary railroad baron.

Even though Jackson expected that Gould's letters would be a great help in securing commissions, Denver was still a gamble, so he left Emilie and the two children with relatives and proceeded west on his own. The family would join him when he was settled.

Jackson's first action when he arrived in Denver early in the summer of 1879 was to secure a studio. Finding a building under construction at 413 Larimer Street in the heart of the business district, he rented the entire second floor and hired a small staff. While the building was being completed, Jackson and his chief assistant bounced off in a light, two-seated wagon to the booming silver town of Leadville to take some pictures. When Jackson was in Leadville five years earlier with the Hayden crew, he had met Horace Tabor, then a shopkeeper, now the town's mayor.

A short time before, Tabor had suddenly become rich when he grubstaked two prospectors who subsequently struck a bonanza. With his mines producing an incredible amount of silver, Tabor's future seemed assured as he chatted with Jackson that day. Indeed, only a few months later he became lieutenant governor, and four years after that he bought himself a seat in the U.S. Senate. About that time he married a lovely young woman, whom everyone called Baby Doe. The guest of honor at their wedding was the president of the United States, Chester A. Arthur. Tabor went on to construct many buildings in Denver, foremost among them the Grand Opera House. Jackson and Emilie would attend the opera house's gala opening.

Thus no one could have foreseen the strange series of bad business decisions that ultimately left Tabor a broken man. Baby Doe lived for thirty-five years after Tabor died in 1899 and became a faded, pathetic woman who finally froze to death in a weather-beaten cabin outside Leadville.

In Denver, Jackson had been busy getting his new life in order. He had established ties with not only Horace Tabor but most of the other influential persons in Colorado by the spring of 1880. With the prestige of associates like these, his business "really began to roll," as he wrote, and Emilie and the children joined him.

Jackson's family responsibilities increased with the birth of his third child, Harriet, or Hallie, and he did the best he could to quiet his wanderlust. He could control it during the winter, when snow clogged the mountain passes. But as spring came and tepid breezes blew faraway fragrances over Denver, the old urge returned. Thus in

The interior of a photographic car. —Courtesy Colorado Historical Society

1881, when the Denver & Rio Grande Railroad—probably responding to one of Jay Gould's letters—asked Jackson to hire on as their company photographer, he eagerly accepted. The railroad gave him a private car, which even included a darkroom. "Thereafter," Jackson wrote, "I spent part of every summer on the rails"—leaving one of his four assistants in charge of the studio.

On the 1881 excursion Jackson was joined by two of his friends, painter Thomas Moran and writer Ernest Ingersoll. Each of the trio contributed to the good time while pursuing his particular interest. Ingersoll capitalized on the excursion to write *Crest of the Continent: A Record of a Summer's Ramble in the Rocky Mountains and Beyond.* Moran, on a commission from the *Colorado Tourist* magazine, found inspiration for some excellent watercolors of Colorado scenery. Many of the photos Jackson took that summer appeared in the *Denver Times,* as well as in an anonymously written book entitled *A Souvenir of the Beautiful Rio Grande . . . Masterworks of the World's Greatest*

Jackson with his wife, Emilie, and their three children, Clarence, Louise, and baby Harriet (called Hallie),
about 1881. —Courtesy Amon Carter Museum of Western Art

Photographic Artist, W. H. Jackson. To be touted as the world's greatest photographer must have amused Jackson—he knew that by this time there were at least half a dozen others taking pictures comparable to his.[2]

Although these summer excursions were ideal for Will Jackson, they were otherwise for Emilie. When her husband was gone, she was left to raise three rambunctious children alone. And when she and the children accompanied him, as they often did, the railroad car became as cramped as a miner's shack. She had no place to wash and dry clothes and no privacy at night. As for the children, while they enjoyed the exciting towns and beautiful scenery, they had no place to play—and they could not make friends when they were in a different locale every day.

Jackson was aware of his wife's concerns, but this was his job. "If it wasn't always as satisfactory for my wife as it was for me," he admitted, "Emilie fully understood and agreed that it was, under the circumstances, the best one possible for all of us. It gave us the income to live well. . . ." Eventually Jackson's railroad work expanded until he was taking publicity pictures across the entire country, from Yosemite to New York to Florida. For a time he even shot photos for the Mexican Central Railway, once bringing home a miniature Chihuahua puppy for son Clarence, which the eight-year-old promptly traded for a full-grown donkey.

As the years passed, Jackson, now one of America's most prominent photographers, became a sort of unofficial chronicler of the changing nation. Meanwhile his business prospered, and in 1886 he built a home at 1430 Clarkson, on Denver's fashionable Capitol Hill. He and Emilie were soon attending society affairs, including at least one reception at the governor's mansion. Among Jackson's friends were community leaders, businessmen, and railroad executives.

The historical value of Jackson's early photos took on added significance in 1890 when the census revealed that the frontier had vanished—Americans had settled virtually everywhere in the transcontinental realm. All that remained of the Old West—that untamed expanse inhabited only by free-roaming Indian tribes, audacious mountain men, and wild animals—were the dusty memoirs of those who had lived during that epic era and the photos of William Henry Jackson. His pictures appeared in almost every book written about the Old West, often with no credit or royalties paid to the man who had expended so much effort to take them. Through Jackson's work the true images of the Wild West lived on.

The Whole World Watching

The Columbian Exposition; Jackson's World Tour (1892–1895)

In 1892, when Jackson was fifty, he was engaged by the Baltimore & Ohio Railroad (the B & O) to take photos for its display at the upcoming Columbian Exposition in Chicago. This exposition, marking the four-hundred-year anniversary of Columbus's discovery of the New World, promised to be even more imposing than Philadelphia's Centennial had been sixteen years earlier. Of course, Jackson accepted. Leaving his family in Denver, he hurried to Baltimore. There he met Joe Pangborn, who was in charge of advertising and publicity.

Pangborn was a polished gentleman who spoke in grandiloquent prose accented by sweeping gestures and cigar smoke. Pangborn sometimes accompanied Jackson over the B & O route as he took photographs, and even tagged along when Jackson visited his son Clarence, now a young man of sixteen attending an academy in New Jersey.

At one point Pangborn asked Jackson to consider joining his proposed World's Transportation Commission on a tour through Asia and Europe to study foreign railroad systems. Jackson responded that he was interested but he wondered how Pangborn would raise the money for such an expensive enterprise. "Ah, that is something I am working on now," was Pangborn's airy answer. The plan was so vague that Jackson dismissed the whole crazy scheme. Besides, nobody could go anywhere until after the Columbian Exposition.

The Baltimore & Ohio exhibit contained more than a hundred of Jackson's photos—including a magnificent thirty-foot panorama. But that exhibit was only a small part of the exposition, which was an awesome collection of two hundred alabaster buildings connected by canals and lit up at night with more electric lights than were used in Chicago itself. So impressive was the illumination that everyone called the collection of buildings the White City.

One structure was devoted solely to the coming wonders of electricity. Here Thomas Edison showed off a contraption called a "phonograph." Close by was a model home demonstrating such futuristic devices as electric stoves, hot plates, laundry washers, and carpet cleaners. The Bell Telephone exhibit was another marvel. Bell engineers had just laid a wire all the way to New York City over which people could hear conversations just as if they were there. At another exhibit visitors could see a carriage run by a gasoline engine—that is, if their view wasn't blocked by the curious young tinkerer from Detroit named Henry Ford.

Buffalo Bill Cody had tried to get space at the Expo for his Wild West show but was turned down; the officials evidently felt that his Indians were already passé.

Undaunted, Cody leased fifteen acres directly opposite the fair's entrance, put up a grandstand that held eighteen thousand people, and ran two performances a day. Although his star attraction, Sioux chief Sitting Bull, had been murdered by Indian policemen four years earlier, the public still enjoyed watching the Indians in their colorful costumes gallop around the ring.[1] Cody and his partner had made a cool million by the end of the summer, at which time the Indian performers were sent back to their reservation.

Even though Jackson was not an active participant in the B & O exhibit, he came to Chicago to enjoy the fair. Oddly, Emilie and their children were not with him. But it was just as well, because the Expo officials, disgruntled with their official photographer's work and learning that Jackson was on the grounds, asked him to take a series of documentary pictures of the event. As a result, his time there was spent making about a hundred exposures, for which he received one thousand dollars.

One of the photos Jackson took at the World Columbian Exposition in Chicago. This one pictures the Grand Court. —Courtesy Chicago Historical Society

Later he sold duplicate negatives to a Denver proprietor for another thousand dollars. It was quite a good haul for ten days of pleasant work.

Meanwhile Joe Pangborn was moving ahead with his plans. When the Expo closed he talked the B & O into donating its entire exhibit, consisting of fifty-eight model locomotives as well as Jackson's photos, to Marshall Field, the Chicago department store magnate, who wanted the exhibit for a museum he was starting. In return Field donated twenty-five thousand dollars to Pangborn's World's Transportation Commission. Helped by Field's endorsement, Pangborn wheedled further donations from such bigwigs as Andrew Carnegie, Cornelius Vanderbilt, and George Westinghouse.

Pangborn renewed his invitation to Jackson to accompany him and the other three members of the commission on their trip, offering to pay all his travel costs in return for the photos he would take en route. Jackson could not resist and quickly shelved his vow to be a more attentive husband. Reinforcing his decision was the discovery that the royalties he would receive from *Harper's Weekly* for his world-tour photos would more than cover his family's living expenses while he was gone.

So early in October 1894 Jackson bid farewell once more to his family and took the train to New York, where he met his party and boarded the ship for Europe. For this excursion Jackson carried an ample supply of dry film—in which he now had cautious confidence. The easily portable rolls of film, along with lightweight handheld cameras, gave him the mobility and independence he so long had yearned for. He could take all the photographs that Pangborn expected, as well as those for *Harper's*, without slowing down the others.

Under Pangborn's flamboyant direction, the commission got off to an imposing start. Nearly every detail of their itinerary, complete with laudatory comments on each member of the commission, appeared in the newspapers, courtesy of Pangborn. The U.S. secretary of state not only offered the commission his blessing but dispatched instructions to American consuls around the world to arrange for a full-blown diplomatic reception in each country they were to visit. After all, they were representatives of America, the new major player on the world stage.

After brief stays in London and Paris, the commission crossed the Mediterranean to Tunis, where a highlight, at least for Jackson, was a visit to the ruins of ancient Carthage. Then they traveled by rail across North Africa to Cairo and from there toured the Nile's storied tombs and temples. Although Egypt was quiet when Jackson took his photos, there was a good deal of underlying tension due to British occupation. British activities had begun two and a half decades earlier with the opening of the Suez Canal, which Britain regarded as the lifeline to its empire in India.

Leaving Egypt, the Americans sailed through the canal to the island of Ceylon (now called Sri Lanka), which had been a British colony for nearly a hundred years. There they bought white suits and enjoyed ten days of parties. "I found myself on the go eighteen hours a day," Jackson recalled. "And I loved every hour."

It was just a short cruise to India, and by January 19 they were in Bombay, where two resplendent carriages took them from their hotel to the palace of British governor Lord Harris for a state dinner. A row of brilliantly uniformed lancers lined the way into the palace and half a dozen turbaned footmen took their hats at the entryway. From there a military aide escorted them to the large reception hall, where Lord Harris soon entered in full military regalia. Thirty men and three women, including the very English Lady Harris, enjoyed one of India's legendary banquets. Jackson was thrilled to be seated next to Lord Roberts, hero of a war against Afghanistan through which the empire had secured India's northern border.

The Americans left Bombay by steamer and three days later were in Karachi (then part of India—the country of Pakistan would not exist for another half century). From there they went north by rail, often along the Indus River, once crossed by Alexander the Great, empire builder of an earlier era. Everywhere they were feted by the British. "I was getting to feel like a character in an English novel," Jackson remembered, "what with dressing for dinner every night and conversing exclusively (so it seemed) with Lord This and Lady That." But gradually Jackson began to see the British as an occupation force: "Anglo-India was still a thin cover on top of a volcano," he wrote, noting the heavy presence of soldiers, many of whom were Indians serving as British mercenaries, as well as military caravans, especially in the north, and cannons at strategic locations.

Much of India was still ruled by local rajas allied with the British. Jackson was present at many military reviews but none as colorful as that in Kashmir:

> . . . troops on foot, all splashed with gold and green and white and crimson—bearded lancers on black horses—red jacketed and white turbaned artillery men firing salvo after salvo—charging elephants—the spires of the temples beyond—and, in the far northeast, against a cloudless sky, the snow-tipped Himalayas. I have never seen a sight to match it. (*TE*, 278)

Leaving India, Jackson and his companions saw more of the empire at its zenith as they passed through British-controlled Burma on their way to Singapore, the mightiest of Britain's Far Eastern bastions. The British were absolutely determined that the details of their military defenses remain secret, and when Jackson unwittingly photographed one of the forts, security forces arrested him. Hence he spent his fifty-second birthday under military guard in the fort until the intervention of the American consul brought his release toward nightfall. Still, the next morning he had to plead his case in front of a magistrate before he was free to leave the island.

From Singapore the commission was off to Australia and New Zealand, two more cornerstones in the British economic and military network that stretched across the entire world. Next they toured Indonesia, then known as the Dutch East Indies, before continuing on to China. The Chinese under the dying Manchu dynasty were a beaten and humiliated people, having lost a series of skirmishes with the British as well as, more recently, a major conflict with the Japanese. Even as Jackson toured

the country, revolutionaries such as Sun Yat-sen were plotting the overthrow of the Manchus. After seeing China, the commission then sailed to Japan, which was just emerging from its centuries-old cocoon.

It was truly a momentous time in history. Jackson was in a rare position to witness the nineteenth century in its death throes. But he took little note of it in *Time Exposure*, stating with apparent smugness: "I can enjoy one of the dubious fruits of autobiography. I can omit when I choose, and I choose to skip the five months we spent in the East Indies, Australia and New Zealand, the Chinese Empire, and Japan."

In October 1895 the commission was in Vladivostok preparing to cross Russia by sledge (the Trans-Siberian Railroad was just then being built). It did not matter, however, that there was no railroad to inspect because by now everyone had admitted that the World's Transportation Commission was more a lark than a real attempt to ana-

This picture of a Russian sledge was taken on Jackson's world tour. —Courtesy Brigham Young University

lyze the world's rail systems. Inasmuch as the tour sponsors had begun to surmise the same, promised money did not come and Pangborn soon found himself so low on funds that he had to borrow from one of the Russian governors.

The group had to wait nearly two months for the many unbridged Russian rivers to freeze sufficiently for the passage of the heavy sledges. But, as they were guests in a governor's luxurious palace, they did not mind. Time passed in a whirl of social functions. At many of these get-togethers conversation centered on the new young czar, Nicholas II, who had just been in a train accident. The Russian upper crust with whom Jackson socialized minimized the role of lower-class oppression in the assassination of Nicholas's father the previous year. Little did anyone realize that the people's antagonism would ultimately result in the violent Communist Revolution and the murder of Nicholas and his entire family twenty-three years later.

The sledge trip across Russia took forty days of continuous travel. The travelers stopped every fifteen miles to change horses and eat hot meals at government stations. Although the temperature averaged twenty below zero, everyone slept in the moving sledges. Jackson refused to travel in a closed sledge, where the windows became so frosted that he could not enjoy the scenery. Instead he bought a used sledge and "from that time forward I rode with the wind in my face and loved it."

By the end of January 1896 the commission was in St. Petersburg, the Russian capital. Here Jackson purchased brooches for Emilie and his two daughters. "As I put the boxes in my pocket, I realized that my little girls would be quite grown up when I saw them again; Louise was now seventeen and Hallie nearly fourteen." Jackson's wanderlust was causing him to miss most of his children's formative years.

Soon the Americans were back on the train, this time headed for Germany. From there they embarked for home, arriving in New York City on March 3. After visiting with officials at *Harper's Weekly*, Jackson took the train to Denver, admitting "home was more inviting now than all the kingdoms of the world." He had been gone seventeen months.

Facing the New Century

The Detroit Photographic Company and the Good Life (1896–1917)

When Jackson returned to Denver in 1896, he learned that his business was in chaos. This was partly the fault of W. H. Rhoads, the man he had left in charge, in that the quality of his work was distinctly inferior to Jackson's. "Rhoads also has lost pretty much all our old line of business—i.e. the hotels and railroads," Jackson lamented.[1]

But it was not solely due to Rhoads's deficiencies that Jackson's business had deteriorated. Publishers all around the country were printing Jackson's photos without giving him either credit or royalties, he discovered. One of the worst was Rand McNally, whose guidebooks not only used Jackson's photos without his knowledge but actually replaced his name with their own in the credits! Furthermore, the company was so brazen as to sell the engravings to other publishers.

From that point on, Jackson made certain that he filed his pictures with the government in accordance with the copyright law of 1891. But it was too late to do anything about the appropriation of the previous photos, quite a few of which had become classic shots of the early West, and many were, in effect, lost to him. To add to his problems, the science of photography had been advancing so rapidly during his seventeen-month absence that Jackson was falling behind. One such advancement involved printing pictures by halftone engraving, which enabled his competitors to print reproductions far more cheaply than Jackson could with his outdated methods. Jackson realized his business was in trouble.

So Jackson began to seek alternative sources of income. One possibility presented itself when an entertainment promoter, upon learning that Jackson had recently given a well-attended speech about his travels, talked Jackson into undertaking a lecture tour. The series was called "One Hundred Minutes in Strange Lands" and included a display of 125 exotic pictures that Jackson had collected on his world tour. The photos were projected onto a screen by a stereopticon. The tour started out well, with Jackson attracting good audiences. However, unanticipated travel expenses, printing bills, and other costs ate such holes into the profits that the venture ended as a financial failure. But, with his usual optimism, Jackson concluded that "the publicity did me no harm."

Actually, that comment proved to be an understatement. The tour added luster to his name, which aided him in negotiations when the newly organized Detroit Photographic Company, headed by William A. Livingstone, offered to buy out his business.

Livingstone was from a wealthy family and had the ample resources that Jackson lacked. Furthermore, Livingstone had just returned from Switzerland, where he had

obtained the exclusive North American rights to the revolutionary photochromic process, whereby black-and-white photos could be converted into brilliant color. This process involved a complicated and now forgotten procedure by which a photographic negative was transferred to a lithographic stone that was coated with a light-sensitive chemical. After exposure to the sun, the positive image was treated to bring out a particular color. The process was duplicated for other colors on separate lithographs—as many as fourteen. The lithographic images were then printed on glossy paper, one over the other. The result was color photographs very nearly as good as those of today. Jackson was quick to realize that having the rights to such breakthrough technology gave Detroit Photographic tremendous potential, although he could not have foreseen that in a single year the company would print an estimated seven million of the extraordinary photochromic prints.

Livingstone was well aware that simply obtaining the right to use the photochromic process did not ensure its success; he still needed high-quality photos. He knew that Will Jackson had the most spectacular photographic collection in America, and he had heard that Jackson was having financial difficulties. So it was natural that the two men should reach a meeting of the minds, and sometime later Livingstone made the long trip to Denver to solidify the agreement. Jackson tells the story:

> He arrived early in the fall of 1897. His company was installed in its new Detroit factory and was ready to turn out the finest color reproductions at prices that could meet all competition. I had two things to contribute: the most complete set of Western negatives yet assembled by one man, and my experience and reputation. After a little beating around the bush Livingstone and his associates agreed to take over the W. H. Jackson Company at its nominal capitalization of $30,000—some $5,000 was paid in cash (and used almost entirely to cover floating indebtedness), while the rest came in stock of the new company. In addition, I was to become a director, at a comfortable salary. (*TE*, 323)

To fill this position as a working director, Jackson and his family moved to Detroit. He had with him fully twenty thousand negatives—a tremendous number, many of which, as we have seen, had been developed on glass plates on windy mountain peaks. Jackson wrote:

> In the fall of 1898, I buckled down to intensive indoor work. The plant of which I was part owner . . . employed about forty artisans. . . . Our business was the production of color prints . . . in sizes varying from postal cards to the largest pictures suitable for framing. . . . Retail sales rooms were maintained in Detroit, New York, Los Angeles, London, and Zurich. Our 342-page catalog went to all parts of the world. (*TE*, 324)

The arrangement was financially a distinct improvement for Jackson, and so he spent as much time in the plant as his itchy feet permitted But the next year he convinced his associates that he would be of more value as a photographer than a manager. So he was on the road again. During 1899 he photographed scenes from San Diego to Boston—traveling more than twenty thousand miles. It was quite a vigorous schedule for a man of fifty-six.

The reason for his heavy activity was the popularity of Detroit Photographic's colored picture postcards. The company "surpassed all others in terms of technical proficiency and scope of issues," concluded George and Dorothy Miller in *Picture Postcards in the United States, 1893–1918*, the definitive book on the first twenty-five years of such cards.

Jackson's pace continued. In 1900 he made the rounds in Canada, then topped the trip off with a voyage along the lower Mississippi. During that winter he ranged through Virginia and Florida before hopping across the Caribbean to get shots of Cuba. By 1902 Jackson's efforts had helped propel Detroit Photographic to its most successful year.

During his travels Jackson sometimes purchased negatives from local photographers to expand his coverage of a subject or region. This was a common practice

Jackson photographed many cityscapes on his trips for the Detroit Photographic Company. This shows San Francisco in 1904. —Courtesy Colorado Historical Society

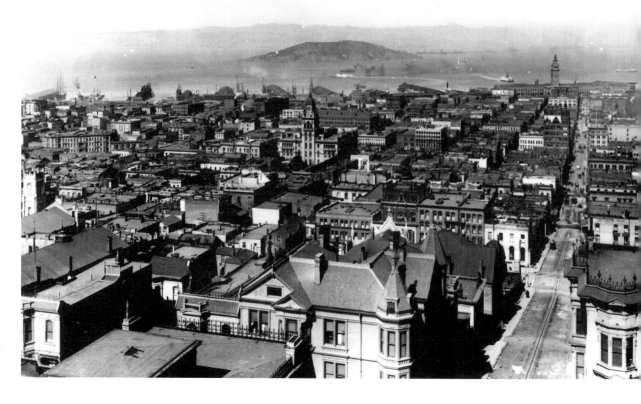

among photographers at the time, and the pictures were published under the name of the Photochrom Company or its parent, the Detroit Photographic Company. For this reason it is difficult or impossible to determine which pictures were actually Jackson's own.[2] But Jackson certainly was responsible for a good many, if not most, of the company's photographs during this period.

Jackson's situation changed in 1903, when Photochrom's plant manager moved to California. For the sake of the company, Jackson had no choice except to take over his position. With that, his career as an active landscape photographer ended. In his heart he knew it was time, for he was now sixty years old:

> After so many years of work in the open, I turned gladly, even enthusiastically, to a routine career. For one thing, it was a much easier life, going to an office every day. . . . For another, there was the almost novel pleasure of living with my own family, of sitting at the table with my wife and daughters, of taking them to the theater, and of going with them on little trips to near-by resorts. (*TE*, 327)

Gradually Jackson began partaking of what society called "the good life." Around 1908 he joined the Detroit Golf Club and soon was on the links regularly with a group of friends. "If we duffers seldom broke a hundred, we always managed to make it up at the 'nineteenth hole' afterward," he commented wryly.

He also learned that Emilie was a pleasant companion:

> All three of my children had married, and my wife and I, for the first time since our marriage, had no immediate obligations to anyone except ourselves. I still made occasional photographic trips, and now, when I went off to Georgian Bay, or to the Gaspé, or to the White Mountains, Emilie accompanied me. Those trips, after thirty-five years of married life, were the first really complete holidays we had ever had together. (*TE*, 328)

It was well that Jackson began finding time for Emilie, for she, unlike him, was fading with the years. Although Jackson devoted very little space in his autobiography to Emilie, she must have been an extraordinary woman — managing a home without a husband for months at a time, raising three children almost by herself, tending their hurts and soothing their fears. It was not until Emilie was in her sixties that Jackson was there to share her life.

Perhaps Jackson originally regarded Emilie as more a convenience than the love of his life — there is no way to know. Could it be that Caddie Eastman was still first in his affections? After all these years, he constantly kept her photo with him. Yet when Emilie died in 1917 Jackson realized that it was she who had been the granite that had given his life stability. "We had lived together in love and harmony through forty-five years," he mourned after she had been buried beside her parents in Baltimore.

Never Stop Moving
The Final Years (1917–1942)

Although Emilie was gone, Jackson was not all alone. His daughter Louise and her family were living in the same house. He also had many interests to keep him from falling into depression.

> Looking ahead without [Emilie] at the age of seventy-five was no easy task. But three lively grandchildren in the house did much to solve the present, while the future, as it always had before, shaped itself. And I had two occupations—my work and the recreation of the golf course. (*TE*, 329)

In addition, Jackson was still going to the plant every day, because the picture-postcard business was thriving during the first few years after World War I. But by the 1920s the competition had begun to produce cheaper and better pictures, and Detroit Photographic's sales plummeted. At last, in 1924, after its debts had become such that it was impossible to continue, the company filed for bankruptcy. "My investment of course disappeared," Jackson lamented, "and, at the age of eighty-one, I found myself without either capital or any certain means of livelihood. It wasn't exactly an encouraging situation."

All Jackson had to live on was six thousand dollars' back salary and his modest Civil War pension of seventy-five dollars per month. But he was not dismayed—he never was. He invested the six thousand dollars in the stock market, which was booming. Then he moved to Washington D.C., where he stayed with his other daughter, Hallie, and her family. His reason for going back to Washington was to use the Interior Department's extensive records to help him write a book describing his days with the Geological Survey.

Jackson also resumed his artwork, which had pretty much lain dormant since he had sketched the ox drives so many years earlier. Rather quickly his new drawings and oil paintings attracted the attention of museums, some of which hired him as a consultant for their western exhibits. Soon national magazines were asking him to illustrate their historical pieces.

Another project Jackson had going at this time was a manuscript about his western experiences, which he titled *Pioneer Photographer*. The enterprise had been suggested by Howard Driggs, professor of English at New York University and editor of the Pioneer Life Series for high school readers. Aided by Driggs, Jackson was able to meet the deadline for a 1929 publication date. The success of *Pioneer Photographer* would encourage Jackson to write his autobiography years later.

The book's publication not only helped in a small way to reignite Jackson's reputation but also brought him much-appreciated extra income. Luckily this income coincided with the 1929 stock market crash, in which he lost virtually his entire nest egg. In addition, the book carried a hidden bonus that Jackson could never have imagined. On the frequent trips he made from Washington to New York to consult with Howard Driggs, Jackson usually stayed at the Hotel Latham, where he frequently encountered Ezra Meeker.[1] Jackson's friendship with Meeker would eventually usher in Jackson's next undertaking.

Meeker was about the only person Jackson knew who was older than he—thirteen years older. Meeker, who had taken an ox wagon over the Oregon Trail in 1851, had dedicated his remaining years to preserving the legacy of the trail, which was fast becoming overgrown with weeds and obliterated by wind and rain. Meeker's dedication rekindled Jackson's interest in the Oregon Trail. When Meeker died, Howard Driggs succeeded him as president of the Oregon Trail Memorial Association and offered Jackson the position of research secretary. Since the job carried what Jackson called a "comfortable little salary," he moved to New York to assume his duties.

Jackson was happy with his new position. In the winters he could hole up in New York doing research, and in the summers he could travel along the trail to help relocate the route, collecting memorabilia from old-timers along the way. Soon he became a popular lecturer on the Old West. In between doing research and giving lectures, he made scores of watercolor paintings. It was a fulfilling time in his life.

Interestingly, in his later years his paintings began to overshadow his photographic work. The height of his new recognition came in 1935 when the Department of the Interior commissioned him to paint four huge murals for their new headquarters building. The paintings, each thirty feet by sixty feet, were to depict representative scenes from the early geological explorations. For this job Jackson was eminently qualified. He knew firsthand almost everything about the surveyors' life, from the equipment they used to the way their mule teams were hitched and the food they ate. For the murals' backgrounds, he used settings that he had personally visited. Thus for the painting of the Hayden Survey he selected Yellowstone's Old Faithful as a backdrop. For the others he used the Zuni Pueblo, the Colorado River, and California's Sierra Nevada. Jackson found this project, which lasted eighteen months, "one of the most gratifying tasks of my life."

Jackson performed another satisfying task the same year, involving the seventy-fifth anniversary of the Pony Express. Three hundred Boy Scouts rode in relays over the old route from Sacramento to St. Joseph, Missouri, where Jackson and a few other dignitaries met them. After the Scouts handed them a dispatch from California, Jackson and the others boarded a plane and flew on to Washington D.C., where they presented it to President Franklin Roosevelt.

At age ninety-two, Jackson wanted to tidy up a certain loose end. It concerned the more than forty thousand glass plates on which he had produced his early

negatives. Either some permanent place must be found for them or they would have to be destroyed. Fortunately Edsel Ford, with father Henry's backing, agreed to house them in the museum they were building at Dearborn, Michigan.

In 1936 Jackson stopped off at Scotts Bluff in Nebraska for the dedication of a national museum.[2] Although the heat was intense, he bore himself with an "arrow-like posture and vigorous manner [that] belie[d] his 93 years," ran a newspaper article.[3] When it came his turn to speak, he shrugged off the oppressive weather. "His only comment was that 'it was on a day like this that I passed through Mitchell Pass for the first time.'" Jackson then presented the museum with an album of pictures and sketches he had made along the Oregon Trail. When the brief ceremony was

Jackson returned to Scotts Bluff in 1936 to dedicate the museum. In this photo he points to the site at Mitchell Pass where he'd camped as a bullwhacker seventy years earlier. Today a trail leads from the museum to an interpretive marker at the campsite. Had Jackson himself taken the picture, it certainly would have been better. —Courtesy Scotts Bluff National Monument

over, Jackson continued on to Yellowstone Park, which he visited each year. From there he went to Walla Walla, Washington, where he represented the Oregon Trail Memorial Association at another celebration.

Well into his nineties, Jackson was still not ready to curb his active life. In 1938 he accepted an invitation to be a guest of honor at the seventy-fifth anniversary of the Battle of Gettysburg. The celebration lasted for six days, and more than nine thousand Civil War veterans were present. Jackson, gregarious as ever, found the companionship delightful. Military-style tents had been set up on the lawn in a mock encampment. It amused Jackson that the longest line formed before the first-aid tent, where the veterans waited, not for medical help, but for their complimentary issue of rum. Jackson, who enjoyed imbibing as much as anyone, no doubt was among them. The highlight of the ceremony, at least for Jackson, was when he and three other veteran dignitaries boarded a small plane and flew over the cemetery strewing roses.

Later that year Jackson again traveled to Scotts Bluff, this time to attend the annual meeting of the Oregon Trail Memorial Association. On this occasion he tramped out to where he had camped nearly a century earlier and drove in a stake to mark the spot.

An entirely new group of photographers had reached national prominence by this time and many revered Jackson. Ansel Adams selected some of Jackson's early prints for inclusion at a Museum of Modern Art exhibition, and Jackson was a guest of honor at the preview. Making his way among photos of the Civil War and the frontier, Jackson paused in front of one and remarked, "That's a pretty good picture, Mr. Adams. Who took it?" Adams answered with a smile, "You did." Jackson mused for a moment, then nodded, "Why so I did. But I can do better now and in color with this . . ." he said as he pulled a small camera from his hip pocket, laughing. "And no need for a string of mules!"[4]

Now in his mid-nineties and active as ever, Jackson began work on his autobiography, *Time Exposure*. To refresh his memory he had his diaries, which covered nearly a third of his life, as well as the sketches that he began during his school days and continued through his service with the Union army and his bullwhacking treks across the West. And, of course, he had his photos—reams upon reams of them, nearly all showing a way of life long since vanished.

Memories must have flooded his mind as his pen scratched across the paper. His mother and father were again with him. His friends from his footloose days laughed and sang once more. And there were the bittersweet memories of Mollie, dear, dear Mollie. It was with great effort that he wrote about his happy days with her, and with greater anguish about her death. If only he could have been there to comfort her during that fearsome ordeal of childbirth.

Hayden appeared, moody, nervous, and brilliant. Emilie, too, who he'd thought would be with him until the end. Even Caddie materialized once more—young and beautiful, and unobtainable. What had happened to her? He probably knew, for he had many friends in Vermont. But, if so, he does not mention it in *Time Exposure*. Yet

Jackson in a photo taken for a program celebrating his ninety-fourth birthday in 1937. —Courtesy Colorado Historical Society

he'd cherished her picture for all those many years.[5] He must have wondered if she'd ever thought of him, and of what might have been.

All these people were doubtless dead now. It seemed impossible that he had really lived for almost a century. Yet *Time Exposure* did not come across as the sentimental ramblings of an old man. Written with wit and a scrupulous regard for accuracy, the book was a vigorous portrayal of a remarkable man living in a remarkable era.

Published in 1940, Jackson's autobiography was exceedingly well received. Few people had seen the West when it was still a place of myth and magic. And Jackson

had actually been among the Indians when they could lift a white man's scalp. His pictures were thrilling not so much because of their quality—for photographic technology had progressed far beyond his primitive cameras—but because they recorded scenes from America's past that would never exist again. In that respect Jackson's pictures could never be equaled.

Jackson ended *Time Exposure* with some reflections:

> There is a legend that I have found curious. It is that when a man grows old he becomes automatically an authority on longevity, a reliable source of scientific information on diet, exercise, and general behavior. And, of course, I have had my share of such inquiries. . . . The first [reason for living so long] is that I inherited a tough constitution. . . . The second reason, in my mind, is that I never took out enough time to get run down. There has always been so much to do tomorrow. (*TE*, 340)

But his tomorrows finally ran out in 1942. He never fully recovered from a fall, and he died in New York City on April 30. At the time of his death Jackson had three children, seven grandchildren, and four great-grandchildren. He was buried in Arlington National Cemetery, just outside Washington D.C. The *Herald Tribune* noted Jackson's passing with an eloquent obituary that began: "Jackson, who for 79 of his 99 years viewed the world through three eyes, two of his own, the other the searching, ever-improving eye of the camera, is dead."[6]

However, it was Jackson himself who may have written his own truest, as well as simplest, epitaph in *Time Exposure:* "I have been one of the fortunate."

Resources

Major Collections of William Henry Jackson
Photographs, Paintings, Sketches, and Other Materials:

Amon Carter Museum of Western Art, Fort Worth, Texas

Boston Public Library, Boston, Massachusetts

Colorado Historical Society, Denver, Colorado

Denver Public Library, Western History Collection, Denver, Colorado

George Eastman House, International Museum of Photography, Rochester, New York

Library of Congress, Washington D.C.

Scotts Bluff National Monument, Gering, Nebraska

U.S. Geological Survey, Denver, Colorado

Yale University, Beinecke Library, Western Americana Collection, New Haven, Connecticut

WEBSITES:

http://www.nps.gov/scbl/whj.htm

http://www.fit.edu/InfoTechSys/resources/cogsei/whjip.html

Notes

Introduction

1. The war between the U.S. and Mexico began in 1846 after the U.S. annexed Texas, then an independent state but ten years earlier part of Mexico. The war ended in 1848. The resulting treaty gave the U.S. territories that eventually became the states of California, Arizona, Nevada, New Mexico, and Utah as well as a major portion of Colorado.

2. Oregon had been jointly owned by the U.S. and Great Britain for several decades. But with the establishment of the Oregon Trail and the resulting American migrations beginning in 1843, the two nations agreed that in five years the area south of the 49th parallel would become part of the United States. The original Oregon Territory included not only what became the state of Oregon but also Washington, Idaho, and parts of Montana and Wyoming.

3. Peter Hales, in *William Henry Jackson and the Transformation of the American Landscape*, makes a case for Jackson as a major force in keeping alive what Hales calls "the twin myths of the radical individual and the free landscape."

4. George Catlin lived among different Indian tribes throughout the U.S. for much of the 1830s and 1840s, becoming a renowned painter of Native American subjects. His *Letters and Notes on the Manners, Customs, and Conditions of the North American Indians* has become a classic of early Western literature. Catlin died in 1872.

5. Karl Bodmer was a Swiss artist who accompanied German naturalist Prince Maximilian on an extensive journey through the western U.S. in 1833 and 1834. Bodmer made dozens of superb sketches and paintings of the landscapes they traversed and the Indians they encountered.

6. Louis Daguerre began working on a camera as early as 1826, when he formed a partnership with Joseph Nicephore, who had achieved a crude photograph four years earlier. The daguerreotype, which formed an image on a metal plate, was costly and time-consuming, and could not be reproduced. In 1851 a new process in which a colloid was applied to glass plates began to replace the daguerreotype. The collodion process predominated for two decades and was the method Jackson originally used. Because the negatives could be reproduced, commercial photography was born, with Jackson at the forefront.

7. Mathew Brady was one of the first American photographic entrepreneurs. He opened a daguerreotype studio in New York City in 1844, and by the time the Civil War began in 1861 he was an unquestioned leader in the field. Convinced that he could make a fortune selling photos of the Civil War, he paid twenty photographers to cover the battlefields and military camps. Unfortunately sales were weaker than expected, and he died in a charity hospital in 1896.

1. Born to Roam

1. Quotations from William Henry Jackson's work are cited in the text with the abbreviations listed here.
 D: The Diaries of William Henry Jackson, ed. LeRoy R. Hafen and Ann W. Hafen (Glendale, Calif.: Arthur H. Clark, 1959). Quotes reprinted by permission of the Colorado Historical Society, Denver.
 TE: Time Exposure (Albuquerque: University of New Mexico Press, 1986).

2. Jackson's Uncle Sam Wilson story is confirmed by many sources, including the entry "Uncle Sam" in the *Grolier Multimedia Encyclopedia*.

3. John C. Frémont had a roller-coaster life. In 1842 he gained fame as an explorer who helped establish the Oregon Trail's best route through South Pass. Over the next two years he roamed the West from the Rockies to California, becoming popularly known as The Pathfinder. He became a public hero for being one of the leaders of the Bear Flag revolt against the Mexican rule in California in 1845. During the Civil War Frémont served for a while as a commander of the Mountain Division of the Union army but was forced to resign for insubordination. He experienced business failures in later life and died a near pauper.

4. Douglas, who supported Lincoln when the latter became president, was on a speaking tour for the Union cause when he died of typhoid fever in June 1861.

3. Toward a New Life

1. In 1861 technology ended the brief but glorious life of the Pony Express. Established in 1860, the Pony Express cut the time for mail to reach California from Missouri from about three weeks to just ten days. But when the telegraph enabled dot-and-dash messages to cross the country in just minutes, the express company went bankrupt.

4. Learning the Ropes

1. The Otoes spoke a Siouan dialect and were also related to the Missouri and Iowa tribes. Originally they lived in the Great Lakes area, but pressure from stronger tribes pushed them out onto the prairies. By the time Jackson encountered them, the Otoe population barely exceeded seven hundred. Eventually the government resettled the tribe in Oklahoma, along with the remnants of the Missouris. Today the two tribes together number around fourteen hundred.

2. Fort Kearny is now a state historical park near Kearney, Nebraska. Its last function of any importance was to provide protection for Union Pacific construction workers. It was decommissioned in 1871 and allowed to deteriorate. Now portions of the 1860s stockade have been restored, as has a sod blacksmith shop and a powder magazine. Relics from the Oregon Trail are also on display.

3. Sod houses had mud floors, which during rains were almost too slippery to walk upon. In addition, the sod roofs leaked, forcing women in wet weather to cook with an umbrella held over the stove!

4. Chimney Rock was a long-anticipated and welcome sight to travelers on the trail. "About noon we came in sight of Chimney Rock," recorded Alonzo Delano in *Life on the Plains and Among the Diggings*, "looming up in the distance like a lofty tower in some town, and we did not tire of gazing at it" (70). Today Chimney Rock is a national historic site.

5. Scotts Bluff was named for Hiram Scott, a young trader with the Rocky Mountain Fur Company, who in 1828 took severely ill near the bluff and was unable to go on. The group leader left two men there to tend him until he recovered. But fearful of their exposure to Indians, the pair abandoned Scott after a few days and rejoined their companions, claiming that Scott had died. Several years later his bones revealed that the poor fellow lived long enough to stagger and crawl sixty miles in search of help before he died. Scotts Bluff is now a national monument, located near Gering, Nebraska. The park has a visitor center where many original Jackson paintings are on display.

6. Fort Laramie was named for a half-mythical French trapper named Jacques LaRamee, who it was said camped near here in 1818. Established sixteen years later, the fort began as

a walled trading post. In 1841 John Astor's American Fur Company bought the fort, tore the jerry-built structure down, and built a walled enclosure that quickly became a major restocking point on the Oregon Trail. In the late 1840s the U.S. Army purchased the fort, and it became their most important base for controlling and combating hostile Indians in the region. The site was abandoned in 1890, but today the renovated fort has become "the crown jewel of the National Park Service"—so says Gregory M. Franzwa in *Oregon Trail Revisited*.

7. The Bozeman Trail had been blazed by fortune seeker John M. Bozeman, along with frontiersman John M. Jacobs, in 1863 as a shortcut to the Montana goldfields.

5. A Change of Plan

1. The Mormon Church, or Church of Jesus Christ of Latter-day Saints, was centered in Nauvoo, Illinois, until its leader and founder, Joseph Smith, was murdered by an armed mob in 1844. Two years later Brigham Young, the new head of the church, began the epic migrations across the plains to the new Mormon homeland in the Great Salt Lake basin.

2. Jackson's train was one of the very few not to stop long enough at Independence Rock to chisel their names into its rounded surface. Rising 193 feet above the level valley of the Sweetwater River, the rock was a natural attraction. Now a Wyoming Interpretive Site, Independence Rock is largely fenced in and closed to those who would like to examine its surface.

3. Although the Oregon Trail went around Devil's Gate, many pioneers waded the Sweetwater through these rocky walls for the sheer exhilaration of the experience. Today the state of Wyoming runs an outdoor interpretive center just south of Devil's Gate.

4. The ascent of South Pass was generally regarded as a momentous event, marking the beginning of the Oregon country. Usually the pioneers cheered as they passed over the Continental Divide.

5. Reared on a farm in Illinois, Jim Bridger left for the upper Missouri River wilderness at age eighteen. On his travels three years later he beheld the Great Salt Lake, probably the first white man to do so. Fort Bridger became one of the most important stops on the Oregon Trail and later served as a military post and Pony Express station. After the fur trade gave out in the 1850s, Bridger served as a government guide. In his later years he settled on a farm in Missouri and died there in 1881.

6. Ticket to Paradise

1. The Paiute tribe was among the most primitive in North America. They grubbed out a precarious existence in the semideserts of the Great Basin and were looked down upon by most of the other tribes. Today about four thousand Paiutes still live on small, scattered reservations in Nevada.

2. Most of the route of the Spanish Trail ran about twenty-five miles north of what is now Interstate 15. At Barstow it followed the Mojave River through Victorville and squeezed through the mountains via Cajon Pass to reach San Bernardino. Today there is a monument at Cajon Junction marking the old trail.

7. Turning Back

1. Many of the coaches were probably Concords, extremely sturdy vehicles easily capable of carrying fifteen passengers: nine bouncing uncomfortably on the inside and six, including the driver, eating the dust and swatting the flies on the outside. It has been said that when necessary these coaches could transport more than thirty tightly packed patrons.

2. This is the last reference to Caddie that Jackson made in his diary.

3. Quoted from *The Great California Deserts* by W. Storrs Lee, 95.

4. Lee, 102.

5. In *The Great California Deserts* Lee tells the gruesome tale of Death Valley. One survivor called it "a horrid Charnel house, a corner of the earth so dreary that it requires an exercise of the strongest faith to believe that the great Creator ever smiled upon it" (59).

8. A New Beginning

1. The Omaha Indians originally numbered around three thousand, but smallpox and measles nearly caused their extinction. Today the tribe lives on a reservation in Nebraska and even combined with the Winnebagos has a population of less than two thousand.

2. Quoted from *Nebraska: A Guide to the Cornhusker State,* Federal Writers Projects, 226.

3. The Pawnee were one of the oldest tribes inhabiting the Great Plains. Their population had plummeted from ten thousand to barely fifteen hundred by 1876, when they were moved to the Oklahoma reservation.

11. Launching a Career

1. The Hayden quotes are from Clarence Jackson's *Picture Maker of the Old West*, 123–24.

2. Unfortunately, Moran's magnificent painting of the Yellowstone canyon deteriorated over the years and, although it was restored, has been removed from the Capitol.

3. Quoted from Richard A. Bartlett, *Great Surveys of the American West*, 48.

4. There had been two other photographers on the 1871 survey. One, J. Crissman, was a freelance shooter who joined Hayden's group mostly for the experience and never sold his photos outside of Montana. The other was T. J. Hine from Chicago. We will never know how his pictures would have rated with Jackson's, for he lost them, one and all, that October in the Great Chicago Fire.

12. Tragedy and Triumph

1. Although in later years Hayden's memory became rather selective and he claimed that he should have sole credit for the creation of Yellowstone Park, it is unlikely that he could have done it without the support of Jackson's photos. The wonders of the region were thought just fanciful tales until Jackson showed that they actually existed. Bartlett goes so far as to state that "all things considered, Jackson's photos were the most important contributions of the 1871 expedition" (59).

2. Between 1872 and 1874 Moran was working almost in a frenzy as he completed some fifty watercolor paintings, large numbers of which went to *Scribner's*. Nonetheless, Moran always remembered Hayden's Yellowstone survey as a turning point in his career. He also acknowledged Jackson as a major influence. For his part Jackson was enthusiastic about Moran's paintings and even purchased some for himself.

13. Touching the Heart of the West

1. William Goetzmann in *Exploration and Empire* outlines the duties of each of the six divisions. First a party was sent out to do a quick general examination of Colorado, dividing it into three sections. The three main divisions, each to do a detailed field survey of its section, comprised a topographer, a geologist, and several naturalists, as well as assistants, muleteers, packers, hunters, and a cook. Jackson's division would concentrate on photography, ranging over the entire area as Jackson saw fit. A fifth division, headed by Jim Stevenson,

was to see that the others were supplied with food and equipment, including replacements for items that were lost, broken, or stolen. The last division was headed by Hayden himself; its job was to supervise and coordinate the operations of the others. What with the lack of good communications, this was undoubtedly the most difficult job of all.

2. Zebulon Pike's mountain exploration was not a happy one. He and his men were ill-equipped for the rugged journey and suffered from cold and hunger. Worse, they became lost and somehow ended up in Spanish territory around the Rio Grande. Captured and sent to Mexico for questioning, they were eventually released. Later Pike was accused, probably erroneously, of conspiring with Aaron Burr to set up a western empire independent of the United States. At age thirty-four he was killed in the War of 1812.

3. Bartlett calls the Mount of the Holy Cross "probably Jackson's greatest picture." Thomas Moran, inspired by Jackson's photo, made a special trip to the mountain the following year. His painting of it won a medal at the Centennial Exposition in 1876. In 1929 Congress established the Holy Cross National Monument, but due to the rough terrain it was disestablished twenty-one years later. Today there is what Lee Gregory in *Colorado Scenic Guide* calls a "serviceable road" to the base of Notch Mountain, from which a "healthy hike" leads up to a view of the Holy Cross similar to the one in Jackson's famous photograph.

14. Revealing the Mysteries of Forgotten Peoples

1. Ernest Ingersoll had studied with the renowned scientist Louis Agassiz at Harvard for many years. In later life Ingersoll became the director of educational natural history at the Montreal *Family Herald*. He lived to be ninety-four, dying only a few years after Jackson, with whom he had remained close friends during their long lives.

2. Ouray's quote is from Nancy Wood's *When Buffalo Free the Mountains: The Survival of America's Ute Indians*, 13.

15. On His Own

1. Further descriptions and sketches of the Zuni pottery can be found in Ferdinand Hayden's *Tenth Annual Report of the United States Geological and Geographical Survey* (1878) at the Government Printing Office in Washington D.C. Much of the material in this chapter comes from that source.

2. Quoted from a manuscript written by Jackson and housed at the Colorado Historical Society, 10–11. This manuscript is the main record of Jackson's trip through the pueblos of Laguna, Zuni, and Tewa.

3. Quoted from *Tenth Annual Report*, 435–36.

4. *Tenth Annual Report*, 447.

16. Winding Down

1. This would be Hayden's last survey, too. Although he would continue to be highly respected in scientific circles, his work was not beyond criticism; many thought the results of his surveys had been published too quickly—and some errors tended to prove their point. But Hayden felt that the West was opening up to settlement and industry so rapidly that the results of his studies needed to be presented as quickly as possible. Bartlett says the Hayden surveys "laid the principal foundations for much of our knowledge of geology, paleontology, paleobotany, zoology, botany, entomology, and ornithology of the Rocky Mountain West" (20). After the surveys ended Hayden went on to become a high official

with the U.S. Geological Survey, which he helped found. But in 1886 he was forced to resign when locomotor ataxia made it impossible for him to perform his duties. He died of the disease the following year at the age of fifty-eight.

2. Among the eminent photographers of the time were Timothy O'Sullivan, Carleton Watkins, Eadweard Muybridge, Charles Savage, and A. J. Russell.

17. The Whole World Watching

1. Sitting Bull had been the Sioux leader at the Battle of the Little Bighorn in 1876. In 1881, after spending four years exiled in Canada, he was imprisoned for two years, then sent to the Sioux reservation in South Dakota. Some say he was allowed to perform with Buffalo Bill's Wild West show to keep him from adding to the unrest brewing among the Indians.

18. Facing the New Century

1. From a letter to Emilie dated August 1895, quoted in Hales's *William Henry Jackson and the Transformation of the American Landscape*, 260.

2. Jim Hughes in *The Birth of a Century: Early Color Photographs of America* states that the Colorado Historical Society found that Jackson had at least seventy-five sources of photos, from his own assistants to other professionals.

19. Never Stop Moving

1. Ezra Meeker had quite a career. After driving an ox team over the Oregon Trail, fifteen years before Jackson had done so, Meeker had hewed out a homestead and led a full life before dedicating himself in his seventies to marking and perpetuating the Oregon Trail.

2. A short path from the parking area at Scotts Bluff leads to where Jackson drove a stake in the soil to mark the location of his 1866 campsite. The Oregon Trail ran directly beside the campsite, and it is possible to walk along its ruts.

3. From a copy of a July 1936 clipping from an unknown newspaper with the headline "Jackson Relates Story of Trip over Oregon Trail by Wagon 70 Years Ago," on file at the Scotts Bluff National Monument, Gering, Nebraska.

4. Quoted in Beaumont Newhall and Diana E. Edkins's *William H. Jackson*, 17.

5. In a February 1989 *National Geographic* article entitled "The Life and Times of William Henry Jackson," Rowe Findley mentions that a picture of Caddie was found with Jackson's effects when he died—"to the astonishment of his family and friends" (234).

6. Quoted in Newhall and Edkins, 150.

Bibliography

Abbott, Carl. *Colorado: A History of the Centennial State*. Boulder: Colorado Associated University Press, 1976.

Ainsworth, Edward Maddin. *Beckoning Desert*. Englewood Cliffs, N.J.: Prentice-Hall, 1962.

Bancroft, Caroline. *Colorful Colorado: Its Dramatic History*. Boulder: Johnson Books, 1959, 1985.

Bartlett, Richard A. *Great Surveys of the American West*. Norman, Okla.: University of Oklahoma Press, 1962.

Billington, Ray Allen. *Westward Expansion: A History of the American Frontier*. New York: Macmillan, 1949.

Catlin, George. *Letters and Notes on the Manners, Customs, and Conditions of the North American Indians, 1832–1839*. 2 vols. New York: Dover, 1973.

Catton, Bruce. *This Hallowed Ground: The Story of the Union Side of the Civil War*. New York: Pocket Books, 1960.

Chadwick, Douglas H. "Roots of the Sky." *National Geographic*, October 1993, 90–119.

Chronic, Halka. *Roadside Geology of Arizona*. Missoula, Mont.: Mountain Press, 1983.

Chronic, Halka. *Roadside Geology of Colorado*. Missoula, Mont.: Mountain Press, 1980.

Chute, William, ed. *The American Scene: 1600–1860, Contemporary Views of Life and Society*. New York: Bantam, 1964.

Clark, Carol. *Thomas Moran: Watercolors of the American West*. Austin, Texas: Amon Carter Museum of Western Art, 1980.

Colbert, Edwin H., ed. *Our Continent: A Natural History of North America*. Washington D.C.: National Geographic Society, 1976.

Delano, Alonzo. *Life on the Plains and Among the Diggings*. 1854. Reprint, U.S.A.: Readex Microprint Corp., 1966.

DeVoto, Bernard. *The Course of Empire*. Cambridge, Mass.: Houghton Mifflin, 1952.

Federal Writers Projects. *Nebraska: A Guide to the Cornhusker State*. 1939. Reprints, Lincoln: University of Nebraska Press, 1979.

Findley, Rowe. "The Life and Times of William Henry Jackson." *National Geographic*, February 1989, 216–51.

Franzwa, Gregory M. *Oregon Trail Revisited*. Tucson: Patrice Press, 1972.

Frazier, Kendrick. *People of Chaco*. New York: Norton, 1986.

Goetzmann, William H. *Exploration and Empire: The Explorer and the Scientist in the Winning of the American West*. New York: Knopf, 1966.

Gregory, Lee. *Colorado Scenic Guide: Northern Region*. Boulder: Johnson Books, 1983.

Gregory, Lee. *Colorado Scenic Guide: Southern Region*. Boulder: Johnson Books, 1984.

Hales, Peter B. *William Henry Jackson and the Transformation of the American Landscape*. Philadelphia: Temple University Press, 1988.

Handlin, Oscar, ed. *This Was America, As Recorded by European Travelers in the Eighteenth, Nineteenth, and Twentieth Centuries*. New York: Harper & Row, 1949.

Hayden, F. V. *Tenth Annual Report of the United States Geological and Geographical Survey*. Washington D.C.: Government Printing Office, 1878.

Heise, Kenan, and Michael Edgerton. *Chicago: Center for Enterprise*. Woodland Hills, Calif.: Windsor, 1982.

Herndon, William. *Herndon's Life of Lincoln*. New York: Fawcett, 1961.

Howard, Robert West. *The Dawnseekers: The First History of American Paleontology*. New York: Harcourt Brace Jovanovich, 1975.

Howard, Robert West. *The Great Iron Trail: The Story of the First Trans-Continental Railroad*. New York: Putnam, 1962.

Howard, Robert West. *Hoofbeats of Destiny: The Story of the Pony Express*. New York: New American Library, 1960.

Hughes, Jim. Photographs by William Henry Jackson. *The Birth of a Century: Early Color Photographs of America*. London and New York: Tauris Parke Books, 1994.

Hungerford, Edward. *Wells Fargo: Advancing the American Frontier*. New York: Bonanza, 1949.

Jackson, Clarence. *Picture Maker of the Old West: William H. Jackson*. New York: Bonanza, 1947.

Jackson, William Henry. Manuscripts from 1877 and 1878 expeditions. Denver: Colorado Historical Society.

Jackson, William Henry. *The Diaries of William Henry Jackson: To California and Return, 1866–67; and with the Hayden Surveys to the Central Rockies, 1873; and to the Utes and Cliff Dwellings, 1874*. Ed. LeRoy R. Hafen and Ann W. Hafen. Glendale, Calif.: Arthur H. Clark, 1959.

Jackson, William Henry, and H. R. Driggs. *Pioneer Photographer: Rocky Mountain Adventures with a Camera*. Yonkers-on-Hudson, N.Y.: World Book, 1929.

Jackson, William Henry. *Time Exposure*. Albuquerque: University of New Mexico Press, 1986.

Jenkins, Myra Ellen, and Albert H. Schroeder. *A Brief History of New Mexico*. Albuquerque: University of New Mexico Press, 1974.

King, Kenneth M. *Mission to Paradise: The Story of Junipero Serra and the Missions of California*. London: Burns & Oates, 1956.

Kirsch, Robert, and William S. Murphy. *West of the West: Witnesses to the California Experience, 1542–1906*. New York: Dutton, 1967.

Kogan, Herman, and Lloyd Wendt. *Chicago: A Pictorial History*. New York: Dutton, 1958.

Lee, W. Storrs. *The Great California Deserts*. New York: Putnam, 1963.

Lekson, Stephen H. *Great Pueblo Architecture of Chaco Canyon*. Albuquerque: University of New Mexico Press, 1986.

Leonard, Elizabeth Jane, and Julia Cody Goodman. *Buffalo Bill: King of the Old West*. New York: Library Publishers, 1955.

Marcy, Randolph B. *The Prairie Traveler: A Hand-book for Overland Expeditions: With Maps, Illustrations, and Itineraries of the Principal Routes Between the Mississippi and the Pacific*. New York: Harper, 1859. Reprint, Williamton, Mass.: Corner House, 1968.

Mattes, Merrill J. *Scotts Bluff*. National Park Service Publication 28. Washington D.C.: Government Printing Office, 1992.

Mayer, Harold M., and Richard C. Wade. *Chicago: Growth of a Metropolis*. Chicago: University of Chicago Press, 1969.

Miller, George, and Dorothy Miller. *Picture Postcards in the United States, 1893–1918*. New York: Clarkson N. Potter Books, 1976.

Morand, Anne R., et al. *Splendors of the American West: Thomas Moran's Art of the Grand Canyon and Yellowstone*. Birmingham, Ala.: Birmingham Museum of Art, 1990.

Moulton, Candy. *Roadside History of Wyoming*. Missoula, Mont.: Mountain Press, 1995.

Nevins, Allan. *The Emergence of Lincoln*, vol. 1. New York: Scribner, 1951.

Nevins, Allan. *Frémont: Pathfinder of the West*. New York: Scribner, 1939.

Nevins, Allan. *The War for the Union*. New York: Scribner, 1959.

Newhall, Beaumont, and Diana E. Edkins. *William H. Jackson*. Fort Worth: Morgan & Morgan, 1974.

Parkman, Francis. *The Oregon Trail*. 1849. Reprint, New York: Mentor Books, 1950.

Pittman, Ruth. *Roadside History of California*. Missoula, Mont.: Mountain Press, 1995.

Pratt, Fletcher. *Ordeal by Fire: A Short History of the Civil War*. New York: Cardinal, 1951.

Roberts, David. *In Search of the Old Ones: Exploring the Anasazi World of the Southwest*. New York: Simon & Schuster, 1996.

Russell, Osborne. *Journal of a Trapper, 1834–1843*. Ed. Aubrey L. Haines. New York: MJF Books, 1955.

Sandburg, Carl. *Abraham Lincoln: The War Years*. New York: Dell, 1954.

Sandler, Martin W. *American Image: Photographing One Hundred Fifty Years in the Life of a Nation*. Chicago: Contemporary Books, 1989.

Schlereth, Thomas J. *Victorian America: Transformations in Everyday Life, 1876–1915*. New York: Harper & Row, 1991.

Sharp, Robert P., and Allen F. Glazner. *Geology Underfoot in Southern California*. Missoula, Mont.: Mountain Press, 1993.

Sprague, Marshall. *Colorado: A Bicentennial History*. New York: Norton, 1976.

Stern, Philip van Doren. *Prologue to Sumter: The Beginnings of the Civil War*. Greenwich, Conn.: Fawcett, 1961.

Stern, Philip van Doren, ed. *Soldier Life in the Union and Confederate Armies*. Greenwich, Conn.: Fawcett, 1961.

Strutin, Michele. *Chaco: A Cultural Legacy*. Tucson: Southwest Parks & Monuments Association, 1994.

Taft, Robert. *Artists and Illustrators of the Old West: 1850–1900*. New York: Scribner, 1953.

Van Every, Dale. *The Final Challenge: The American Frontier 1803–1845*. New York: Mentor Books, 1965.

Waitley, Douglas. *The Age of the Mad Dragons: Steam Locomotives in North America*. New York: Beaufort Books,1981.

Waitley, Douglas. *Portrait of the Midwest*. New York: Abelard-Schuman, 1963.

Waitley, Douglas. *The Roads We Traveled*. New York: Messner, 1979.

Waitley, Douglas. *Roads of Destiny: The Trails That Shaped a Nation*. Washington, N.Y.: Luce, 1970.

Welling, William. *Photography in America: The Formative Years, 1839–1900*. Albuquerque: University of New Mexico Press, 1978.

Wellman, Paul I. *Death on Horseback: Seventy Years of War for the American West*. New York: Lippincott, 1947.

Wilkins, Thurman. *Thomas Moran: Artist of the Mountains*. Norman, Okla.: University of Oklahoma Press, 1966.

Wood, Nancy. *When Buffalo Free the Mountains: The Survival of America's Ute Indians*. New York: Doubleday, 1980.

Yenne, Bill. *The Encyclopedia of North American Indian Tribes*. New York: Random House, 1986.

Index

About the Author

Douglas Waitley grew up in the Chicago area some time ago. His family took trips each summer to Wyoming, during which young Doug developed a passion for the West. After earning a master's degree in history from Northwestern University, Waitley ran several independent businesses before becoming a full-time author. He became interested in William Henry Jackson after viewing the Jackson collection at Scotts Bluff National Monument in 1995. Waitley is the author of thirteen previous books, including *Roadside History of Florida,* published by Mountain Press in 1997. He currently resides in Florida with his wife.

Check for Mountain Press books at your local bookstore. Most stores will be happy to order any titles they do not stock. You may also order directly from us, either with the enclosed order form, by calling our toll-free number (800-234-5308) using your MasterCard or Visa, or via our website: www.mtnpress.com. We will gladly send you a free catalog upon request.

Some other titles of interest:

_____Climax The History of Colorado's Molybdenum Mine		$20.00
_____Forty Years a Forester: 1903-1943 (paper)		$16.00
_____Forty Years a Forester: 1903-1943 (cloth)		$30.00
_____The Journals of Patrick Gass (paper)		$20.00
_____The Journals of Patrick Gass (cloth)		$36.00
_____Lakota Noon The Indian Narrative of Custer's Defeat (paper)		$18.00
_____Lakota Noon The Indian Narrative of Custer's Defeat (cloth)		$36.00
_____The Lochsa Story Land Ethics in the Bitterroot Mountains (paper)		$20.00
_____The Lochsa Story Land Ethics in the Bitterroot Mountains (cloth)		$36.00
_____The Mystery of E Troop Custer's Gray Horse Company at the Little Bighorn		$18.00
_____The Ranch		$14.00
_____The Range (paper)		$14.00
_____The Range (cloth)		$25.00
_____South of Seattle Notes on Life in the Northwest Woods		$10.00
_____Tough, Willing, and Able Tales of a Montana Family		$12.00
_____Yogo: The Great American Sapphire		$12.00

Also look for our Roadside History series:

Arkansas • Arizona • California • Florida • Idaho • Montana • Nebraska • New Mexico
Oregon • South Dakota • Texas • Utah • Vermont • Wyoming • Yellowstone Park

Please include $3.00 per order to cover shipping and handling.

Send the books marked above. I have enclosed $_____

Name_____

Address_____

City_____State_____Zip_____

☐ Payment enclosed (check or money order in U.S. funds)
Bill my: ☐ VISA ☐ MasterCard Expiration Date:_____

Card No._____

Signature _____

MOUNTAIN PRESS PUBLISHING COMPANY
1301 S. Third St. W. • P.O. Box 2399 • Missoula, Montana 59806
e-mail: mtnpress@montana.com • website: www.mtnpress.com
Order toll-free 1-800-234-5308—have your Visa or MasterCard ready.